CHINA DESIGN NOW

EDITED BY ZHANG HONGXING & LAUREN PARKER

WITH SPECIAL ASSISTANCE FROM BETH MCKILLOP

V&A PUBLISHING

CONTENTS

SPONSOR'S FOREWORD

HSBC's partnership with the V&A's *China Design Now* exhibition illustrates our close and long-standing relationship with China. We have been operating in China for 142 years and our presence there continues to grow.

China Design Now, as the title suggests, is about modern China. The exhibition puts a finger on the pulse of today's Chinese culture, enabling us to observe a critical time of change through the lens of design.

This is a remarkable exhibition and we hope it will help you experience the exciting creativity within China, from fashion to technology, design and art, to business and commerce.

Stephen Green
Group Chairman, HSBC Holdings plc

The world's local bank

DIRECTOR'S FOREWORD

In presenting *China Design Now* the V&A is taking notice of a great change in today's world. Building on four years of research, visits and interviews in the cities of the China coast, curators Zhang Hongxing and Lauren Parker have uncovered an untold story. They have benefited from numerous people's and institutions' wisdom and experience. I take this opportunity to extend warm thanks to all who have contributed in different ways to this pioneering exhibition. Difficult as it is to single out one institution from those that have worked with us, we do want to mention the Central Academy of Fine Art, Beijing, which has offered invaluable cooperation. Above all, we are enormously grateful to our sponsor, HSBC, for so generously supporting the project and sharing in our commitment to enhance the cultural understanding of China in the UK.

We believe it is fitting that the V&A should be first in the UK to explore the impact of economic expansion on design in China today. As an international museum with a long-standing interest in design history and world trade, the V&A is uniquely qualified to look at *China Design Now*. I believe that this exhibition will reveal to UK and international audiences something of the astonishing vitality of China's twenty-first-century design culture. The exhibition will guide them through an astonishing period of reform and growth, starting with Deng Xiaoping's determination to develop the economy.

The stirrings of change started in the far south of the country, when graphic artists and designers in Shenzhen began to explore new directions in the 1980s. This was the early period of economic reform, when export-led expansion in production got under way. Next we move up the coast towards Shanghai, focusing on the period from the mid-1990s. Here, consumerism and a phenomenally vital urban culture came together with surprising results. With its iconic waterfront, its historic place as China's first industrial city and its confident, fashionable image, Shanghai emerged once more as a great international metropolis. When Expo opens there in 2010, 70 million visitors will experience the transformed, consumer-driven excitement of new Shanghai. From Shanghai, the *China Design Now* journey moves towards its ultimate destination, Beijing, the national capital. The Olympic Games of 2008, the impetus for this exhibition and for so much monumental architecture that is changing the Beijing cityscape, marks China's arrival on the world stage in spectacular fashion. Beijing is a historic city, with a uniquely significant layout that has been profoundly altered by twentieth-century urban planners. In the twenty-first century, buildings by Herzog & de Meuron, Foster + Partners and Chinese designers like Zhu Pei are heralding another new era for China's capital.

In the exhibition, and in this book, curators and commentators discuss the surprising choices facing and shaping Chinese design today. Designers are working in ways that grow out of the social realities of Chinese life. Their impact is seen in the print industry, advertising, white goods, transport, architecture and more. A recurring theme is the growing middle class and its appetite for consumer goods. Even more striking, perhaps, is the explosive growth of design as a professional discipline. Today students are enrolled in more than 500 design colleges operating across the country. They will form part of the continuing story of China's growing economic strength. Through them, many of the important questions posed in this exhibition will be answered. After the rapid changes of the past two decades, there is yet more growth and change to come. Design in twenty-first-century China will certainly affect consumers across the global economy.

Mark Jones
Director, Victoria and Albert Museum

ACKNOWLEDGE

This book and the exhibition it accompanies could not have been realised without the contributions and kind help of a large number of people. Although it is not possible in this short space to thank each one of them, we are tremendously indebted to the individuals and institutions who have lent to this exhibition or contributed to the book, to those who have helped us during our research, as well as to many V&A colleagues. We could not have a more appropriate sponsor than HSBC, which has embraced the project so enthusiastically.

The preparation for the *China Design Now* exhibition has taken the best part of four years. Over this time, we have met many inspiring and creative individuals in China and elsewhere. On pp.188-9 we acknowledge our immense gratitude to all of the architects, artists, designers and participants who have so generously contributed work to the exhibition, both at the V&A and during its international tour, but here we would particularly like to thank the following individuals:

In Beijing, colleagues at the Academy of Arts and Design, Tsinghua University, including Cai Jun, Jin Jianping, Li Yanzu, Liu Guanzhong, Lu Jingren, Lu Xiaobo, Wang Mingzhi, Wu Yong and Yan Yang; *Art and Design* Publishing staff, including Emma Cheung, Hu Xiaowei, Qian Zhu and Wu Tong; at the Central Academy of Fine Arts, including Jin Hua, Li Shaobo, Lu Shengzhong, Pan Gongkai, Pi Li, Tan Ping, Wang Min, Xu Ping, Yin Jinan, Zhang Qiman and Zheng Tao; at Crystal CG, including Jason Leigh, Lu Zhenggang and Joy Yang; at the Ministry of Culture, including Cai Lian and Wang Yansheng; Ai Wei Wei; Robert Bernell, Timezone8; Chaos Y. Chen; Chen Man and Raphael Cooper; Chen Xiaojun; Colin Chinnery and Fei Dawei, Ullens Center for the Arts; Fan Di'an, National Art Museum of China; Fu Yu and Jia Meiqing (8GG); Jean-Marie Gescher, CGA; Huang Ping, Chinese Academy of Social Sciences; Huang Shengmin and colleagues, Communication University of China; Hung Huang and Johannes Neubacher, China Interactive Media Group; Jiang Jian; Lao Yang, Sugar Jar; Kent Li, Philips China; Lu Lijia, Atelier FCJZ; Ma Ke, Design Library; Meg Maggio, Pekin Fine Arts; Neville Mars, Dynamic City Foundation; Rory McGowan, Arup Beijing Office; Urs Meile; Mo Geng; Frank P. Palmer; Tom Pattinson, *Time Out* Beijing; Peng and Chen; Shao Fan and Anna Liu; Shao Xin, Beijing Ideal Design Art Co.Ltd.; Shen Lihui, Modern Sky; Varvara Shavrova; Ole Scheeren and Kevin Ou, Office for Metropolitan Architecture; Karen Smith and Liu Xiangcheng; Sarina Tang; Brian Timmoney and Loretta Law, Foster + Partners; Universalstudios Beijing; Wang Hui, *Dushu* magazine; Wang Yun; Jeremy Wingfield, Courtyard Gallery; Yan Jun; Yang Rui, Siemens; Yao Bin, 11-Art.Com; Yao Yingjia and colleagues at Lenovo; Ye Weiyang, Lotosland Design Workshop; Ye Ying, *Economic Observer*; Zhang Xin and Xu Yang, SOHO China; Zhang Yiwu; Jessie Zheng, NEC.

In Shanghai, Vera Bao, Jiang Mei and Li Lei, Shanghai Art Museum; P.T. Black; Chen Xudong; Chen Yifei family; Angelica Cheung, *Vogue China*; Parson Ge; Ramon Gil; Gu Zhenqing and Biljana Ciric, Doland Museum; Hai Chen; Han Feng; He Yan; Lorenz Helbling, Shanghart; Pete Heskett, BBH; Richard Hsu; Ji Ji, Pole Design Consultants; Jiang Qiong Er; Jin Jaehan and team, Samsung Design China; Yue-sai Kan; Samuel Kung and Victoria Lu, Museum of Contemporary Art; Pearl Lam and all her staff at Contrasts Gallery; Michael Lee and his team at Ogilvy & Mather Advertising; Li Xu, Z-art Center; Joe Liu, Nike Sports China; Ma Degang; Lyndon Neri and Rossana Hu, Design Republic; Dana Nicholson, IDEO; Davide Quadrio and Francesca Tarocco, BizArt; Paul Rice and Xin Wu, Atkins; Thomas Shao, Peter Wong and Shaway Yeh, Modern Media Group; Les Suen; Sun Tian and Zhi Wenjun, *Time + Architecture* magazine; Wang Dawei, Shanghai University; Wang Wei; Wang Yiyang; Wang Xingzheng and Lori Lee, Yong Foo Elite; Wei Shaonong, Yang Mingjie and Zhu Chun, Shanghai Normal University; Weng Ling, 3 on the Bund; Xu Dongwei, GK Design; Eddi Yip, Adfunture; Zhang Da; Zhao Bingbing, Greater London Authority, Shanghai Office; Zhao Yongzhi, Designonline; Zhou Yi and Tim Richter, S. Point Design; Zhu Dake, Tongji University.

In Shenzhen, Bi Xuefeng, Chen Shaohua, Han Jiaying, Han Zhanning and Wang Yuefei, Shenzhen Graphic Design Association; Chen Xiangbo, Huang Zhicheng, Wang Xiaoming and Wilson Yan, Guanshanyue Art Museum; Dong Xiaoming, The Association of Writers and Artists in Shenzhen; Stefan Sagmeister; Yan Shanchun, Shenzhen Painting Academy; Yang Zhen, Fire Wolf Design. In Guangzhou, Cai Tao, Guo Xiaoyan, Adela-Jianfen Liao and Wang Huangsheng, Guangdong Museum of Art; Cao Fei and Ou Ning; Feng Yuan and Yang Xiaoyan, Zhongshan University; Jim Hollington and Florence Zeng, British Council; Hu Fang and Zhang Weiwei, Vitamin Creative Space; Charlie Koolhaas and Laetitia Migliore; Ma Ke and Mao Jihong; Tong Huiming, Yin Dingbang and Zhao Jian, Guangzhou Academy of Fine Arts; Eric Zhu. In Hong Kong, Chang Tsong-zung, Hanart; Doris Fong, British Council; Claire Hsu and Phoebe Wong, Asia Art Archive; Lorraine Justice, Hong Kong Polytechnic University; Freeman Lau and Victor Lo, Hong Kong Design Centre; Stanley Wong. We would also like to thank He Renke in Changsha; Liu Jiakun in Chengdu; Wu Haiyan and Zhao Yan in Hangzhou.

Our additional thanks go to Bettina Back and Esther Zumsteg, Herzog & de Meuron; Emily Campbell, Nina Due, Sorrel Hershberg at the Design and Architecture department, British Council; Christine de Baan; Philip Dodd; John Gittings; Simon Groom, Tate; Dale Harrow, Royal College of Art; Ke Yasha, Culture Office, Chinese Embassy; Simon Kirby, Artistlinks; Li Hua; Jennifer Mundy, Tate; Hans Ulrich Obrist and Julia

ENTS

Peyton-Jones, Serpentine Gallery; Christopher Phillips and Sally Wu; Wei Wei Shannon, People's Architecture; Uli Sigg; John Thackara; Matthew Turner; Wu Hung; Zhang Ga.

Research for this publication has benefited from the help of many people, including the following individuals and organizations: *Art and Design* magazine in Beijing, the National Art Library at the V&A, the School of Oriental and African Studies library in London, Hang Jian, Jiang Jun, Ou Ning, Rodolf Wagner, Verity Wilson, Xu Ping, Xu Yang, Yan Shanchun. We would particularly like to thank the Central Academy of Fine Arts (CAFA) for the generous support and assistance they have given. Our warmest thanks go to Jin Hua, Pan Gongkai, Tan Ping, Xu Ping and Wang Min.

CAFA and the V&A co-hosted a three-day research workshop in Beijing in October 2006. We would like to thank all the individuals that took part, their contributions proved invaluable in the development of the publication: Bao Mingxin, Donghua University; Cai Jun, Academy of Arts and Design, Tsinghua University; Christopher Breward, V&A; Gigi Chang, V&A; Fu Gang, CAFA; John Heskett, Hong Kong Polytechnic University; Tessa Hore, V&A; Huang Zhicheng, Guanshanyue Art Museum; Li Shaobo, CAFA; Jan Staël von Holstein, Network with a Silver Lining; Ou Ning; Shi Jian; Xiao Yong, CAFA; Xu Ping, CAFA; Wang Min, CAFA; Wendy Wong, York University, Toronto, Canada; Yan Yang, Academy of Arts and Design, Tsinghua University; Ye Ying, *Economic Observer*; Yin Zhixian, *Trends Home* magazine; Zheng Tao, CAFA and all the translators.

This publication could only be realized through its contributors. We would like to thank Bao Mingxin and Lu Lijun, Helen Evenden, Huang Zhicheng, Stefan Landsberger, Li Wen, Ezio Manzini and Benny Ding Leong, Shi Jian, Ye Ying, Yin Zhixian and Jianfei Zhu for their essays; Hu Yang, Yu Haibo and Zeng Li for three photo essays; and Guang Yu, He Jun and Liu Zhizhi of MEWE Design Alliance for their specially commissioned maps of Beijing, Shenzhen and Shanghai. Our sincerest thanks go to Anjali Bulley and Beth McKillop for their hard work pulling the book together, Mandy Greenfield for copy editing, Nicky Harman for translating a number of the essays, and David Bothwell from Hybrid 2 Ltd UK for designing the book.

Many individuals and departments within the V&A have provided a strong commitment to make *China Design Now* happen. In particular, our thanks must go to V&A Director Mark Jones, who initiated and supported this project throughout. We would like to thank the *China Design Now* Advisory group for their sound advice and resolute steering of such an ambitious project, including Christopher Breward, Anna Jackson, Linda Lloyd Jones and Beth McKillop. Our gratitude also goes to Kate Best who took a journey with us; to the Exhibitions team,

particularly Ann Hayhoe, Poppy Hollman, Tessa Hore, Diana McAndrews and Anne Starkey; to colleagues in the Research Department including, Glenn Adamson, Christopher Breward, Ulrich Lehmann, Jane Pavitt, Carolyn Sargentson, Claire Wilcox and Gareth Williams; to the exhibition editor Lucy Trench; to the Public Affairs team including Sarah Armond, Olivia Colling, Dorothee Dines, Meera Hindocha, Debra Isaac, Ben Weaver and Damien Whitmore; to the Development Department including Pippa Broadbent, Laura Hingley and Nicole Newman. Additional thanks to Clair Battisson and colleagues from the Conservation Departments; to Annabel Judd, Michael Malham, Jane Scherbaum and colleagues from Design; to Jan Bourne, Gail Durbin and colleagues from ISSD and the Web Team; to David Anderson, Rajiv Anand, Jo Banham, Kara Wescombe and colleagues from Learning and Interpretation; to Michael Casartelli and colleagues from Purchasing; to all at Events, Finance, Gallery Services, Members, Property, Safety, Security, and Technical Services; to Mary Butler, Julie Chan, Clare Davis, Annabelle Dodds, Mark Eastment, Asha Savjani, Sarah Sevier and Monica Woods from V&A Enterprises; and to colleagues in the Asian Department, Research Department and Contemporary Team who offered advice as well as a great deal of understanding and support during our regular absences from the V&A.

Mike Tonkin, Anna Liu, Pereen d'Avoine and Neil Charlton from Tonkin Liu and David Bothwell from Hybrid 2 Ltd designed the exhibition; Airside designed the exhibition website – we thank them for their creative and thoughtful work. We would also like to thank others who helped to realize the exhibition, especially Mike Cook and Sam Clark from DBA, Greenway Associates, Huaxie, The Hub, Interactive View, Bruce Kirk, Iain McGhee from Cromium, Momart and many others. Our particular and whole-hearted thanks go to Research Assistant Gigi Chang and her team of interns and volunteers (Chang Ya-chuan, He Weiwei, Henriette Hofmann, Anna Holmwood, Rachel Fan Li, Yan Xia, Zhichun Zhang, Zhao Shan). Gigi has been an invaluable and tireless colleague – researcher, organizer and sometimes interpreter and translator. Without her, this project could not have been as it is.

Finally, we owe an immense debt to our families. Hongxing: to Ruihua and Chun for their understanding and support during the period of working on the project. Lauren: to my parents for their support and enthusiasm for the project, and especially to Jan, you deserve my greatest thanks of all.

Zhang Hongxing and Lauren Parker

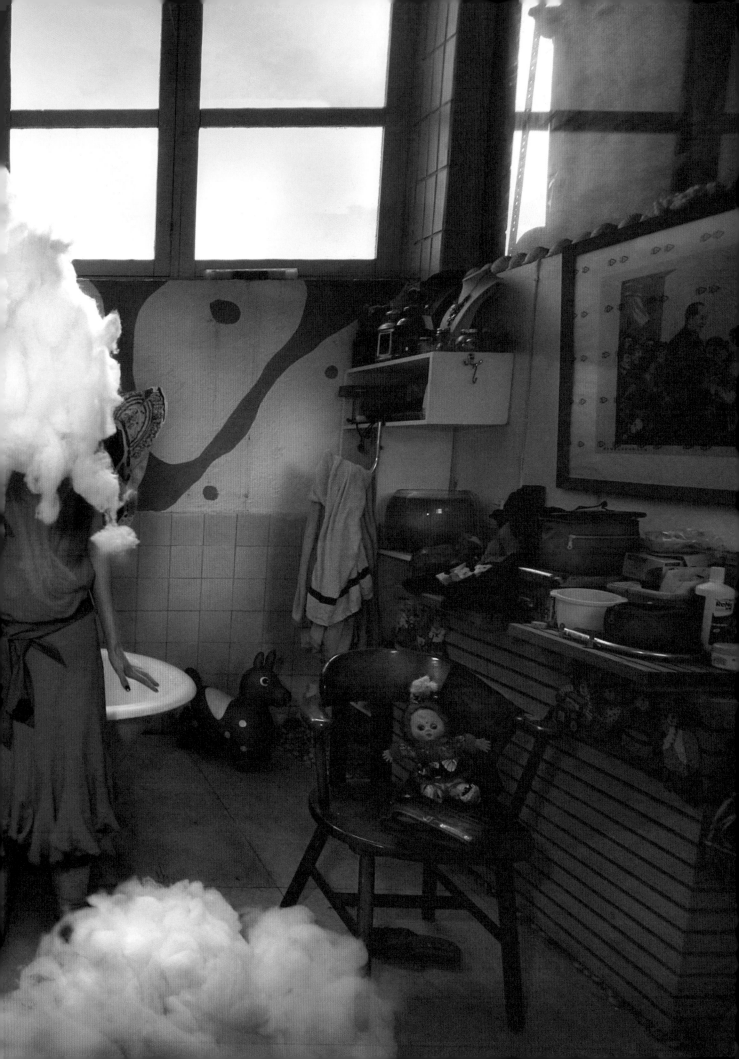

CHRONOLOGY 1949–2008

1949 People's Republic of China founded under Mao Zedong

1953 State-ownership Land Reform completed
Soviet-style Five-Year Plan model adopted
Rice coupons issued due to food shortages

1956 Socialist transformation in urban areas begins, through which all private industry and commerce are changed to state-owned enterprises

1958 Residency permits adopted into law to control internal immigration
People's Communes formed in the countryside
Great Leap Forward leads to famine from 1959 to 1961

1966 Cultural Revolution: first phase completed by 1969, but policies continue until 1976

1972 President Richard Nixon visits China and meets Mao Zedong

1976 Mao Zedong dies

1977 Deng Xiaoping assumes power
20 million youth return to the city from the countryside
University entrance examinations re-introduced

1978 Four Modernizations policy (in agriculture, industry, science and technology, and national defence) outlined, marking the beginning of China's reform era

1979 Contracted responsibility system adopted in the country-side, by which farmers can sell surplus crops on the open market
Ambiguity Poetry, an avant-garde poetry movement, spreads
Intellectual magazine *Dushu* published
Independent artist group Stars exhibits work in Beijing
Commercial advertising appears in newspapers and on TV
Taxis appear in Guangzhou

1980 Special Economic Zones (SEZs) set up in Guangdong and Fujian provinces
One Child family policy implemented

1981 China Art and Craft Association set up

1982 Socialism with Chinese Characteristics becomes the official definition of China's political system
China Packaging Technology Association established

1983 Anti-Spiritual Pollution Campaign attacks the 'contamination of Western ideas and influences'
Coca-Cola launches in China
China Advertising Association set up

1984 Dual-track price reform implemented
Pierre Cardin store opens in Beijing

1985 Village and township enterprises emerge
'Culture Fever' surges in urban areas, a cultural criticism composed of embracing Western culture and searching for alternative Chinese traditions
85 New Wave avant-garde art movement launched
Private housing begins to appear in Beijing

1986 First public-service advertisements broadcast
Rock singer Cui Jian becomes popular among urban youth

1987 Private enterprises emerge
Kentucky Fried Chicken outlet opens in Beijing
China Industrial Design Society set up

1988 Construction of national highways begins
TV serial *Yellow River Elegy* broadcasts
Red Sorghum feature film by Zhang Yimou screened
Elle China, the first Chinese version of an international style magazine, is published
Nanfang Studio, the first private industrial design studio, set up in Guangzhou

1989 The Berlin Wall falls
China Avant-Garde Art exhibition opens at the National Art Museum, Beijing
Tiananmen Square protest
Jiang Zemin becomes General Secretary of the Communist Party of China

1990 First McDonald's outlet opens in Shenzhen
Cynical Realism movement becomes popular in fine art
New Documentary Movement in film begins
China Museum of Art and Craft opens in Beijing

1991 Collapse of the Soviet Union
Ration coupons abolished
First Nike shop opens in Shanghai
First Chinese Supermodel Contest held in Beijing

1992 Deng Xiaoping's Southern Tour calls for faster economic reform
A Socialist Market Economy becomes the goal of China's economic reforms
Shanghai Pudong New Area development intensified
Large influx of migrant workers into China's cities begins
First Louis Vuitton store opens in China
China's first graphic-design exhibition, *Graphic Design in China*, opens in Shenzhen

1993 China Guardian Auctions Co. Ltd, the first state-level fine-art and antiquities auction company, established in Beijing
Sixth Generation of film directors emerges (e.g. Zhang Yuan, Jia Zhangke)
Corporate Identity Committee of China Industrial Design Society set up
First China International Clothing and Accessories Fair
China Fashion Designers' Association established
First Carrefour supermarket opens in Tianjin

1994 Evening and weekend newspaper boom

1995 Job-assignment system for university graduates abolished
Two-day weekend adopted
Oriental Pearl TV Tower built in Pudong, Shanghai
Private architecture firms and studios emerge

1996 Widespread price reduction of commercial goods
First Wal-Mart supermarket opens in Shenzhen

1997 Deng Xiaoping dies
East Asian Financial Crisis
Shareholder-oriented reform of state-owned enterprises starts
Insurance medical-care system adopted, replacing free healthcare
Internet cafés appear
First China Advertising Festival in Guangzhou
First L'Oréal store opens in China
First China Fashion Week launches in Beijing
Layefe, one of the first Chinese private fashion brands, launches in Shanghai
S. Point, the first private product-design company, starts in Shanghai

1998 Welfare-housing distribution system abolished
10 million workers in the cities are unemployed, caused by reforms
The 88-storey Jinmao Tower built in Pudong, Shanghai
Art and Design replaces Art and Craft as an official degree title in design education

1999 First Starbucks outlet opens in Beijing
50 Moganshan Road (M50) becomes a popular art space for artists and galleries in Shanghai
9th National Art Exhibition extends to include an art-and-design section

2000 Beauties' Literature, the genre of a group of women writers born in the 1970s, becomes popular
First Dior and Chanel stores open in China
Online gaming emerges as a popular pastime

2001 China joins the World Trade Organization (WTO)
Beijing wins bid to host the 29th Olympic Games in 2008
Copyright Law amended to include design work
First Giorgio Armani store opens
798 Art Factory becomes a popular art space for artists and galleries in Beijing

2002 Hu Jintao becomes General Secretary of the Communist Party of China
Shanghai wins the bid to host World Expo 2010

2004 *Creative Economy in China* exhibition held at Beijing Science Expo
CCTV 2004 Innovative Design Gala Night, organized by the State Intellectual Property Right Bureau and China Central Television (CCTV)
China International Industrial Design Summit in Wuxi, organized by the China Industrial Design Association
China Lifestyle Award launches

2005 Google enters China
Vogue China launched
Lenovo purchases IBM's personal computer division and becomes the world's third-largest computer manufacturer
Haier becomes world's third-largest white-goods manufacturer
Design Resource Cooperation (DRC) established in Beijing
50 Creative Cluster Parks established in Shanghai
Get It Louder design exhibition opens

2006 Sustainability, innovation and a 'harmonious society' are emphasized in the 11th Five-Year Plan

2007 Private property law passed

2008 29th Olympic Games held in Beijing

Map of China, Hybrid 2 Ltd

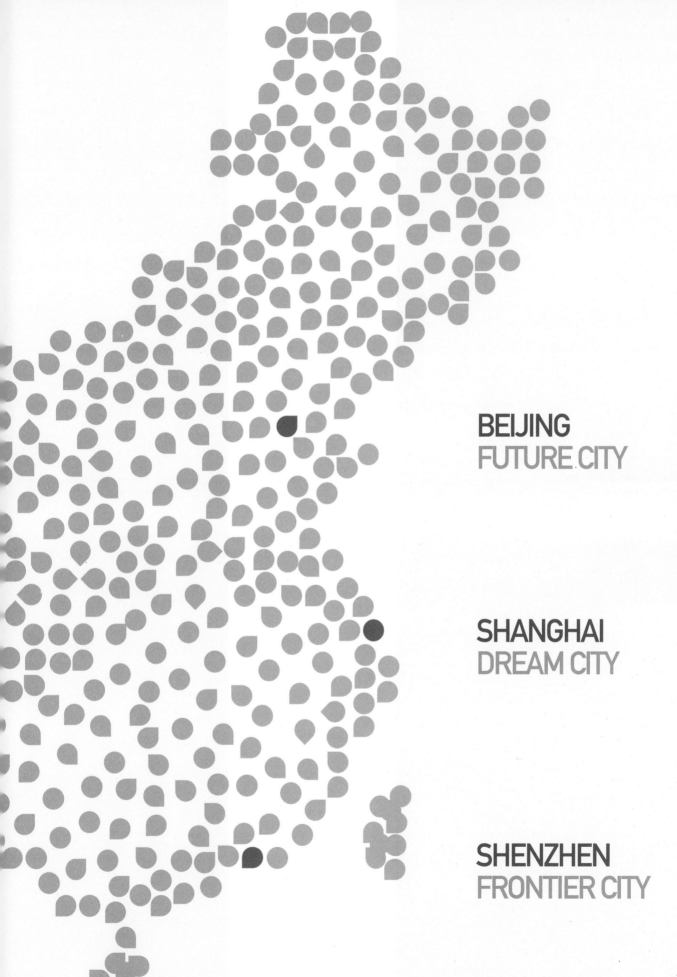

BEIJING
FUTURE.CITY

SHANGHAI
DREAM CITY

SHENZHEN
FRONTIER CITY

DESIGN IN CHANGING CHINA

ZHANG HONGXING AND LAUREN PARKER

The last 20 years have witnessed a spectacular series of changes in the world. The disintegration of the Soviet Union, the growth of free-market economies in Eastern Europe and the concurrent redrawing of Europe's economic and political boundaries, alongside the rise of new emerging economies – from Brazil to India – have begun to reconfigure the global landscape of international development, economics and society. China sits at the very heart of these global shifts. To the degree that its development is changing China itself, these are important, but as political and economic analyst Joshua Cooper Ramo states:

What is far more important is that China's new ideas are having a gigantic effect outside of China. China is marking a path for other nations around the world who are trying to figure out not simply how to develop their countries, but also … in a way that allows them to be truly independent, to protect their way of life and political choices.[1]

As recently as 1999, *Foreign Affairs* magazine could publish an article called 'Does China Matter?'; today China's rise is an unarguable fact of life. The scale and speed of its transformation, as well as its emergence as a global power, are remaking the international order.

China's statistics dazzle the rest of the world with this massive scale. China has 1.3 billion people, representing more than one-fifth of the world's population. Between 1978 and today it has witnessed one of the most sustained and rapid econo-

mic transformations seen in the world economy in the past 50 years, averaging a growth rate of over 9 per cent a year. Since 2000 China's contribution to global GDP growth (in purchasing-power-parity terms) has been greater than America's, and more than half as big as the combined contributions of India, Brazil and Russia, the three next-largest transitional economies. Its low-priced manufactured goods are propping up western consumer spending. In 2001 alone, China produced 96 million electric fans, 41 million colour television sets and 25 million mobile phones.[2] At the same time, since China's 'Reform and Opening Up' process began in the late 1970s, the World Bank estimates that China has lifted 300 million people out of poverty, a historical accomplishment.[3]

This reform process has seen two main thrusts. The first has been a move towards a free-market economy in China, and the second has been an opening up to the global economic and political community – a so-called 'globalization with Chinese characteristics'. The changing status of China from the periphery to the centre of the world stage has provoked different reactions. Peter Nolan, a China economic and business analyst, has described the nation as being at a 'crossroads' in this process of transition.[4] Traditional views of China, from Washington hawks and others, have seen the country either as a market to be exploited or as a 'threat' – whether economic or military – to be contained.[5] Some commentators (for example, journalist and editor of *China Dialogue*, Isabel Hilton) are critical of China's record on environmental issues and human rights.[6] For others, however, China represents an opportunity that we cannot afford to miss. Tony Blair, the former British prime minister, in his speech to the European Parliament in June 2005, claimed that the European Union's choice was either to regain competitiveness through reform or fall behind the rising powers of China and India.[7] Amsterdam-based cultural and architectural historian Ole Bouman has written more recently that China is not only a land of change, but also a land of ideas: '… rather than the best [Chinese] minds and talents flocking to the West, now the best minds of the West have become consultants in China'.[8]

INTRODUCTION

China's economic transformations have had a profound impact on China itself – its social structures, urban environments and creative pioneers, from designers and architects to artists and film-makers who are charting a course through China's new cultural landscapes. Architects, graphic designers, photographers, publishers, bloggers and style trendsetters are responding with vigour to this moment of intense transformation – acting both as chroniclers of China's changes in all its intensity, energy and uncertainty, revealing what design in a Chinese context means today, and providing a first glimpse of what Chinese design may offer to the wider world in the future.

This book and the V&A exhibition that it accompanies are a critical survey of the development of a new design culture in post-reform China – that is, China after 1978 when economic reform began. They showcase a range of major design and architecture projects, and present the pioneering generations of creative practitioners who are shaping China's contemporary cultural landscape alongside major international contributors. Focusing on China's hopes and dreams – from the entrepreneurial spirit of individual designers, to society's aspirations at a moment of tremendous change, and the global ambitions of a nation – *China Design Now* explores how China's new design culture began, how it is developing, what its driving forces are and, above all, where it is going.

Before introducing the narratives of the book, what follows is a summary of our thoughts on some key issues with regard to the characteristics of the new design culture in China. These issues have interested us throughout the preparation of the book and the exhibition, and have undoubtedly influenced the way we approach the subject. How can we describe the state of design in an emerging economy like China? Given the diverse nature of design development in China, can we provide any kind of coherent picture? Is it possible to expect China's trajectory to fall into the pattern we have seen in the West since the Industrial Revolution? Or is a new path emerging?

Design in developing China

The 'added value' of design is increasingly being recognized as an essential tool for economic competitiveness for both developed and developing countries in the global market. Dominant commentaries about the development of Chinese design have tended to view it in the light of the country's place in the global economy.[9] To some design commentators, what is most crucial about the origins of contemporary Chinese design has been China's strategic decision to follow a number of its Asian neighbours (from Japan and South Korea to Taiwan, Hong Kong and Singapore) in the adoption of an export-oriented development path. Part of Deng Xiaoping's 'Reform and Opening Up' policies from the early 1980s, this development strategy focused on China's competitive advantage at that time, producing low-cost manufactured goods principally for export and using one of the country's greatest resources, its reserves of cheap labour.

For design commentators including Clive Dilnot and John Heskett, this pragmatic approach has had strong implications for the development of a Chinese design culture. Within an increasingly globalized system of design, production and consumption, China found itself in a situation where the research, design and engineering of products were essentially determined by outside forces, and for outside markets. Product design for the domestic market, in the Pearl River delta for example, has been largely a matter of the low-value adaptation of existing product types. In this context, local design could only play an imitative role. The end result was not innovation in design, but a culture of the copy.[10]

Heskett has recently highlighted some of the challenges presented in the development of a strong design culture in China.[11] A major issue facing Chinese designers has been the understanding of the nature and function of design. In large Chinese manufacturing companies, design has operated at best at a middle level, buried in large marketing and engineering departments. In this context design is a styling tool, shaping the appearance of a product, not influencing the engineering, function or use of an object, and certainly not

engaging in research into user needs. In general, although the notion of design in a manufacturing context is moving away from the notion of cosmetic design alone, designers often still have little role to play in wider corporate decision-making or in new product concepts. Designers working in these companies tend to have high visualization skills, but, with little encouragement to use their initiative, they may get into a habit of looking to the rule book for guidance. More experienced designers are often promoted quickly into management roles, leaving new graduates and young designers to take on most of the practical design delivery.

In the area of design education, there are an estimated 550 institutions across China providing a range of design courses. Many courses and institutions have an international reputation, but across China some problems still remain. A shortage of good teachers is one of them. Because design is a relatively new field, teachers can be drawn from many different backgrounds, often with little design training. Students learn to use computers, but the provision of workshop facilities can be poor. Teaching may be theoretical, with few on-the-job training or internship possibilities, and it is still fairly unusual for practising designers to be invited to teach or lecture at design colleges. Perhaps most symptomatic of all is the fact that the Chinese government has few initiatives to promote or support design, and no coherent national design policy. However, as John Heskett has argued, what has occurred historically in the development of design in China is not atypical of many other newly industrializing countries, from Germany and the United States in the late nineteenth century to Japan following the Second World War. In all these cases, copying the production practices and manufacturing models of other successful nations enabled a dynamic manufacturing economy to develop, leading to later innovations.[12]

However, Heskett also points out that China has seen plenty of signs of change, particularly in the past few years. In 2006 the Chinese government set up the goal of becoming an innovation-driven country – to achieve the transition from 'Made in China' to 'Innovated in China'. The consequences

for not doing so are serious. 'We are doomed,' wrote state councillor Chen Zhili in the Party intellectual journal, *Qiu Shi*, unless China's society is able to find a way to innovate; and he argued that the two pillars of China's future are, on one hand, the development of science and cutting-edge technology, and on the other, the resources available from China's greatest natural resource, its people.[13]

Design centres are being established in cities such as Beijing and Shanghai. The State Development and Reform Commission of the State Council is preparing a document on design policy, covering a wide range of areas, from technology and design management to international collaboration and intellectual property. The *Cox Review*, a review of creativity in British business, has noted that between 2003 and 2005 China had the most rapid global increase in research and development, now estimated to have reached 1.5 per cent of GDP. China is building a capability based on strong investment, high-level skills and a low cost base.[14]

The need to develop and promote an innovation-led approach to design is something that is being acknowledged both at state level and by manufacturers. A small but growing number of Chinese companies are aware that the future of design in China hinges on gaining a deeper understanding of the way Chinese people live, designing for the patterns of daily life in China to create winning innovations. Spearheading investment in design, research and development are companies like computing and electronics giant Lenovo, Philips China, mobile-phone manufacturer Ningbo Bird and China's largest white-goods brand Haier. New areas of design and manufacture are also growing – over the next decade China will enter the global market as a key provider of cars, mobile phones, gaming, Internet services and digital communication and entertainment.

Observations such as the above are a useful starting point for understanding the development of design and manufacturing in transitional China, but they should be read with some caution. The emergence of in-house design in manufacturing,

INTRODUCTION

and of design schools, design publications and promotional bodies represent important indicators of an emerging culture of design, but they account for only part of a bigger picture. The institutional story of design development is one part; others include the vital role that individual designers have played in promoting and pursuing creativity in a number of design fields, from graphics to fashion. If we can uncover some of these other stories, we can perhaps look beyond the notion that China is simply 'catching up' with more-developed creative economies, and instead appreciate the complexity of the extraordinary changes that are taking place.

Design in informal China

China's transition from a command economy to an open market-oriented economy has taken a different route from the 'shock therapy' of the former Soviet Bloc countries, adopting a series of incremental measures and allowing ideas to be implemented locally or in a particular economic sector. Most recent research by Chinese leading economist Hu Angang has demonstrated that China's sustained strong economic performance has had as much to do with the informal economy that the reform process facilitated as with directly state-controlled initiatives.[15] In Mao's era, any work carried on outside the state structure was illegal. However, from the early 1980s when reforms began, an informal sphere of activities was encouraged to solve the increasing problems of goods shortages, unemployment, system inertia and to meet the increasingly diversified demands of a growing consumer market. An entrepreneurial spirit – of 'jumping into the commercial ocean' – started to develop. This informal economy in China includes both the self-employed and private sectors, as well as unregistered rural migrant workers in the cities. The informal economy has a loose organizational structure. Working relationships may be based on kinship and other forms of *guanxi* or traditional *quid pro quo* social networking. The reasons driving people to enter this sector vary hugely depending on the context, ranging from the sheer necessity of surviving, to getting additional work, to maximizing income. Despite being subject to increasing government regulation, the informal economy remains a potent force in China because of the continual and fast-paced development of new industries and new customer demands.

In the context of design, China has in its cities a thriving creative informal economy – creative professionals engaged in informal networks, deregulated activities and, on the whole, small-scale entrepreneurial work. As Saskia Sassen suggests, these cultural pioneers are able to:

function in the interstices of urban and organizational spaces often dominated by large corporate actors and to escape the corporatization of creative work. In this process they contribute to a very specific feature of the new urban economy: its innovation and a certain type of frontier spirit.[16]

For many designers in China, the informal sector has provided a major source of employment throughout the post-reform period. In the 1980s and early '90s, most designers worked for state-owned institutions, such as art and design schools or design institutes affiliated to various government ministries, but because salaries at the schools and institutes were low and the demand for commercial design work was high, it was popular among such state-employed designers to take 'second employment' from outside the official system, an activity known as *di'er zhiye* or *chaogeng*. Ma Qingyun, a leading Chinese architect, gives an engaging explanation of how second employment worked for architects in Shenzhen during that period:

1

The McGraw·Hill Companies

BusinessWeek

EUROPEAN EDITION / NOVEMBER 8, 2004

www.businessweek.com

CHINA'S POWERBRANDS

AUSTRIA€4.50	LUXEMBOURG............€4.50
BAHRAINBD 2.50	NETHERLANDS€4.50
BELGIUM€4.50	NORWAYNKR 40
CZECH REPUBLICCZK 120	POLANDZ 16.50
DENMARKDKR 35	PORTUGAL (CONT)€4.50
FINLAND€4.50	SAUDI ARABIASR 26.00
FRANCE€4.50	SOUTH AFRICASAR 27.50
GERMANY€4.50	SPAIN€4.50
GREECE€3.95	SWEDENSKR 36.00
HUNGARYFT 1090	SWITZERLANDCHF 8.30
ICELANDIKR 475	U.A.E.DH 24.00
IRELAND€4.50	UNITED KINGDOM£2.75
ISRAELNIS 22	UNITED STATESUS$4.95
ITALY€4.50	
LEBANONLL 7500	**NUMBER**3891-1221

9 770007 713081 4 6>

Bold entrepreneurs are producing the mainland's hot consumer products. The multinationals are fighting back. Who will the big winners be? BY DEXTER ROBERTS (P. 44)

1. 'China's Power Brands', *Business Week*, European edition, 8 November 2004.
2. 'China Design', *Business Week*, Asian edition, 21 November 2005.

2

FRANCE'S CRISIS (P. 24) | **THE WEBSMART 50** (P. 48) | **NISSAN'S DIP** (P. 20)

The McGraw-Hill Companies

BusinessWeek

ASIAN EDITION / NOVEMBER 21, 2005

www.businessweek.com

CHINADESIGN

How the
mainland is
becoming
a global
center
for hot
products

BY DAVID ROCKS (P. 64)

Lenovo
video
phone

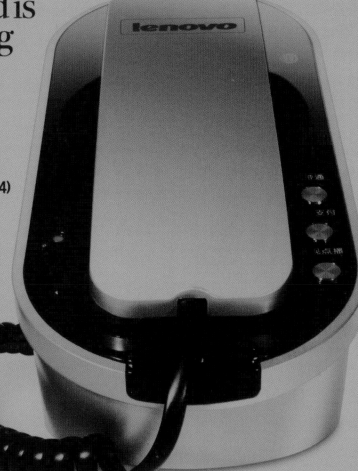

AUSTRALIA	$6.60	NEPAL	NR 150
BANGLADESH	TAKA 90	NEW ZEALAND	NZ $7.90
BRUNEI	B $8.00	PAKISTAN	RS 200
CAMBODIA	US $4.00	PAPUA NEW GUINEA	K 6.00
CHINA	RMB 55	PHILIPPINES	PESOS 120
HONG KONG	HK $45	SINGAPORE	S $8(inc.GST)
INDIA	RS 120	SRI LANKA	RS 140
INDONESIA	RP25,000(incl.tax)	TAIWAN	NT $150
JAPAN	¥840 (¥800)	THAILAND	BAHT 145
KOREA	WON 6,000	TONGA	T $5.00
LAOS	US $4.00	VIETNAM	US $4.00
MACAU	HK$45	UNITED STATES	US $4.95
MALAYSIA	RM 9.90		
MYANMAR	K 600	NUMBER	3941-1270

4 7>

9 770007 713081

Although it gained popularity during the peak years of Shenzhen's growth, chaogeng *has never been a legal form of practice, therefore never recognized by any design institute. A design institute could be criticized if its employees were discovered to be involved in legal disputes related to* chaogeng *practice … The careful ones keep a very low profile while the more aggressive ones would choose to leave the institute and become professional* chaogengers. *A designer could also stay with an institute and continue to pay a loyalty fee to attain the privileged status of an 'inactive employee'.*[17]

However, as China's economic reforms pressed on, the official design institutes and design schools had to change their traditional ways of working. A new employment system was created, called *chengbao* or 'contracted responsibility'. In this new system, small companies or studios were set up under a special financial arrangement with the official body, and these companies and studios were legally protected by that institution.

During this early period of reform many designers chose to take second employment, instead of embracing wholly the entrepreneurial culture – 'jumping into the commercial ocean' – that would sever their link with their institutions. Navigating through the changing landscapes of formal and informal projects, between career security and taking risks, and between securing social status and maximizing financial gain, became a major theme in design activities at the time.

For most designers, striking a balance between these two poles was an important concern. In Shenzhen, an architect's work was often classified into two categories: 'face' projects and 'stomach' projects. A 'face' project was normally done for the design institute, displaying the architect's design ability; while a 'stomach' project, as part of their second employment, was done merely for monetary purposes. The income earned from a 'stomach' project could be 10 or 20 times the average salary. However, the success of a designer was also measured by his or her social status, which was in turn linked to the official rank and benefits (from free or subsidized housing to official recognition and fame) bestowed upon those working in official institutions. These were hard-won benefits and not always easy to relinquish.[18]

This dual system continued to exist across the design professions in China beyond the mid-1990s, even as setting up one's own private practice became the preferred business model among designers. The opposing attractions of formal and informal practice, commercial and self-initiated work have led to the growth of small-scale independent working as a way of life for many.

For the pioneering generations of graphic designers in Shenzhen starting their own independent design practices in the early to mid-1990s, spurred on by Shenzhen's status as one of China's first Special Economic Zones (SEZs) and by their own entrepreneurial spirit, this duality of ambition has led to a mixture of commercial and self-initiated projects. Despite the fact that the majority of their time is spent on commercial work, they pour most of their creative energies into non-

INTRODUCTION

commercial and often self-initiated projects – from international poster competitions to local exhibitions. Wang Yuefei, one of Shenzhen's most established designers, calls their non-commercial work a form of *xiulian*, a term that refers to Taoist meditation or alchemical practices.

Wang Yiyang, a Shanghai-based fashion designer, presents another example of the duality of design practice taking place in China. Before becoming a professional fashion designer, Wang Yiyang taught in Shanghai's Donghua University for five years. He resigned from the university to take up a post as chief designer for the newly established Layefe fashion company in 1997, launched by artist, film-maker and entrepreneur Chen Yifei. In 2002 he left to establish his own fashion label ZucZug. With retail stores in more than 20 Chinese cities, Wang was able to capitalize on the commercial success of the brand, launching a more conceptual fashion line, Cha Gang, in 2004, winning him critical acclaim within China and a growing reputation internationally.

These designers are not exceptions. Quite the opposite, they represent the norm of design practice in China today. While this search to find a balance between commercial imperatives and creative endeavour is a common challenge that faces designers across the world, in China practitioners tend to see these as two opposite and often incompatible states. Designers often consciously keep them far apart as two separate activities: work that is overtly commercial or official, and other projects that are absolutely independent and alternative.

This strongly dualistic attitude is not always easy to understand. In part, it may be a consequence of commercial clients who do not always see the value of creative design, instead providing projects where design work is often completed at a rapid pace and without time to develop creative ideas. Other factors may include more deeply rooted cultural ideas – for example, the Chinese literati's traditional self-identification as intellectuals, with their concomitant bias against commercial activities. One could also argue that these attitudes towards uncompromising independence and alternative production mirror some of the

chief concerns of contemporary avant-garde artists in China from the 1980s onwards: the search for authenticity, for presenting work that is personal and sincere, and that is without compromise. The lines between art and design practice are more or less blurred in China, remaining one of the very few sites where an avant-garde spirit can dwell in an increasingly commoditized Chinese society. This dualist culture, nourished by an informal creative economy, has resulted in some of the most imaginative and captivating design work, informing a rapidly growing and dynamic design culture.

Designing 'New New China'

There is no doubt that China is in the midst of one of history's most dramatic modernizations. The question is how to identify the driving forces behind this. Since 1978, 450 million farmers have migrated into China's cities and towns.[19] In 1982 one-fifth of China's population lived in its cities; by 2000 more than one-third were urban dwellers, and by 2020 it is estimated that approximately 60 per cent of the population will be city residents.[20] Britain has five urban centres of more than one million people; China has 90. In Beijing alone, more than 2,000 new high-rise buildings are either on the drawing board or on site. In Shanghai 4,000 new tall buildings have risen since 1990.[21]

China's new megacities are where speedy economic development is creating new typologies and new urban features day by day. Their rapid birth is a signal of a new economic order – a shifting of economic power away from a primarily Eurocentric world towards Asia, driving an increasingly urban society, in step with the flow of people away from the land into China's service and manufacturing industries.

The emptying of the countryside and the ambitious growth of China's cities are based precisely on the desire for social mobility that the city offers. China's urban societies are changing so fast that few people – even those within China – can keep pace with it. There are now around 200 million middle-class consumers, mostly in the coastal cities, and they are young (more than 40 per cent are between the ages of 16 and

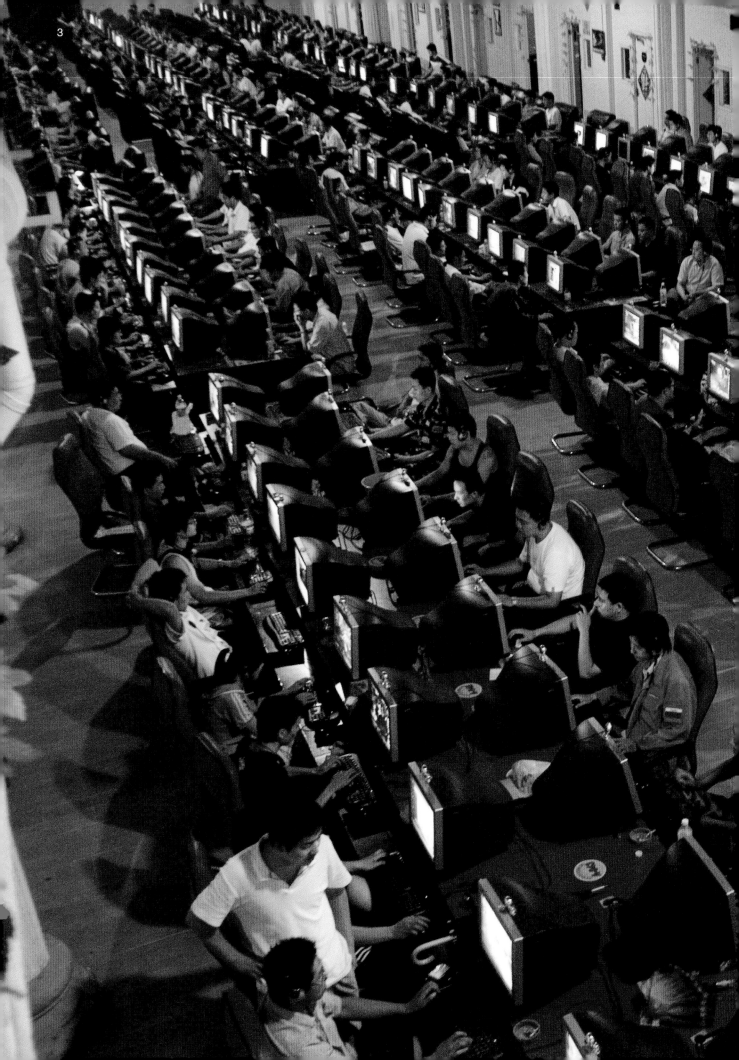

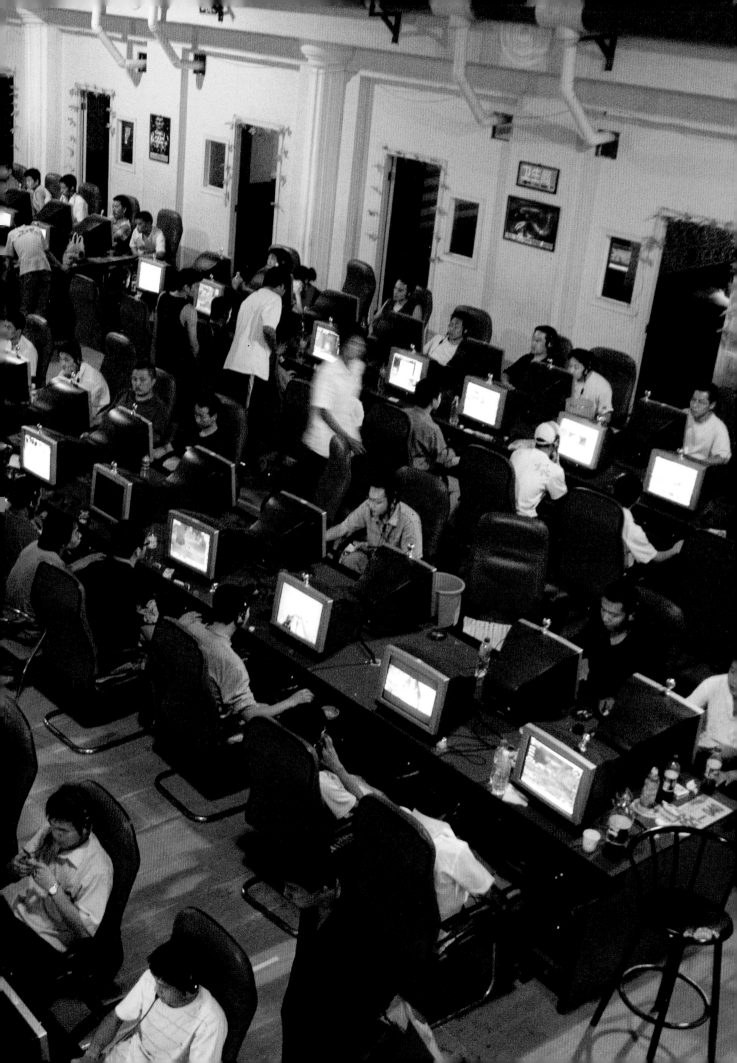

35), the first generations of lone children produced by China's 'One Child family' reproductive policy. They all share an enthusiastic adoption of the perceived benefits of private housing and car ownership – shorthand symbols of success in today's China. In 2004 there were more than two million cars on the road in Beijing, three times more than ten years previously, and by 2020 there will be seven times more cars again.[22]

Meanwhile China has rediscovered retail therapy, with a reinvigoration of a love for consumer goods that has always existed, as demonstrated by national shopping sprees for the 'Four Great Things' (*si da jian*): objects of consumer desire for each generation, from the bicycle, watch, sewing machine and radio in the 1960s and '70s, through the refrigerator, television, tape-recorder and electric fan in the 1980s, to the car, mobile phone, laptop and apartment at the start of the twenty-first century.[23] A new global generation of design consumers has emerged. Lifestyle commodities are sold as symbols of a successful modern life by 'style bibles' such as *Elle China* and *Vogue China*.

These are just one part of a media and communications explosion. China has become the world's largest print-news market and the fifth-largest magazine market, with close to 10,000 magazine titles and 36.8 billion newspapers being sold every day. More than 700 million Chinese listen to 1,000 radio stations and watch 2,000 television stations broadcasting almost 3,000 channels.[24] At the end of 2006 the number of fixed-line and mobile-phone subscribers had reached 830 million.[25] By the end of 2007 China was projected to overtake the United States as the biggest online population on the planet.[26] China's youth has embraced the opportunities that being online can offer – blogging, message boards, peer-to-peer networks and online chat rooms are incredibly popular, enabling direct communication between Web users across China, while online gaming is thriving, with more than 30 million regular online gamers as of 2006.[27]

China's modernization is taking place at speed. Whereas it took Britain 58 years during the Industrial Revolution to double its per capita output, and America 47 years, it has taken China only a decade.[28] Strong centralized decision-making, the prevalence of top-down urban planning, and a reliance on increasing economic progress as a means of ensuring political stability have created a unique set of responses focused on production-oriented modernization, as well as a scale of urbanization unlike anything seen before.

The modernization of China's cities through major architectural projects is part of this state agenda. Every major Chinese city has a vast urban-planning exhibition hall at its centre, displaying super-sized urban-planning models. Visitors are presented with the image of a polished, flawless virtual city. To turn these utopian visions into reality, strict systems of planning and administration are developed; often very different from the everyday experiences of China's urban citizens. As a result, China's cities are being filled with replica public spaces: enormous squares, symmetrical high-rises and vast lawns. From the China Central Television headquarters designed by the Office for Metropolitan Architecture (OMA) in the heart of Beijing's Central Business District to the heavyweight architectural projects associated with the Beijing Olympics, these grand visions are architecture as icon, a visual shorthand marking Beijing and Shanghai as globalized 'world cities'. Being part of the international community matters to China. Chinese leaders have called the next 20 years a period of 'great strategic importance'. The 2008 Beijing Olympics and the 2010 World Expo in Shanghai mark China's emergence onto the world stage – a coming-out party of great symbolic importance.

For Arif Dirlik and Zhang Xudong, two America-based academics investigating contemporary China in a global context of modernity, this state-driven modernization began as early as the second half of the nineteenth century, as a response to a modern world order set out by the leading industrialized nations of the time. Chinese modernization went through various phases in the search for a modernized industry, military and constitution, from the Qing dynasty's Self-Strengthening Movement in the 1870s and the Hundred Days' Reform in 1898 to the 1911 Republican Revolution and the May Fourth

INTRODUCTION

Movement in 1919. The apogee of this radical process was the rise of so-called 'New China' (*xin zhongguo*) and the eventual dominance of a modernist vision based on a Soviet-style total rationalization of Chinese society – state centralization and planning – for three decades between 1949 and 1976.[29]

The death of Chairman Mao and consequently the end of the Cultural Revolution in 1976 marked the end of the New China period, while the launch of Deng Xiaoping's 'Reform and Opening Up' policies in 1978 and the transition to a free market-oriented economy from 1992 marked the beginning of a Chinese post-socialist 'new period' (*xin shiqi*) and the rise of a New New China (*xin xin zhongguo*), a term created by the Beijing-based literary critic Zhang Yiwu. For him, this New New China is born out of the marketization (in the broad sense of the word) through which Chinese citizens are finally able to bid farewell to the field of ideological warfare against material consumption and individual needs and desires, while returning to embrace the pleasures of everyday life.[30] Within a globalized post-modern context, China's process of modernization – the overlapping of state and market, the co-existence of both formal and informal economies – has, however, broken free from classic paradigms of modernity, either capitalist or communist.

China Design Now: the book

This narrative of China's unique and dynamic design culture is set in its urban environment. Chaotic, unstable and in constant flux, Chinese cities are crucibles for creativity, attracting an abundance of creative talent seeking educational, artistic and commercial opportunities. Within this city context, our stories take their shape from the idea of a journey – from the southern regions of China to the north along the east coast, through Shenzhen to Shanghai to Beijing. Each city is a starting point for the exploration of different design fields: graphic design and visual culture in Shenzhen, fashion and lifestyle in Shanghai, and architecture and the city in Beijing and beyond. The breadth of work covers the early 1990s to the present day, before looking further ahead to future projects.

Within this framework of three cities – Shenzhen, 'Frontier City', Shanghai, 'Dream City', and Beijing, 'Future City' – 12 commentators, journalists, academics and practitioners have contributed their thoughts and experiences to a broad range of topics, including graphic design, branding, new medias such as advertising, television and blogs, the family and the home, fashion, youth cultures, luxury goods and everyday objects, architecture and urban planning, vehicle design and transportation, and designing for sustainability.

Shenzhen: Frontier City

Contemporary Chinese design was born in the mid-1980s, when graphic design was introduced into China's Special Economic Zones. In Shenzhen, the largest manufacturing centre in the world, the first generation of Chinese graphic designers 'jumped into the commercial ocean' and established independent design practices for the first time. Alongside commercial projects for local enterprises, these pioneers embarked on a series of self-initiated projects that developed channels of communication with the international design community and established unique graphic forms that departed from both the propaganda posters of the Cultural Revolution period and the commercial advertising seen on the streets of China's post-reform cities. In their essays, Stefan Landsberger and Huang Zhicheng explore this rapidly changing environment, describing the government's move to embrace commercial strategies for propaganda – from television 'partymercials' to celebrity endorsements – and the emergence of a pioneering graphic-design industry that attempted to define both what graphic design in a Chinese context could mean and to balance commercial and creative impulses.

By the late 1990s the creation of graphic design had begun to spread to other coastal cities, becoming more diverse in outlook and approach, as designers experimented with new technologies and absorbed global design trends. In the hands of a younger generation of designers, graphic design rapidly became an integral part of a fast-growing urban youth culture, which also found expression in music, art and through the Internet. These young designers identified themselves not

only as an alternative to China's cultural mainstream, but also as part of an influential global creative force. For Ye Ying, journalist and cultural commentator, 2005's *Get It Louder* exhibition proved a critical moment for the development of these new independent creative forces – embedding design in the heart of China's contemporary culture, crossing boundaries between different art forms and media, and establishing connections between a new generation of dynamic young Chinese creatives.

Shanghai: Dream City

As China's reforms developed during the 1990s, when the 'Reform and Opening Up' policies were implemented beyond China's Special Economic Zones, Shanghai became the centre of national attention. Society underwent fundamental changes, witnessing the growth of a new urban middle class, the associated rise of a consumer society, and the growing legitimacy of the pursuit of material dreams. A vital manifestation of these societal changes, Shanghai – the 'Paris of the Orient' in the 1920s and '30s – began to witness the revival of a lifestyle culture of fashion and glamour.

From the mid-1990s, a range of influential taste-makers – from Yue-sai Kan to Chen Yifei – launched successful cosmetic brands, luxury retail developments, fashion empires, and film and publishing companies, helping to establish a cult of romantic nostalgia about the Shanghai of the 1930s, and presenting an idealized aspirational lifestyle that was consumed by affluent members of Shanghai's urban society. Young fashion, furniture and interior designers began to create a hybrid style that became part of this 'dream-making', while others strove to find a successful balance between commercial pressures and their own creative vision. Bao Mingxin and Lu Lijun present an account of the first generations of Chinese fashion designers trying to find their own way in the fashion market, both nationally and internationally. For Shanghai's urban middle class, material consumption and personal achievement were important symbols of a newly acquired social status. The status symbols ranged from the modern Chinese concept of the 'Four Great Things' (represented in

contemporary society by the house, car, computer and mobile phone) to success in education, at work, in marriage and in health. *Trends Home* magazine editor Yin Zhixian traces the development of this new Chinese middle class – their influences, aspirations, values and tastes – through their relationship with their home, while Li Wen, editor of *City Pictorial*, charts the changing nature of China's youth cultures – from television phenomenon *Supergirl* to the rise of the Internet.

Beijing: Future City

China's accession to the World Trade Organization in late 2001 marked the beginning of a new phase in China's reform process that had begun two decades before, signalling the country's arrival on the contemporary global stage. If there is a tangible symbol of this critical moment, it is the transformation of Beijing's architecture and urban spaces in the process of preparation for the 2008 Olympic Games – a city re-imagined for international consumption through a series of extraordinary infrastructure projects – from the extension of Beijing's Capital Airport by Foster + Partners to Herzog & de Meuron's National Stadium and the China Central Television headquarters, designed by OMA. China's grand ambitions are reflected in the rise of Beijing's new megastructures, and behind these projects lies the pivotal role of the state. At the same time, with a growing commitment to finding a more balanced approach to progress and sustainability, the city is privileging its ancient axis, the palaces, the urban fabric, the horizontality of the cityscape in the city centre and the Great Wall further outside, through its urban planning policies.

For writers Jianfei Zhu and Shi Jian, Beijing as a 'form' has crucial implications for China's future – revealing the interconnections between the state, the market and society, and highlighting the tensions at work in China's cities: between continued economic growth and quality of life, and between the role of the state in guiding these changes and greater room for participation and expression for all. Helen Evenden's essay explores China's global ambitions in car design and manufacturing, while highlighting the future

challenges and potential solutions to China's transportation questions.

China's reforms have led to genuine benefits for millions. However, they have also brought problems in their wake. On a society-wide level, these include rising pollution, social instability, instances of corruption, mistrust of the government and rising levels of unemployment, alongside a dissolving system of social guarantees and a rapid restructuring of relations between Chinese social classes. On a personal level, all but the youngest Chinese citizens find themselves coping with major changes in their lives. Opinion polls have shown a deep vein of optimism in Chinese society, but also persistent worries. China's president, Hu Jintao, is aware of the need to bring together an increasingly divided nation, and to counter the stresses and anxieties facing China's citizens while retaining the integrity of the nation state. China's leaders are beginning to promote the benefits of a 'harmonious society' focused on 'improving people's livelihoods, narrowing the gap between rich and poor, and encouraging innovation from the people. This ... harmonious society should be built by the people and for the people.'[31]

Finding solutions to China's future needs (ranging from an ageing population to environmental concerns) will require not only technological innovations, but also social innovations. Designers, as imaginative, interested people, can be innovators – innovators of the relationship between producers and consumers, facing what Ezio Manzini describes as 'the present-day challenges, and intervening on the strategies that determine the social and environmental quality of the changing world of today'.[32] Dealing with these challenges requires designers to become strategists, innovators and managers, as much as form-givers.

In the final essay Ezio Manzini and Benny Ding Leong suggest that design can be a positive agent in reorienting China's energies in the direction of sustainability – a development that would value social harmony and protect the environment. There is still some way to go. Free communication, basic legal and intellectual property protections, an open media, accessible capital and strong civic organizations are all key to providing the right background conditions for cultural innovation. Nevertheless for China this is a challenge worth facing. From eco-cities to community projects and sustainable public transportation, these emerging design cultures are a vital part of China's extraordinary future.

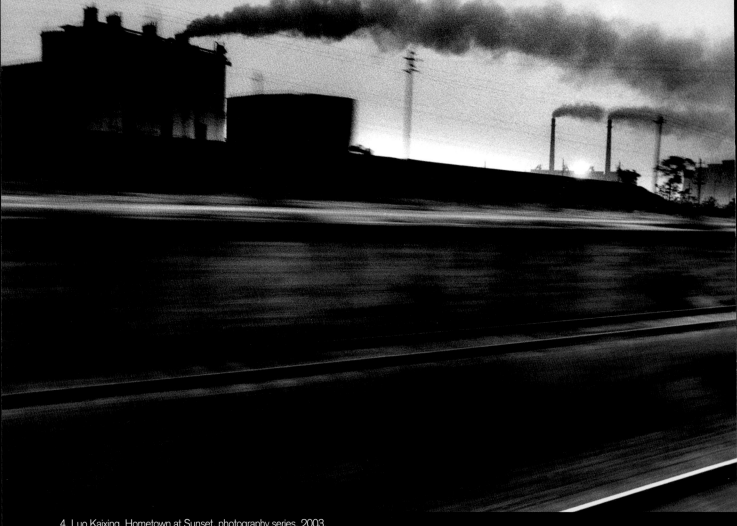

4. Luo Kaixing, Hometown at Sunset, photography series, 2003.

SHENZHEN:
FRONTIER
CITY

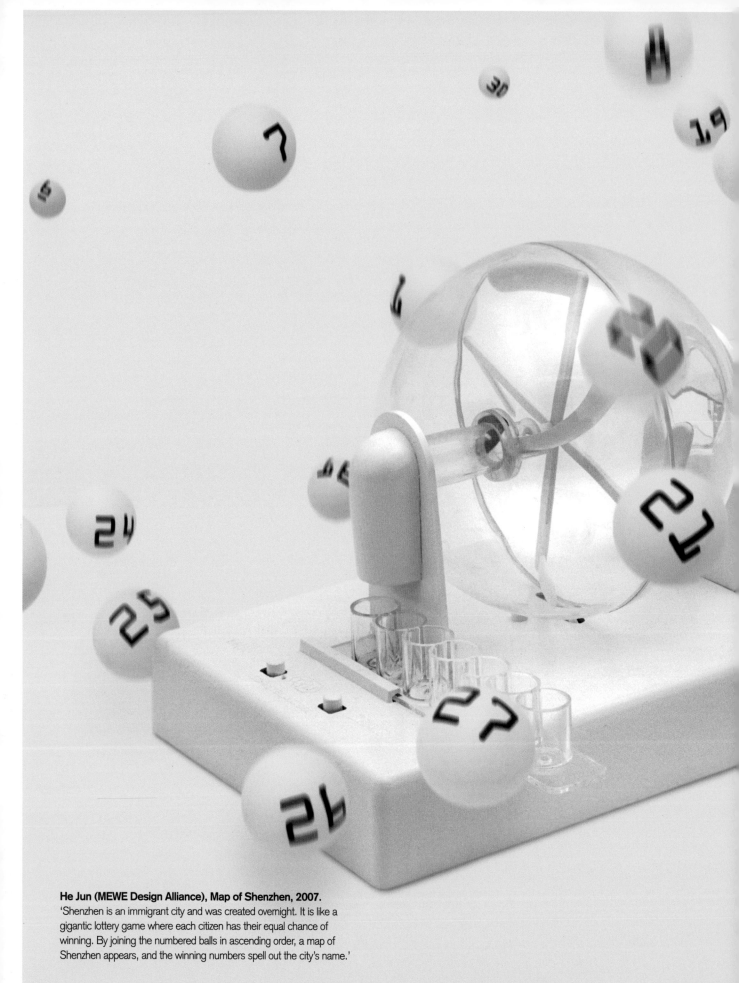

He Jun (MEWE Design Alliance), Map of Shenzhen, 2007.
'Shenzhen is an immigrant city and was created overnight. It is like a
gigantic lottery game where each citizen has their equal chance of
winning. By joining the numbered balls in ascending order, a map of
Shenzhen appears, and the winning numbers spell out the city's name.'

5

6

7 8 9

5. Freeman Lau, *15 Hong Kong Graphic Designers* exhibition in Guangzhou and Beijing, poster, 1994.

6. Taddy Ho, Communication Requires Patience, poster series for *Taiwan Image* exhibition, 1997.

7, 8, 9. Kan Tai-keung, China, Taiwan, Hong Kong and Macau, poster series for *Communication* exhibition, 1996.

10,11. Wang Xu, Chinese Characters – Fork of Tree and Bird's Foot, poster series for *Taiwan Image* exhibition, 1995.

12. Alan Chan, Design and Lifestyle, poster for a lecture by Alan Chan at Shenzhen University, 1998.

13. Kan Tai-keung, Eastern Philosophical Thinking & Design, poster for Kan Tai-keung's lecture in *Graphic Design in China* exhibition, 1992.

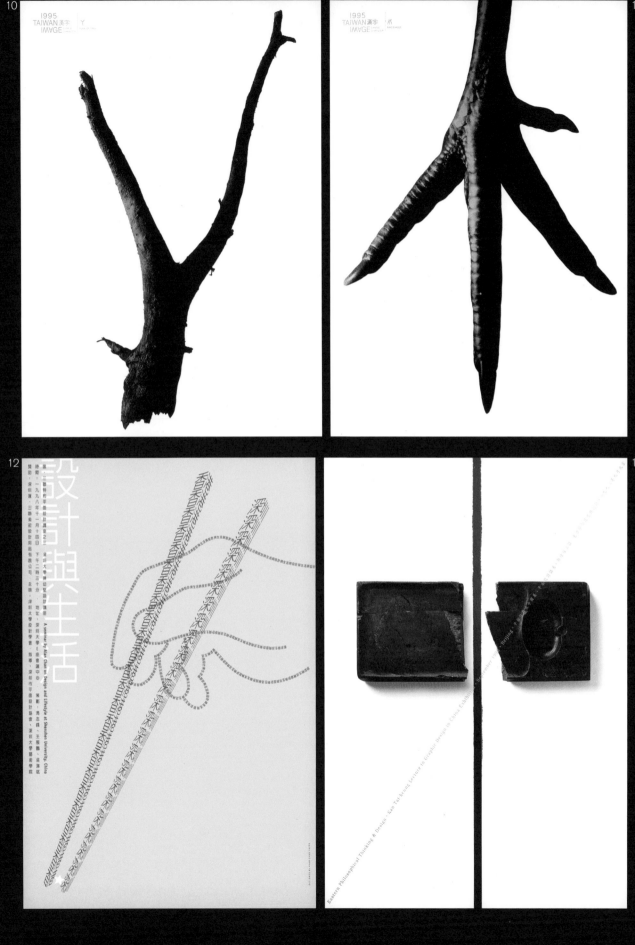

4. Wang Xu, Artistic Conception Writing, book design, 2000.
5. He Jianping, China Image, poster, 2005 (ceramic characters by Sonny Kim).
6. Han Zhanning, Bamboo, poster series for *Traditional Imagery* exhibition, 2004.

17. Wang Yuefei, An Inspiration from Tibet, book design, 2003.
18. Han Jiaying, Beauty, poster series for *Frontier* magazine, 1997.
19. Han Jiaying, Mouth, poster series for *Frontier* magazine, 1999.
20. Han Jiaying, Fusion, poster series, 2001.
21. Guang Yu (MEWE Design Alliance), Youth and Beauty, poster series, 2004.

5

16

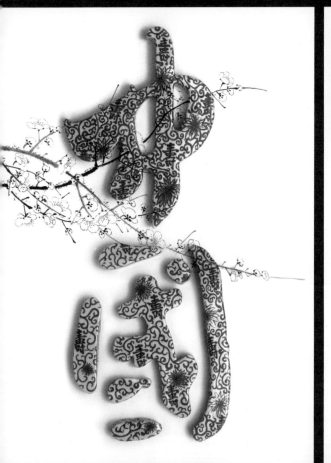

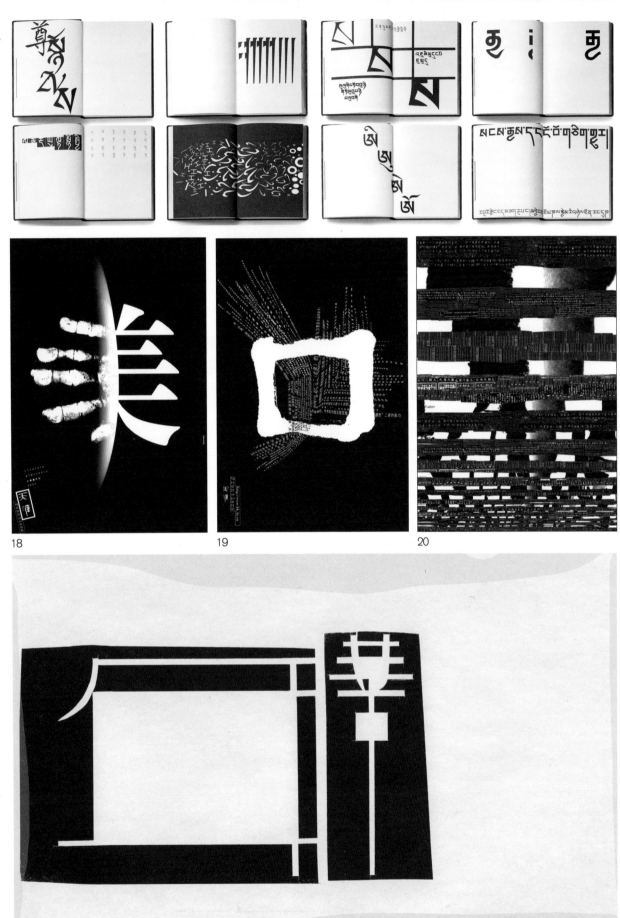

17

18

19

20

21

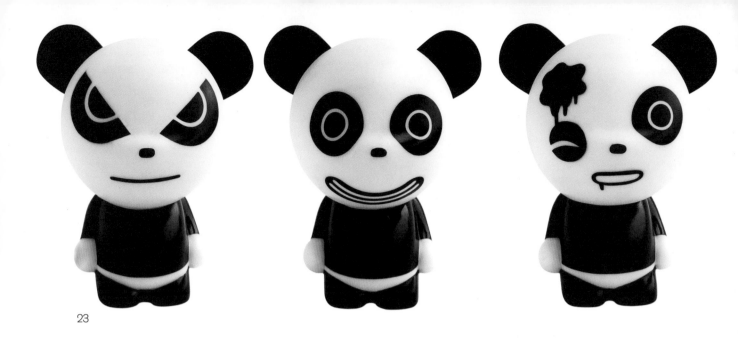

23

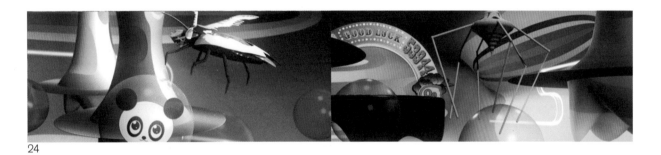

24

22. Guan Xiaojia, The Chinese Worldview, poster, 2005.
23. Ji Ji, Hi Panda, toy figure, 2006.
24. Qian Qian, *Air Riders − Nike Born From Obsession: Qian Qian x Air Max 360 Running*, animation, 2006.
25. Fang Er and Meng Jin, *The Hidden Depth*, animation, 2005.

25

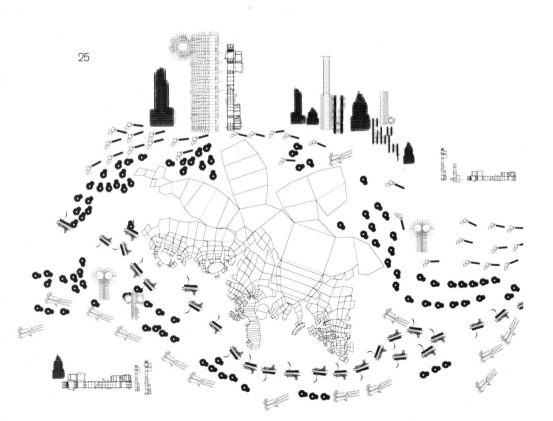

SHENZHEN: FRONTIER CITY
ZHANG HONGXING

A cultural desert?

We go across the border
Eager to buy cheap fabric
To make low-priced *cheung-sam* in a craze
Try hot herbal wrap and weight-reducing machines
Foot massage
Acupoint massage
Bring back a roast duck at bargain price
On the other side we do
All the absurd things we won't normally do
Shenzhen is the excuse
Shenzhen is the spare part
Shenzhen is the loose screw.[1]
Leung Ping Kwan

In the late 1990s a Hong Kong writer, Leung Ping Kwan, thus sketched Shenzhen in his poem, describing the ambiguous activities of tourists from Hong Kong in this mainland city on its northern border. As a Hong Kongese, he would have known well that 20 years previously Shenzhen was only an insignificant town in Baoan county, with slightly more than 20,000 people, located along the railway between Hong Kong and the provincial capital Guangzhou. Yet in 1979 Deng Xiaoping, the paramount leader of post-Mao China, singled Shenzhen out to be the first of the Special Economic Zones (SEZs) in China, a decision that changed the future of this small frontier town in a single stroke.

The adoption of the SEZ policy resulted from the Chinese government's realization in the late 1970s that, in order to modernize, the nation had to follow the example of other East and South-East Asian countries and expand its international exports. Yet China had just emerged from the catastrophic Cultural Revolution (1966–76) and had been isolated from global advanced technology for so long that its industry had little chance to catch up without an injection of foreign capital and industrial expertise. Meanwhile, without trade barriers China's domestic market would be dominated by foreign goods and its infant industries would not have time to develop. Setting up the SEZs – where cheap land, cheap labour and low taxes would attract foreign companies to bring in supplies and produce goods for export – was a logical answer to China's situation. Shenzhen was chosen as an SEZ due to its proximity to Hong Kong, a global economic player. In the early 1980s, when it was given the status of provincial-level city,[2] it was decided that the entire Shenzhen SEZ would incorporate the old town of Shenzhen, another smaller town and 15 former communes,[3] covering a strip of land measuring 49 kilometres from east to west and an average of seven kilometres from north to south.[4] In the south the Shenzhen River formed a natural frontier with Hong Kong, while the northern boundary was marked by mountainous terrain. The boundaries of the zone were drawn to ensure easy border control and its future development into a linear city, which would in turn make the city efficient for the flow of export goods. The concept proved a great success. In the ensuing couple of decades Shenzhen developed into one of the economic powerhouses of China as well as the largest manufacturing base in the world.

Shenzhen is not easily loved by outsiders. As Leung Ping Kwan's poem suggests, tourists from Hong Kong view Shenzhen as the place for cheap and ambiguous goods and services. For business people from the West or from Hong Kong, Shenzhen is part of Hong Kong's industrial hinterland, and they much prefer Hong Kong with its greater sophistication and variety; while within China, many people living in cities such as Beijing, Shanghai or Xi'an think Shenzhen has a reputation for being materialistic, decadent, corrupt and, above all, the greatest manifestation of the notion of a 'cultural desert'. Is this fair? Some western observers have noticed that the city is much more than simply a factory site and shopping paradise. In 1989 Ezra F. Vogel produced his seminal study on economic reform in Guangdong province, in which he argued that, compared to export-processing zones elsewhere in Asia, Shenzhen SEZ played a larger role with broader functions, for the zone was established at the time when China as a whole was at the beginning of a process of profound change: political, cultural, educational and technological as well as economic. The central government looked to Shenzhen SEZ as a test-site for bold experiments in system reform, with the expectation that successful practices could then rapidly be diffused throughout the rest of the country. One example of this experimentation in Shenzhen, Vogel pointed out, was in the realms of city planning and architecture.[5] Several years later, Vogel's observation was reconfirmed by architect Rem Koolhaas and his postgraduate students from the Harvard Design School, who carried out a series of case studies on the urban conditions in the Pearl River delta, the low-lying areas along the Pearl River estuary in Guangdong province, of which Shenzhen is a part. Their research shows that Shenzhen's experimentation in city planning and architecture resulted in the rise of a new urban model for post-reform China – what Shenzhen people have created is not a traditional Chinese city with characteristics of balance, harmony and homogeneity, but a city based on a perpetual competition between its different parts, a 'city of exacerbated difference'.[6]

Throughout the 1980s and '90s, with such bold urban experiments running alongside the steady growth of foreign investment, Shenzhen SEZ continuously attracted many talented young people from across the country. Young and adventurous Chinese from the inland provinces moved there because of its higher salaries, free employment market and atmosphere of experimentation. In Shenzhen they no longer felt constrained by the bureaucratic hierarchies that existed in their home cities. For the first time in their lives they could make their own decisions. To them, the city was porous, full of mobility and flexibility. Here they could find a new way of being – open, vivid, spontaneous and in opposition to everything they had experienced in the sober and melancholy

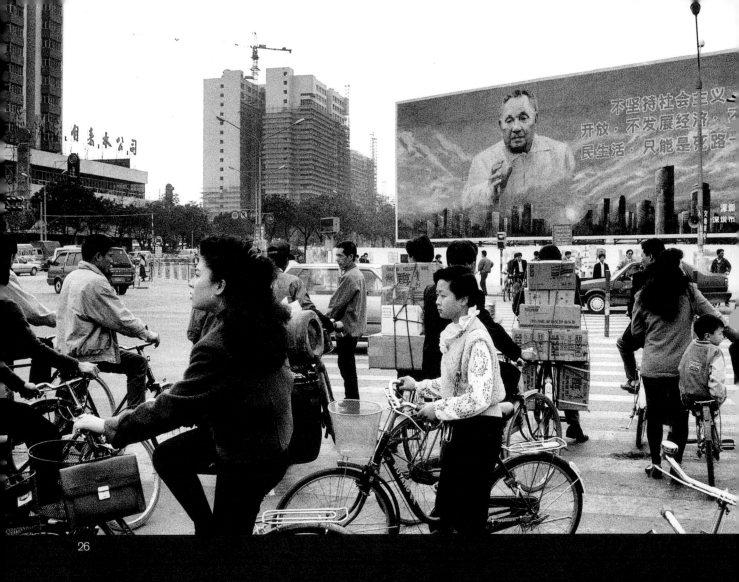

26

26. An Ge, Portrait of Deng Xiaoping on Shennan Zhong Road, Shenzhen, 1992.
27. He Huangyou, Sino-British Street on the border of Hong Kong and Shenzhen, 1981.
28. He Huangyou, Wenjindu, the bridge linking the borders of Shenzhen and Hong Kong, 1972.

27

28

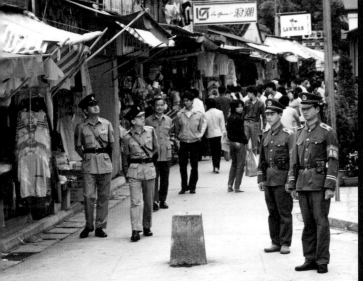

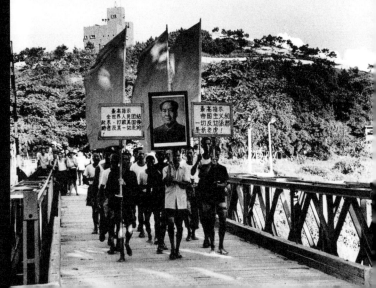

29

30

31

29. Guangdong White Horse Advertising Company Ltd, Nanfang black sesame paste, TV advertisement, 1991.
30. Toothpaste advertisements, *Tianjin Daily*, 4 January 1979.
31. Xinjinjie Design Group, Guangdong Apollo Group, logo, 1988.

socialist cities. Here they could finally leave behind the shadow of the Cultural Revolution and its accompanying socialist mentality and search for their own dreams.

Designers before the period of design

Graphic design as we understand it today is a very recent concept in China. Throughout the austere period from the 1950s until the mid-1990s, the word *zhuanghuang*, meaning 'decoration', was widely used to refer to graphic designers' activities. Between the 1950s and much of the '70s the term referred to two major types of activities: *shuji zhuanghuang*, or publication design, and *guanggao zhuanghuang*, or advertising. In book and magazine design, designers tended to create the covers, while printers were asked to handle the basic typographical requirements. Advertising agencies did not produce commercial advertising messages because goods were not treated as commodities for exchange in the market place. The advertising agencies' job was to reproduce government-funded public billboards, featuring portraits of Mao and other leaders or political slogans. And while there was limited work for logo design, packaging design was virtually non-existent. The Chinese word for packaging is *baozhuang*, or 'wrap and pack', meaning that products such as ceramics or tea were wrapped in paper and straw and then placed in large wooden chests to be transported to the shops. Buyers were then normally expected to provide their own containers, bags or bottles in order to take items home.[7] Designers who worked on book design, advertising and logos were not called *shejishi*, or 'designer', as they would be today, but *meigong* (shorthand for *meishu gongzuo zhe*), or 'artist-worker' – an ideologically charged umbrella term that referred to anyone working on art and design-related jobs, usually for a state-owned enterprise. It was not until a substantial number of designers were free to leave the state system and set up their own design practices in the early 1990s that this socialist job title was dropped.[8]

By the mid-1980s several changes were under way in both society and design. Packaging design was the first area to take off. In the late 1970s and early 1980s the government, eager to export products to international markets, realized that it was impossible to achieve this without changing the traditional 'wrap and pack' notion of packaging to adapt to foreign packaging standards, and it urged its state-owned trading companies to acquire up-to-date information about packaging technology and design from the developed world. A national collection of packaging samples from industrialized or newly industrialized countries was soon built up in Guangzhou, thanks to the city's long-time experience of running the Canton Fair, the largest international trade fair in mainland China. In 1982 the newly established National Committee for Packaging Technology even organized a touring exhibition across China to display more than 3,000 of these packaging samples. At the same time, some young people were selected to be trained in design in the newly reopened universities and art and design schools, and were assigned to work in national or provincial packaging companies.[9]

During this period another, and more dramatic, change was taking place in advertising. Commercial advertising, which had disappeared completely during the 10 years of the Cultural Revolution, reappeared after 1979, with Deng Xiaoping's 'Reform and Opening Up' policy bringing back notions of commodity, client, consumer and market competition. Revolutionary slogans and images soon disappeared from the pages of national and local government newspapers and from the billboards in city streets. In their place (and later presented on television) were images and words about machines, medicines, consumer goods or aspirational western items, such as Lantian toothpaste, Xinren cough syrup, the Dongfeng diesel motor and the Rado watch.[10]

In the 1980s these changes in advertising were centred on major cities such as Beijing, Shanghai and particularly Guangzhou. Beijing was (and still is) the country's political centre and historically its cultural centre, while Shanghai – as China's old capital of commerce – had a strong advertising history, but both cities were still very much tied to the practices of the old planned-economy system; in this context the growth of commercial advertising was slow and difficult. By contrast, Guangzhou's advertising industry was emerging quickly, thanks in part to the city's 'one step ahead' status, conferred by the economic reform programme, and in part to the traditional Cantonese entrepreneurial culture. This meant that Guangzhou advertising agencies could be more innovative, despite still being state-owned entities. More critically, the manufacturer boom in the Pearl River delta region, as a result of the combination of a privileged economic status and a risk-taking spirit, provided a broad client base for Guangzhou's advertising industry and helped it to thrive. During the 1980s most of the active manufacturers in the region were new and small-sized township and village enterprises specializing in producing domestic consumer goods.[11] Eager to enter the new consumer market then being monopolized by state-owned companies, these small enterprises turned to advertising.

The Guangzhou Academy of Fine Arts quickly responded to this surge of market demand, incorporating the teaching of advertising and corporate identity design into its graphic-design curriculum.[12] Since the late 1970s the Academy had been known nationally for advocating the introduction of Western Bauhaus design principles to replace traditional art- and craft-based teaching, during debates with its counterparts in the north, such as the Nanjing Art Institute and the Tsinghua Academy of Fine Art (formerly the Central Academy of Arts and Crafts).[13] In the mid-1980s young graduates in Guangzhou banded together to open semi-independent advertising agencies; these included the Heima Advertising Company (1985), Baima Advertising Company (1986) and Xinjinjie Design Group (1986).[14] By the early 1990s these young advertising agencies had helped local manufacturers to establish numerous national household brands, such as 999 medicine, Jianlibao drink, Taiyangshen (Apollo) drink, the Rongsheng refrigerator, the Meidi electric fan, the Weili washing machine and the Nanfang sesame pastry.[15] In many art and design students' eyes, these young advertising agencies

revolutionized the notion of Chinese advertising by applying the approaches and techniques – then so fresh and new in mainland China – learned from commercial advertisements on Hong Kong televisions or from Japanese publications on corporate identity.[16] Advertising was the hottest career choice for young designers and students alike in Guangzhou.

It is understandable that advertising attracted many talented young designers at a time when society had just started to accept the notion that advertising could be other than political propaganda, and when conservative academics were still questioning whether design for business could be a legitimate discipline taught in universities. But the advertising vogue served to mask the fact that the development of graphic design in the mid-1980s and early '90s was at an initial stage, where some crucial differences between design and advertising went unrecognized. It is remarkable, however, that in the midst of this, a few young graphic designers did not flow with the tide, but pursued something that later proved to be an influential model for defining graphic design as a discipline in China.

The Shenzhen paradigm

Wang Xu and Wang Yuefei, fellow packaging designers working in the state-owned Guangdong Provincial Packaging Company from 1980, were two pioneers in this search for graphic design's disciplinary identity. 'At that time information from the outside was very limited,' Wang Xu recalled in a recent interview with a design colleague. 'Also there was a big divide between the northern and the southern academic worlds in China with regard to the concept of design, and no genuine dialogue existed between them.'[17] For Wang Xu and Wang Yuefei there was no question that Chinese graphic design lagged behind that of many other countries, and their first task was basic: namely to find out how their fellow designers practised in those countries and what they had achieved. For several years their research consisted of spending hours and hours in their company's collection of packaging samples of foreign goods, and reading subscriptions to foreign publications such as *Graphis* and *Idea* magazines and the Art Directors' Club annual report in their company's library. Occasionally they had professional visitors from a foreign country, in which case they would grab every opportunity to obtain as much information as they could. On one occasion they were so eager to obtain a copy of the slides that an American ad-agency head brought with him for his lecture, while realizing that they would not be allowed to make the request officially, that they sneaked into the hotel where their guest stayed, taking out the slides and having them duplicated overnight.[18]

In 1986 both Wang Xu and Wang Yuefei left Guangzhou as part of their company's reform programme, which aimed to be more market-oriented. As part of this programme, Wang Yuefei moved to Shenzhen to open Jiamei Design Ltd, the first graphic-design consultancy on the mainland, serving as its director. The consultancy was jointly owned with Ken Seng Trading & Co. Ltd from Hong Kong, a company specializing in distributing graphic-art books and stationery.[19] For the Guangdong Packaging Company to choose Shenzhen as the location for this joint-venture was a careful decision; it was not just that a business of this nature was only allowed to exist in an SEZ at that time, but also that many printing factories with the state-of-the-art technology so important for the graphic-design business had by then been founded in Shenzhen. Besides, Shenzhen's proximity to Hong Kong would give the company fast access to industry information from the outside world. And it was mainly for this reason that Wang Xu was entrusted to work in Hong Kong under the Yuehai Group, then the largest so-called 'window company' in Hong Kong, owned by the Guangdong provincial government.[20] A 'window company' was a mainland city or province's trading company; it also functioned as an information centre to gather data on industries, technology and capital from overseas and distribute it within Guangdong, and vice versa. Over the succeeding eight years Wang Xu was responsible within the company for passing information on the design business back and forth.

In Shenzhen, after he had settled in, Wang Yuefei was soon joined by several designers from various places across the country, who would later become key players in the design scene in China. In 1988 Chen Shaohua quit his teaching position at Xi'an Academy of Fine Arts and joined as art director of the new Shenzhen International Service Management Co. Ltd, a design and advertising company jointly invested in by a Shenzhen property company, Vanke Co. Ltd, and international advertising agency JWT. Before he came to Shenzhen, Chen was already an established poster artist and had made his name for his work on projects such as the film *Red Sorghum* by director Zhang Yimou. In the same year Zhang Dali arrived in Shenzhen, also from Xi'an. In 1989 Bi Xuefeng graduated from the China Academy of Fine Arts (then Zhejiang Academy of Fine Arts) in Hangzhou and came to join Wang Yuefei's firm. Finally, in 1990, Han Jiaying, again from Xi'an Academy of Fine Art, joined Chen Shaohua in his company.[21]

Wang Xu often travelled to Shenzhen during his Hong Kong years. While in Hong Kong, he visited the studios of many designers such as Kan Tai-keung and Alan Chan, attended lectures by Japanese designers such as Sugiura Kohei and Takenobu Igarashi, and participated in design competitions.[22] He was particularly interested in Henry Steiner, an American designer who had been working in Hong Kong since the early 1960s. Steiner was a student of Paul Rand at Yale and had introduced to Hong Kong his theory of cross-cultural design.[23] Wang Xu's close contact with Steiner had a decisive influence on his own work. Eager to share his experiences in Hong Kong and his newly acquired knowledge about graphic design with his fellow designers in mainland China, Wang Xu persuaded the company to support his idea of publishing a magazine devoted to introducing established international designers, national trends and design news to China. The outcome was *Design Exchange*, which he edited and designed single-handedly from the first

32

33

34

35

36

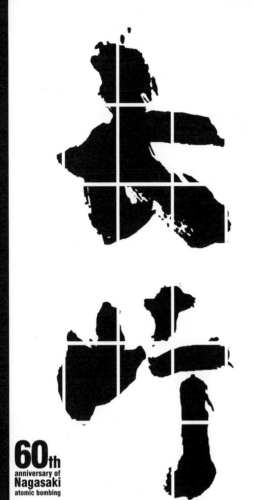

37. Wang Xu, Nagasaki, poster series for *60th Anniversary of Bombing* poster invitation exhibition, 2005.
38. He Jianping, Art, poster series for 75th anniversary of Chin Academy of Art, 2003.
39. Bi Xuefeng, *Typography*, film, 2004.
40. Chen Feibo, Four, poster, 2005.

issue in 1987 to the last one in 2000. Revisited today, the design and content of this magazine, which emphasized a classic style of graphic design, contain little that might appeal to a contemporary Chinese practitioner, but at a time when graphic design had yet to gain status as a distinctive discipline in visual communication, this magazine gave those who had recently chosen graphic design as their career a sense of professionalism and purpose.

At the beginning of the 1990s a central concern for these young graphic designers in and around Shenzhen was the question of how their work would be assessed against an international standard. At that time it was still almost inconceivable to communicate with design professionals from developed countries such as America, Britain, France or Japan, but thanks to personal connections and a finely tuned cultural understanding, it was possible to open a dialogue with other parts of the Greater China region such as Taiwan, which had been one step ahead of the mainland in developing a graphic-design community, and Hong Kong, which was considered to be the home of some of the most established designers in the region, despite difficult political relationships on an official level. As a result, in 1992 the Shenzhen designers formed a committee to plan a *Graphic Design in China* exhibition in Shenzhen, a design competition calling for entries from both the mainland and Taiwan. The idea was an immediate success. Within the three-month period of call for entries, an overwhelming 5,362 were received, including 1,600 entries from Taiwan, out of which the jury selected 174 entries for display and awarded six golds, 12 silvers and 10 bronzes. During the jury members' discussions, Kan Tai-keung expressed how rudimentary the mainland Chinese designers' understanding of design concepts had been 10 years before, compared to the Taiwanese, and how surprised he was that their works 'revealed substantial improvement' and 'were on a level with their international counterparts'.[24]

The *'92 Graphic Design in China* exhibition marked a major breakthrough for the newly emerging profession of graphic design in mainland China in many respects. Immediately after the show Han Jiaying set up his own design practice, and within the next five years other key members of the exhibition committee all formed their own design partnerships.[25] The rapid growth of their self-confidence and ambitions was also shown in the flurry of activities they either initiated or participated in. In August 1995 some of the members of the 1992 exhibition formed the Shenzhen Graphic Design Association (SGDA), the first non-official design association on the mainland. Through the SGDA they hoped to promote the notion of graphic design nationally, as well as further dialogues with the international design community through the Association's publications, exhibitions and other events. In September 1996 the SGDA organized the *'96 Graphic Design in China* competition. This time entries were called for not only from the mainland and Taiwan, but also from Hong Kong and Macau.[26] In conjunction with this competition there was an invitational poster exhibition on the theme of communication, the first thematic poster exhibition held on the mainland.[27]

Starting from the mid-1990s, SGDA members cast their eyes beyond the Greater China region and sought actively to participate in international competitions, such as the Poster Biennale in Warsaw, Poland, the Brno Biennale of Graphic Design in the Czech Republic, and the Lahti Poster Biennale in Finland, becoming regular award-winners at those competitions.

By the end of the 1990s it was evident that Shenzhen graphic designers' activities had begun to exert an influence on other cities, and came to represent a paradigm for graphic-design practice in post-reform China. Organizing exhibitions, setting up privately owned design partnerships and forming non-official graphic-design associations spread widely across China. On an operational level, the Shenzhen paradigm was composed of two coexisting but clearly separate activities. On the one hand, their commercial design proudly served clients – particularly clients from the manufacturing, property development and financial sectors, including well-known companies like Haier, TCL, Konka, Vanke and Shenzhen Development Bank, providing them with desirable product packaging and with corporate identities. On the other hand, they also self-initiated design projects. The design of personal or company portfolios, exhibition catalogues, the Association's magazines, name cards and calendars belonged primarily to this category of non-commercial work, but it was the design of posters that was most characteristic of Shenzhen designers' self-initiated projects and into which they poured most of their energy.

Looking at the posters that Shenzhen designers produced, from both historical and global perspectives, it is clear that they form a unique group. They not only departed from *xuanchuan hua*, or the propaganda posters commissioned by the state in the three decades after the founding of the People's Republic of China in 1949, but also had little in common with the first generation of Chinese posters that appeared in 1920s and '30s Shanghai and other colonial cities, advertising commercial or cultural messages, despite choosing to use the same word – *haibao* (literally, the announcement from overseas) – for this media. Comparing them globally, the Shenzhen posters were not created for streets or other public spaces, like their counterparts in Europe and North America. Nor had they much in common with the self-initiated works by contemporary Polish poster artists, who had been supported by a gallery system since the fall of communism in that country.[28] Typically the production of the Shenzhen posters was completely self-funded. The posters went out of the studio in a tiny print run to an exhibition, to be viewed mainly by judges and fellow designers, and then came back to the same studio and ended up in its archival drawers. However, the poster played a strategic role for Shenzhen designers, functioning as a vehicle through which they could build up communication with the outside world – the graphic-design communities in Taiwan, Hong Kong and beyond – in order to establish the standards and language of graphic design in China. The medium of the poster was effective because it is the *lingua franca* spoken by the international design community.

The passion for the poster soon spread across China and,

when it did, it turned into a national poster mania. In Shanghai the newly established Graphic Designers' Association organized the *Shanghai International Poster Invitational Exhibition* in 1999, and the theme for the invitees was 'Interaction'.[29] In Ningbo the *International Poster Biennale* was launched in 2001.[30] In Beijing the Central Academy of Fine Arts (CAFA) even mounted an exhibition entitled *Contemporary Chinese Avant-garde Artists' Posters* the same year, interestingly displaying works by artists rather than designers, such as Tan Ping, Zhao Bandi, Wang Guangyi, Fang Lijun, Liu Xiaodong and Zhan Wang.[31] In Shenzhen itself, *Graphic Design in China* has also become a biennale, the city's major cultural event from 2003, in which the poster has remained the most popular form.

Surveying the posters produced in China from the early 1990s to the present day suggests that, since the dialogue with the international design community began, apart from promoting professional standards, Chinese designers have also been concerned with developing a graphic language that can both maintain China's traditions and incorporate international influences, and this search for a distinct graphic language has been undertaken largely through typographic experiments, thanks to the distinctive qualities of Chinese type and their related cultural traditions. Unlike the letter type in western typography, Chinese type is a character that is either pictogram, ideogram or the combination of multiple parts. The way in which these parts are put together can involve piling, juxtaposing or containing different elements, depending on the individual character in question. A Chinese character is not only visually but also semantically richer. Many multipart Chinese characters have an element indicative of a general category of meaning. For instance, the element meaning 'water' appears in every character that has something to do with water, such as river, sea, juice, bath or ditch. For many Chinese designers, these unique qualities of the Chinese character, alongside the accompanying tradition of calligraphy as the highest form of fine art, offer resources to create something both Chinese and contemporary. In a poster by a designer such as the Berlin- and Shanghai-based He Jianping, the visual quality inherent in Chinese characters is often exploited by letting the word and the image run into each other, as we see in historical Chinese painting. For other individuals, such as Wang Xu, the link between script and calligraphy enables him to explore the expressive quality of graphics. Other designers, less interested in Chinese characters' rich culture, take the characters as alphabetical scripts, handling them in a way akin to western typographical approaches – testing out legibility and readability.

Beyond Shenzhen

As the new millennium arrived, Shenzhen continued to be a place of fine graphic design, but the city itself seemed to be losing its edge for which it had been famous. On 16 November 2002, a 28-year-old Shenzhen citizen, with the pen name Wo wei yi kuang (I'm Crazy About Her), sent a long and polemical article entitled 'Shenzhen, Who Abandoned You?' to the two Chinese official websites Xinhua Net and People's Net,

which became the most widely read Web article of the year, blaming local authorities for economic slow-down, thereby causing a great stir among Shenzhen's citizens and municipal government officials.[32] Shenzhen's perceived slowdown was largely due to the fact that, as reform deepened and spread across China from 1992, inland cities began to enjoy the same amount of policy support as Shenzhen SEZ. Those cities, with their richer social and cultural resources, were soon in a more advantageous position to develop fast in the new round of reform, particularly in areas such as media, publishing, art and culture. By the beginning of the twenty-first century, Guangzhou, Shanghai and Beijing had become the cities where market-oriented publishing and media industries (magazines in particular), the contemporary art market, urban middle-class lifestyles and above all urban youth culture had been growing rapidly, which in turn created conditions that enabled a new kind of design to emerge.

A single person's career may suffice to illustrate what graphic design means in this shifting cultural landscape. A native of Guangzhou, Ou Ning is not a designer by education. He began his career as a writer for an advertising company in Shenzhen, and came into contact with graphic design by working alongside Han Jiaying as the text editor of the SGDA membership magazine in 1996. In the first two issues that he edited he published his interviews with key SGDA members, as well as design work by leading international designers such as David Carson and Vaughan Oliver.[33] By this time Ou Ning had also been part of the urban youth-culture scene that was just emerging in Chinese cities. This led to the founding of the cultural agency Sonic China, through which he organized music performances and facilitated the publication of indie magazines and books on music, literature and film. His first graphic-design project was the self-initiated book *Beijing xinsheng* (*New Sound of Beijing*, 1999), for which he spent a summer in Beijing interviewing the capital's punk and rock artists. In the same year he also formed the video and film club Yuanying Hui (U-thèque), screening experimental works by emerging video and film artists in the Pearl River delta. Since 2003 he has been art director for the supplement of the popular Guangzhou-based lifestyle magazine *Zhoumo huabao* (*Modern Weekly*).[34]

For the standard-defining professionals in Shenzhen, the design of *New Sound of Beijing* could have been considered amateurish. Yet this judgement was made from outside a new cultural trend that began to emerge in urban China. On the title page of the book Ou Ning made it clear that the publication was 'dedicated to the *dakou* generation'.[35] In modern Chinese, *da* means 'strike' or 'attack', and *kou* means 'cut' or 'opening'; together *dakou* stands for 'cut CDs' – the CDs cut on the edge by North American record companies and shipped to China as industrial rubbish, but, since a CD player reads CDs from the centre to the edge, only the end of the music is lost; consequently they were illegally smuggled out of the rubbish-processing sites in south China and sold in cities to the urban youth who were hungry for western indie music.[36] Throughout most of the 1990s these cut CDs,

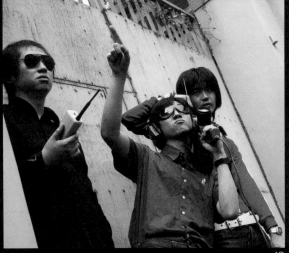

41

42

43

44

45

46

41. Feng Jiangzhou, Noise is Bad for Health, poster (detail), 2006.
42. Peng Lei and Pang Kuan, pop band New Pants, photograph, 2005.
43. Ou Ning, Media Monsters, *Modern Weekly Alternative Issue* 30, magazine design, 2004.

alongside other *dakou* products (including Ou Ning's *New Sound of Beijing*), 'ushered one million Chinese youth into a new wave, a new listening sensibility, a new awareness, a new mind and a new set of values'.[37] To put it in another way, the book was designed by someone inside the indie-music scene so as to share his personal and emotional experiences with his 'comrades'.

'Everyone is a designer. Everyone can design. Let the masters be narcissistic!'[38] Ou Ning's manifesto at the *Get It Louder* exhibition, which he co-curated in 2005 and which showcased the new urban creative scene, may sound aggressive and arrogant, but it sums up succinctly the DIY aesthetic shared by Chinese urban youth since the mid-1990s. The professional standards and expertise upheld by the Shenzhen designers are no longer relevant; a graphic language with Chinese characteristics is not important. Crucial is using their own hands to design and make things related to their own lives.

If one argues that in the second half of the 1990s the indie-music scene, alongside products such as books, magazines, fliers and CDs, was an early form of this DIY spirit, in the new century this spirit has diversified into numerous forms, ranging from graffiti, T-shirt designs, cute toys, illustrations and animations, to websites, blogs, webzines and music downloads. Geographical differences can also be discerned. In Shanghai the DIY spirit combined with the city's reviving fashion culture to form new youth lifestyle trends. In the quiet Nanchang Road in the old French Concessions, Ji Ji, a trained product designer, opened the lifestyle shop Shirtflag in 2004, pioneering Chinese streetwear, selling T-shirts, jeans, caps, bags and trainers. All his products bore retro-style designs that juxtaposed Cultural Revolution icons, such as the 'worker, peasant and soldier' trio, with images of western counter-culture products in unexpected ways. This was followed by a small boutique belonging to graphic designers Perk, in which they presented quirky notebooks, posters, stickers and toys that they designed themselves alongside fashion items and accessories. In Beijing 'lifestyle' is less of a primary concern among young creatives. The DIY culture is instead defined either by a concern for a *shougong zuofang* ('home-made') aesthetic or by a *caogeng* ('grass-roots') artistic activism. The MEWE Design Alliance, a young design practice of three Central Academy of Fine Arts graduates with a typically home-made vernacular style, is an example of the former, while Luxiao (Green School), the loosely organized art and design collective of young illustrators, animators, graphic designers and fine artists founded in 2003, represents the latter, where its members are committed to the notion of creating art and design for non-commercial use and using them for free community purposes. Initially Luxiao members, such as Yan Cong and Gu Fan, shared their ideas among themselves on the Internet. Since 2006 they have begun to come out of the digital world and walk into reality, organizing art fairs where the party and the workshop converge, and working with young people with autism at a local school. In their own words, 'we are not concerned with buzzwords such as creativity, new design, new illustration and the post-80s generation.

We just want to confront social problems we are living with, begin to tackle them, be more outgoing, be more communicative with people.'[39]

Hence there is real hope for the future of Chinese design. The Beijing-based indie-music critic and sound-art promoter Yan Jun has recently argued in 'The Pleasure of Tambourine', an article published in *Art and Design* magazine, that the new DIY culture in China is not a case of 'take it and use it', but evidence of a convergence with current international graphic-design trends.[40] As the development over the past three decades has suggested, generations of Chinese designers have always engaged with design in a critical way. As China continues to develop at awe-inspiring speed through the late 2000s, we can expect that its design will be as risk-taking and innovative as the first pioneers were in Shenzhen.

FRONTIER CITY

**DESIGNING
PROPAGANDA:
THE
BUSINESS
OF
POLITICS**
STEFAN
LANDSBERGER

Since 1977 Chinese popular culture has moved away from the tight control under which it was placed since the founding of the People's Republic in 1949, as the state gradually withdrew from day-to-day interference in the lives of its citizens. As the successes of China's economic modernization policies started to benefit ever-increasing numbers of people from the 1980s, particularly in urban areas, the population began to understand that having fun was permissible. In particular the 'Opening Up' policy adopted from 1979 onwards exposed many people to western, or non-Chinese, popular culture – from art, music and fashion to lifestyle choices and a range of media channels. And the television set, considered the ultimate modern symbol of personal prosperity, provided people with their own 'Open Door' to the world.

Between 1949 and 1977 the government's political messages were communicated through many media, but propaganda posters were among the most important. They gave graphic expression to the many different abstract policies and numerous grandiose visions of the future that it proposed and entertained over the years. But they were also employed to provide examples of politically correct or desired behaviour. With the high levels of illiteracy in the early decades of socialist China, posters simply conveyed ideological messages to educate the people.

Propaganda posters could be produced cheaply and easily, and this made them one of the most-favoured vehicles for state-directed communication. Because they were widely available, they could be seen everywhere. And they were an excellent way to bring some colour to the otherwise drab places where most people lived and worked. Posters were able to penetrate every level of society: the multicoloured prints could be seen adorning the walls not only of offices and factories, but of houses and dormitories as well. Most people liked the posters for their striking visual qualities and did not pay too much attention to the slogans printed underneath. This enabled political messages to be passed on in an almost subconscious manner.

All this changed with the 'Opening Up' policy. Posters now had to compete with a flood of other voices and images – not only those produced by and for the market, but also those produced by and for the people themselves. As a result, state-sponsored messages were increasingly seen by many as irrelevant, falling on unseeing eyes and deaf ears. Chinese urbanites now dreamed of achieving instant celebrity by participating in a reality knock-out television show, or of earning an MBA at a western university, going into business and making a fortune. Millions of people from the countryside started flocking to the cities, hoping to profit on the margins of the emerging urban consumer culture that was being beamed daily into their television sets back home.

This changing environment provoked a serious rethink in the state departments responsible for what is euphemistically called 'popular education'. Not only the medium, but more importantly the message, had to alter. In line with the general shift of the state's preoccupations towards economic development and well-being, the tone of the posters needed to change. This new approach was summed up in remarks such as 'Less talk, more action' and 'Let some get rich first' by Deng Xiaoping, China's president and the architect of the reform policies after 1978.

One of the attempts to give propaganda posters a fresh and modern feel was through the use of photography and photomontage in their design. Photography had become a true art form of the people. As more and more Chinese gained easy access to the equipment, it became one of many new status symbols and one of the essential activities of urban life in China's reform era. The growth of commercial advertising in China greatly helped in the spread of more sophisticated design techniques that were already in use in Taiwan and Hong Kong. Japanese and American design influences also made their way into China.

Various posters produced in the 1990s reflected these new trends. Many dropped in images of defining landmarks of China (including Hong Kong and Macau) as a visual background to their message. These elements included the Great Wall, signifying timeless national unity; the rostrum of Tiananmen Square (from where the leaders inspect parades), representing the power of the state; and the Oriental Pearl TV Tower in Pudong, Shanghai, illustrating the successes of China's economic modernization.

In today's China, the burgeoning commercial sector exercises a strong pull on graphic artists and designers. Before the economic reforms, these same artists were confined to propaganda posters as an outlet for their creativity. But, in the changed reality of post-reform China, artists and designers are no longer held in the highest esteem as the state's ultimate 'spin doctors' – a role they played during the heyday of poster production. Artistic freedom and independence, coupled with opportunities to earn more money, have a great influence on their decision to work for the independent art and design market. Designed by second-rank artists, the posters that are still published by the state now lack an inventiveness and brilliance of execution. They have become rather tame, both in their content and in their colour. All this raises questions about whether state-produced materials are still able to capture the attention of the public. The posters of the late 1990s that addressed the 'dangers' of the religious Falun Gong sect are good examples of this.

With the effectiveness and appeal of printed propaganda clearly declining, the Chinese state had to devise new strategies for bringing their message to the Chinese public. During the 1990s, in line with ever-increasing ownership, television was initially considered to be the most effective medium for presenting propaganda. More recently the Internet has become a favoured medium for state messages. But using moving images for official broadcasts has demanded different formats and novel ways of presenting content. As a result, the state began producing highly sophisticated,

extremely well-made forms of political advertising, also known as 'partymercials' or 'indoctritainment', inspired by commercial advertising techniques.

Chinese television viewers were confronted with a new and subtle type of propaganda that often was very difficult to identify as such at first sight. Political messages seemed to be less crude than before and were embedded in the avalanche of commercials with which spectators were inundated as soon as they switched on their sets for their daily dose of entertainment.

These government adverts often addressed general themes, from the central role of the state in China's successful development, to the needs for ethnic unity under the leadership of that same state. Increasingly, in the form of public-service broadcasts, they dealt with the pressing problems of contemporary society: healthcare, including HIV/AIDS, SARS and avian flu; protecting the environment; providing education for migrant children; closing the gap between town and country; combating the adolescent addiction to Internet gaming; violation of others' intellectual property; the dangers of smoking; gambling; domestic violence; and so on. In pre-reform China most of these social issues simply did not exist or, even if they did, were not publicly acknowledged.

But the state's messages are not limited to addressing social problems. They are also intended to engender a sense of pride and patriotism in China's people. Small wonder that patriotism has become an element that has found its way into public-service adverts, as illustrated by events such as the 2008 Beijing Olympics, China's ambitious space programme and Shanghai's hosting of the World Exhibition in 2010.

One presentation device adopted from commercial advertising is the use of celebrity endorsement. As a result, many national and international Chinese stars from a variety of disciplines have been called upon to broadcast for the public good. Actress Zhang Ziyi, star of the film *Crouching Tiger, Hidden Dragon* and the face of a wide variety of cosmetic products and luxury goods, featured in a 2003 advertisement calling for personal hygiene to prevent SARS contamination. Professional basketball legend Yao Ming, who endorses a range of international brands including Apple, Pepsi-Cola and McDonald's, appeared in a message urging people not give the cold shoulder to those infected with HIV/AIDS. And film star Pu Cunxin, who has appeared in various serious productions staged by the Beijing People's Art Theatre, not only endorsed the HIV/AIDS awareness campaign of 2003, both in print and in television commercials, but also supported national blood-donation drives.

This modern use of celebrities to drive home a message is all the more interesting when we compare it with historical propaganda practice in China. For millennia the state has presented role models to try and influence the behaviour of the rest of the people. After 1949 the government made extensive use of role models to explain policy and give examples showing how the people should live their lives. One of the main reasons why such models tended to be exemplary was because they were recognizable, ordinary people, like 'screws in the machinery of the revolution'. In present-day China, however, it is the star status of celebrities that now influences the people who are exposed to the messages in which they appear.

Propaganda posters have not disappeared from the public realm in China, but their numbers are dwindling. The government has shifted its communication practices almost completely to new electronic media. But the effectiveness of these modern forms of propaganda may be less than that of their old-fashioned predecessors. Propagandists are faced with the same problem that vexes advertising executives all over the world: how can the viewers be dissuaded from 'zapping' to another channel when the commercial break starts, or from 'tuning out' when confronted with what is essentially boring propaganda? Moreover, with their contents 'sexed up', the 'partymercials' and 'indoctritainment' look more like their commercial counterparts than ever before. In China, as elsewhere, politics truly have become business.

47. China Communist Youth League and China Central Television, 'Care for Children, Tomorrow's Future', TV public advertisement, 2005.
48. CCTV Mass Media International Agency and CCTV Advertisement Division, 'Success Originates from Perseverance', TV public advertisement, 2006.
49. Mengniu Dairy and China Central Television Advertisement Division, SARS Prevention – Zhang Ziyi, TV public advertisement, 2003.
50. Hao Xueli, New Beijing, Great Olympics - Beijing 2008, poster, 2000.
51. Ministry of Health and Durex, AIDS Live and Let Live, poster, 2003.

51

2003年世界艾滋病宣传运动主题

相互关爱 共享生命

AIDS
Live and let live

**TRY THE
CRAB***
HUANG
ZHICHENG

At the beginning of the 1990s a group of young *meigong* (artist-workers), all graduates in art and craft, congregated every evening in a conference room at Jiamei Design, the first graphic-design company in Shenzhen, a city then at the forefront of China's economic reforms. They were planning a revolution in graphic design – an exhibition entitled *Graphic Design in China*, which came to the stage amid great enthusiasm in 1992.

In the foreword to the exhibition catalogue, *'92 Graphic Design in China*, the following lines appear:

The Emperor Fu Xi of the ancient Chinese Shang Dynasty devised the Eight Trigrams that make up the Book of Changes (I Ching) as a way of divining the laws of the universe and bringing order to the lives of humans. His 'design' is of unsurpassed originality throughout the world.

These comments struck me as deeply perceptive, showing how an awareness of the essence of Chinese culture could permeate contemporary design. Building on this theme, the cover of the exhibition catalogue bore a logo based on the Eight Trigrams, devised in a classic Dutch design style. There is an interesting story attached to this: on the eve of the exhibition's opening on 8 April 1992, the General Secretary of the organizing committee, He Maohua, was asked to consult the Book of Changes, in order to invoke good weather and a favourable atmosphere. The hexagram generated was the *tong ren*, or 'fellowship between people'. Long Zhaoshu, a member of the committee, explained that this was a fire hexagram and bore the shape of a torch. Apparently, when opening day arrived, the sun did indeed burn down from a cloudless sky.

This logo of the 1992 exhibition foresees the unique quality of contemporary Chinese design: fusing modern western creative thinking and the spirit of eastern culture. Chen Shaohua's poster for the exhibition makes this clearer than any text (see p.47).

The emergence of a graphic-design industry is dependent on two conditions. First, it is market-driven; if the advertising industry is flourishing, it opens up a greatly expanded market for graphic design. Second, it is technology-driven – graphic design requires a manufacturing infrastructure, particularly in the printing industry. Shenzhen was pre-eminent on both these fronts and was therefore able to attract many excellent designers, with the vast majority of high-quality printing jobs from all over China being undertaken there. Many of the pioneering generation of designers were involved in Shenzhen's printing industry.

Leading designers Wang Xu and Wang Yuefei played key roles in the planning stages of the 1992 exhibition. Jiamei Design, the company where Wang Yuefei worked, provided the funds, while Wang Xu was responsible for liaising with overseas Judging

Panel members. Both of them had qualified in *zhuanghuang*, or interior design, at Guangzhou Academy of Fine Arts, where they had been classmates. On graduation, both found jobs in the Guangdong branch of Chinapack, a national packaging company. Then, in 1986, Wang Xu was sent to Hong Kong as a designer for Yuehai Packaging, and the following year Wang Yuefei arrived at Jiamei Design in Shenzhen. Wang Xu soon developed contacts with fellow designers both in Hong Kong and overseas and – with the help of the 'father of Hong Kong design' Henry Steiner – set up the influential magazine *Design Exchange*. This magazine introduced international graphic designers and their work to the mainland for the first time, influencing and spurring on a whole generation of Chinese designers. *Design Exchange* published its last issue in 2000.

The *'92 Graphic Design in China* exhibition was the first to bring together graphic designers from Hong Kong and Taiwan with those from the mainland, and the first to define clearly what graphic design could mean in a Chinese context. Most importantly, it brought into being the first community of designers in mainland China who made their living from graphic design.

The exhibition's huge success filled its organizers with confidence for the future. It was the yeast that eventually gave rise to the Shenzhen Graphic Design Association (SGDA). Set up in August 1995, the SGDA was mainland China's first non-governmental designers' association and involved the participation of a range of leading designers, including Long Zhaoshu, Wang Yuefei, Chen Shaohua and Han Jiaying. The logo that Han Jiaying designed for the association – a vertical eye – seemed to hint at the difference between designer and fine artist, in that a designer looks at the world from a different viewpoint.

Planning began for two important exhibitions: the *'96 Graphic Design in China* competition and the *Communication* poster show. Funding for both came from the personal contributions of core members of the association, with designers' associations from mainland China, Taiwan, Hong Kong and Macao joining together in collaboration. With a desire to enable Chinese design exhibitions to reach international standards as quickly as possible, the SGDA invited four international designers to join the Judging Panel for the *'96 Graphic Design in China* exhibition: Ken Cato from Australia, Michel Bouvet from France, Keizo Matsui from Japan and Ahn Sang-Soo from Korea. The exhibition subsequently toured to venues in Japan, Korea and France.

During the early 1990s Hong Kong was recognized as having the best Chinese graphic designers; Kan Tai-keung and Alan Chan had been judges at the 1992 exhibition, and in the *'96 Graphic Design in China* exhibition both entered the competition as contenders, part of a talented group of Hong Kong designers. The participation of the Hong Kong contingent undoubtedly raised the overall quality of the 1996 exhibition, and

the designer Esther Liu won the Grand Prize. Shenzhen designers' work also received public and critical acclaim: Huang Yang, Han Jiaying and Bi Xuefeng, together with Wang Xu from Guangzhou and Hong Kong's designer Esther Liu, won six gold medals between them. Han Jiaying alone won a total of 13 prizes, including gold, silver and bronze medals and excellence and merit awards.

The *Communication* exhibition, held in conjunction with the *'96 Graphic Design in China* exhibition, was the SGDA's first poster exhibition and proved extremely influential in the ongoing development of Chinese graphic design. Although *Communication* was only an ancillary exhibition, its value should not be underestimated. Lin Pansong from Taiwan commented: 'This exhibition and everything happening in it is surely in itself an act of communication.' In a sense, *Communication* was not only a coming together of fellow designers from mainland China, Taiwan, Hong Kong and Macao, but was – more than anything – an expression of concern for the contemporary reality in which Chinese designers live as citizens.

The series of *Graphic Design in China* exhibitions made Shenzhen the centre of Chinese contemporary graphic design in the 1990s: from that city, ideas about contemporary design radiated out to other parts of mainland China. Following the 1996 exhibition, graphic-design associations were set up across Chinese cities such as Ningbo, Shanghai, Suzhou and Hangzhou. Towards the end of that decade the first International Poster Biennial held in mainland China opened in Ningbo. The *Graphic Design in China* exhibitions had opened the eyes of mainland designers to the outside world. Chinese designers now began to show their work frequently at major international poster and design exhibitions. At the same time Chinese graphic design, as represented by Shenzhen designers, began to attract international attention. From 2000 established designers like Wang Xu, Wang Yuefei, Chen Shaohua, Han Jiaying and Bi Xuefeng all became members of international design organizations such as the AGI, ADC (New York) and D&AD (UK).

Shenzhen's graphic-design association's success was short-lived. By the end of 1997 private differences came out into the open and the organization began to fragment. Most of its members turned their attention to commercial designing, setting up their own independent design studios. The economic reform process was increasingly opening up China to the outside world. Commercial opportunities for designers could now be found across China, and noted designers were increasingly choosing to work outside Shenzhen, particularly in Shanghai and Beijing. It was a depressing time for Shenzhen designers. The Shenzhen City Government began to consider what measures it could take to sustain the development of innovative design in the city, and focused its attention on promoting the design industry. In 2000 Chen Shaohua's logo for Beijing's bid

for the 2008 Olympic Games caught the cultural imagination of the whole of China and, in so doing, helped to heighten levels of public awareness of design in Shengzhen.

In 2003 the Guanshanyue Arts Museum in Shenzhen once again brought designers together, organizing the *'03 Shenzhen Design* exhibition. The theme devised by the organizers was 'Design Shenzhen, Shenzhen Design': exploring the interaction between design and the development of the city. Once more the creative enthusiasm of designers from all over mainland China, as well as Hong Kong and Macao, was focused on Shenzhen. For designers based there it was like a festival, and it was one into which they threw all their energies. They saw the *'03 Shenzhen Design* exhibition as a continuation of the previous decade's *Graphic Design in China* shows and, when it was over, it had created the momentum and the will to set up a new graphic-design association.

This association included Han Jiaying, Bi Xuefeng, Zhang Dali, Wang Yuefei and Chen Shaohua, and some younger designers such as Han Zhanning, and it co-hosted the *'05 Graphic Design in China* exhibition, in partnership with the Guanshanyue Arts Museum. The 2003 exhibition was a turning point, reviving the ambitions of the Shenzhen design industry. The city now buzzes with design exhibitions and academic exchange visits organized by government departments, arts organizations, schools and colleges, trade associations and commercial enterprises. Local media attention is growing, with the *Shenzhen Economic Daily* devoting much coverage to reviewing the history of design in Shenzhen and to reporting on major designers and design events. All of this has given a much-needed impetus to the ongoing development of the creative industries in Shenzhen.

If we see the *'92 Graphic Design in China* exhibition as a critical moment in time, launching China's first generation of graphic designers, then the 2003 and 2005 exhibitions have helped to highlight a new generation. Designers such as Guang Yu, founder member of Beijing-based design group MEWE and Grand Prize-winner at the *'05 Graphic Design in China* exhibition, and poster-section silver-medal-winner Chen Feibo (Zhejiang province) were both born after 1970. And on the eve of the opening of the 2005 exhibition, a group of young designers in Shenzhen, all in their twenties and thirties – among them Hei Yiyang, Chen Yueyang and Xia Wenxi – launched an alternative design show called *Look at Me 30*, choosing a huge shopping centre as their venue, rather than a traditional gallery space. In it they were exhibiting not only their own conceptual work, but also projects for their clients. They proudly called themselves 'creative citizens' who served the public. These examples demonstrate the creative potential of the young generation, and fill us with hope for their future.

52

53

54

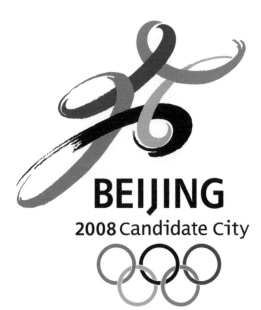

BEIJING
2008 Candidate City

55

60

FRONTIER CITY

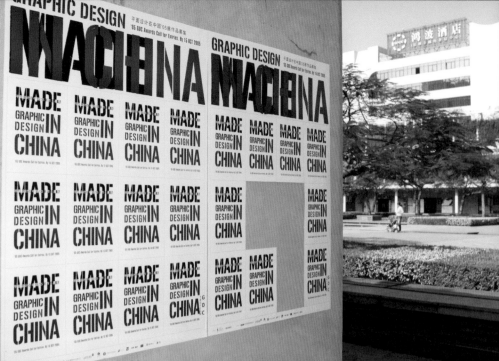

52. Han Jiaying, Shenzhen Graphic Design Association, logo, 1995.
53. Wang Yuefei, *Graphic Design in China* exhibition catalogue, book design, 1992.
54. Chen Shaohua, Beijing 2008 Olympics Candidate City, logo, 2000.
55. Wang Yuefei, *Graphic Design in China* exhibition catalogue, book design, 1996.
56. Huang Yang, *Graphic Design in China*, photography series, 2005.
57. (following pages) *Get It Louder* exhibition, Shanghai, 2005.

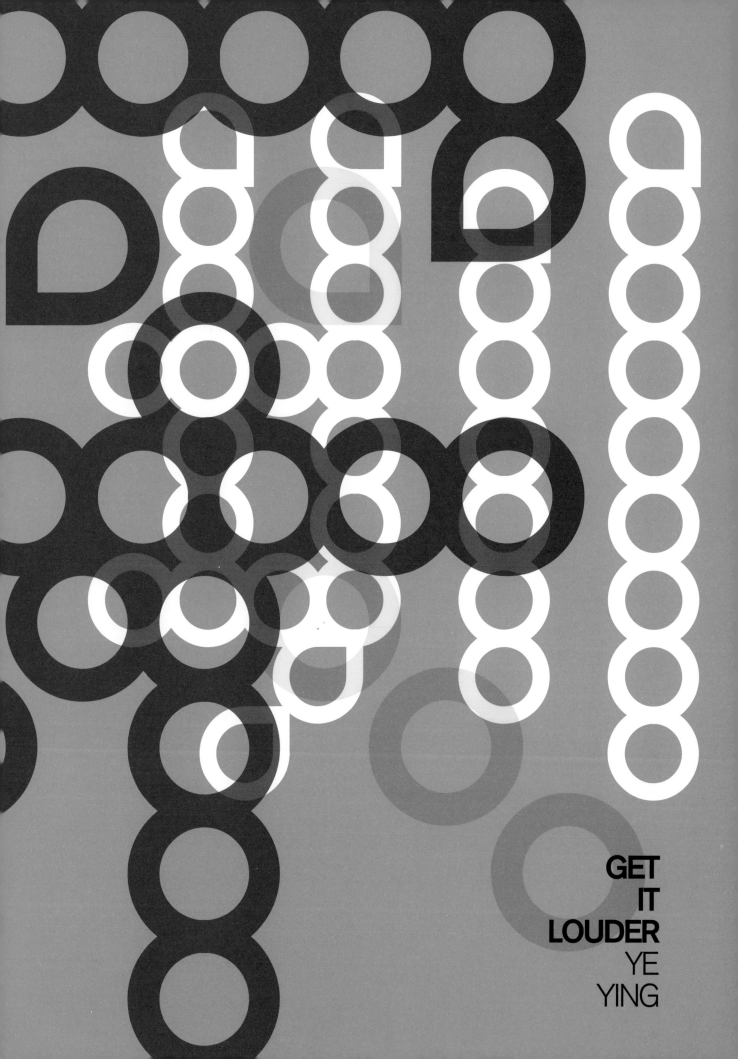

GET
IT
LOUDER
YE
YING

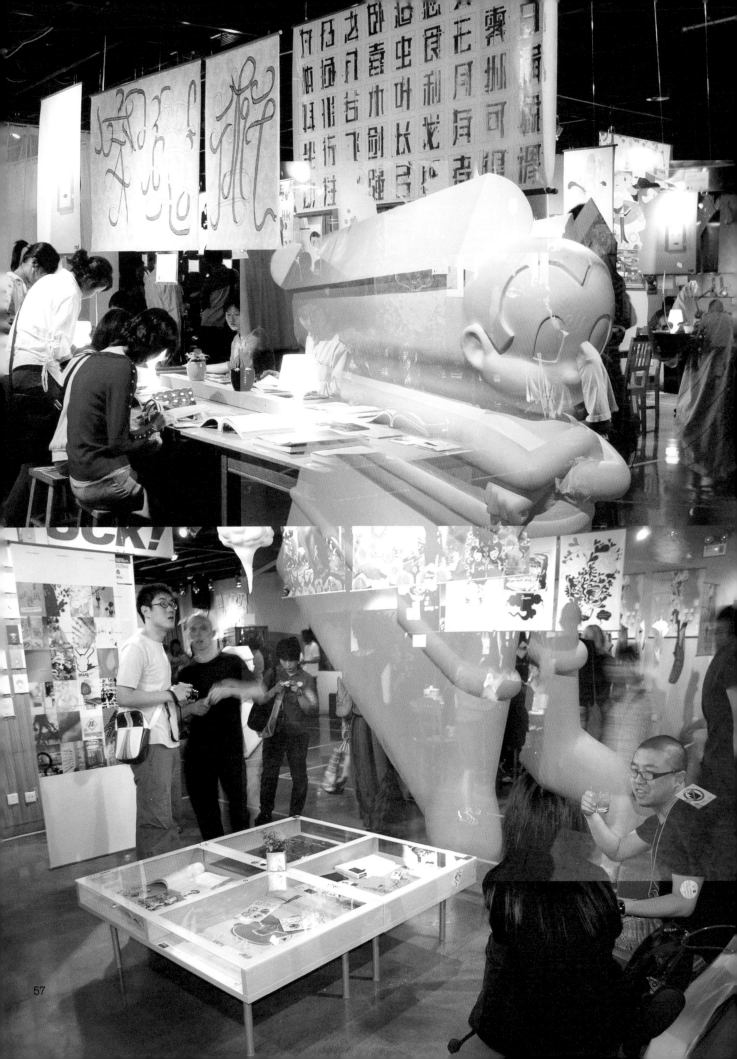

'Where to start?' asked the curators of 2005's *Get It Louder* exhibition as they began planning the influential project that was to showcase a new generation of Chinese artists and designers. *Get It Louder* brought together exhibits from around 100 designers and artists and was the first in mainland China to show the work of the generations of designers born in the 1970s and '80s. These creative practitioners had begun to work well before the *Get It Louder* exhibition, but had yet to come to the attention of the wider world.

From 2000 onwards with the rapidly growing popularity of the Internet, independent designers' websites in China boomed. Scores of independent websites and webzines appeared, such as 'Coldtea' based in Guangzhou, embracing different means of expression – experimenting with design, animation and sound. The rise of design and style websites not only gave young Chinese speedy access to information from outside China, but also provided them with a forum for nationwide contacts as they showed their own work.

In 2003 Chinese design students Jiang Jian and Xia Qing in Australia and Qian Qian in the USA met on the Internet. Their discussions kick-started the process of organizing the *Get It Louder* exhibition. Their initial intention was to show the creative work of young Chinese designers overseas. However, after having made contact with respected designer, filmmaker and cultural commentator Ou Ning in Guangzhou and with Ji Ji, a designer and gallery owner from Shanghai, the focus of the exhibition was expanded to include young Chinese artists and designers working overseas and from mainland China. At the same time young creatives from other countries were also invited to exhibit.

Get It Louder opened on 30 April 2005 in Shenzhen, and then toured to Shanghai in May and Beijing in June of that year. The exhibition included graphic design, fashion, multimedia, art installations, architecture and sound projects, and well-known Chinese designers such as Kam Tang and Saiman Chow, who work in Europe and America, were invited to give lectures and demonstrations alongside the show.

Ou Ning, one of the exhibition curators, said: '*Get It Louder* focused on every aspect of new, independent creative work influenced by web culture in a globalized era. It was not just a carnival occasion where enthusiastic young designers and artists could let rip, but also included discussion of this cultural phenomenon.' As Ou Ning saw it, *Get It Louder* was part of this cultural phenomenon by bringing a new generation of young designers to public attention.

Ou Ning has been active on the Chinese cultural scene since the beginning of the 1990s. His acuity in discovering and documenting China's youth culture ensured that *Get It Louder* was not simply a showcase for young designers, but that the nature of the exhibits was closer to being artworks – in fact most of the designs picked were self-initiated non-commercial projects.

One of the exhibits that Ou Ning submitted for *Get It Louder* was the 1999 publication *New Sound of Beijing*, which recorded in words the Beijing punk and rock scene at the end of the 1990s and was designed by Ou Ning himself. He had studied advertising at Shenzhen University and, after entering the design world, did not want to be controlled by clients, so when he was working on *New Sound of Beijing* he kept it as an independent publication. This book was followed by two independent magazines on art films, *Film Talk* and *Film Works*. In Ou Ning's view, design is a means of expression; he regards these publications as a way of sharing his personal views and thoughts on alternative culture and avant-garde art with other people, and he calls *New Sound of Beijing* 'a record of the generation growing up in the period of transformation' – the period when Chinese society underwent dramatic changes during the 1990s. In this context *Get It Louder* was not just a showcase for young talent; it was, even more importantly, a declaration to mainstream society that design could be a powerful means of expression for this generation of young people, and that it could achieve the sort of cultural status that music and films already had in China.

Since the beginning of the 1990s China has seen successive cultural trends emerge – from punk and rock music to independent film-making and fringe theatre. These trends come and go, and many of the participants are interconnected. China's new generation of designers has very close ties with their fellow artists, and their work has been strongly influenced by the alternative culture that emerged during the 1980s. They have chosen a different path from the previous generation of designers, who worked almost exclusively in the world of commerce during the 1990s, instead developing an interdisciplinary approach and retaining close links with the rest of China's cultural scene by actively participating in a variety of artistic and cultural activities. The background against which they grew up, the contemporary art scene in China, and rapid changes in society have all served as sources of inspiration for the designers featured in *Get It Louder*.

Guang Yu, a member of the MEWE (Me + We) Design Alliance graphic design group, uses his primary-school homework books as a reference in his designs – shades of a remembered past. The warmth and sentiment of such designers' work reveals the search for self, which is universal to young Chinese born in the 1970s, filled as they are with self-doubt and confusion in an ever-changing world. Of course their work is not simply a nostalgic reproduction of the past; it also reveals the potent influence of contemporary western design, and their current preoccupation with how to create and define a Chinese design identity and how to express themselves within this.

The speed of social change in contemporary China is a constant influence on this generation. How can one derive inspiration from a rapidly changing reality? Can those cheap Chinese textiles and plastic products, the socialist way of life and socialist habits be transformed into a design language with distinctive Chinese features? One example of an attempt

to negotiate some of these ideas is the design created by fellow MEWE Alliance designer Liu Zhizhi from the national China Central Television (CCTV) station's logo – a commonplace image in China, which – through his translation – has been transformed into an interesting piece of design.

The frequent use made by an earlier generation of Chinese artists in the 1990s of political symbols as tools for artistic expression has also influenced the *Get It Louder* generation of designers, although the latter do not approach these political symbols in perhaps the serious and judgemental spirit that those 1990s artists did. Ji Ji's T-Shirt series, for example, takes a humorous tilt at the political propaganda of the 1960s and '70s.

A group of young designers who studied design in the West have now returned to China – such as *Get It Louder* curator Jiang Jian, who studied in Australia before returning to live and work in Beijing. He and others have put their experiences of overseas study into their approach to design. Since the 1990s the Chinese economy and culture have become more global, encouraging an increasing number of young people to go overseas to study or work. In addition to his involvement in *Get It Louder*, Jiang Jian also designs and produces the design magazine *Plugzine*, which is published independently. During his time in Australia he came into contact with a large number of independently published magazines, and it was this experience of non-mainstream publications that encouraged him to start his own. He has used the *Plugzine* series to showcase the work of young designers from China and abroad, and plans in subsequent issues to work in collaboration with other creative practitioners, from musicians to architects, and to feature in his magazine experimental work from these areas.

Since the end of 2005 and the close of *Get It Louder*, young designers have chosen to continue collaborating with artists of the same generation. The graphic designers of the MEWE Alliance studio (Guang Yu, He Jun and Liu Zhizhi), who all graduated from the China Central Academy of Fine Arts, have designed the catalogues for a range of fellow artists. Guang Yu focused on the games that he remembered from his childhood for the catalogue of artist Qiu Xiaofei's 'Heilongjiang Box', a box of childhood memories containing objects ranging from marbles to old 50- and 20-cent notes, in such a way that it was hard to tell whether the catalogue presented Guang Yu's work or Qiu Xiaofei's, because in his paintings Qiu also draws on his childhood memories. 'Heilongjiang Box' was a true collaboration between artist and designer, stemming from shared experiences of a childhood spent growing up in China.

When the first post-1949 advertising agencies were set up at the beginning of the 1980s, design was an almost unknown territory in China. During the 1990s, as the economic expansion gathered pace, a large number of advertising agencies were set up. Designers fell over themselves to imitate Hong Kong and Taiwan styles, and all of them worked solely for commercial clients. The work of that generation was a product of the high tide of consumerism that emerged in China in the 1990s, but the availability of commercial design work could not satisfy the new generation's need for self-expression in their work. Far from inheriting a design tradition, or subverting it, today's new designers are indifferent to it. Instead they choose to take far more inspiration from the West, and from contemporary life around them, than they do from their predecessors.

At a time when 'everyone is a designer' – through the spread of the Web and easy access to design software – young Chinese designers can, for the first time, have instantaneous access to the latest developments in western design, learning quickly about current trends. However, many of them, while being 'nourished' by these influences, also fall into an 'anxiety of influence'. Most of what they see on the Web comprises snippets of news and low-resolution images, making it difficult for young designers to learn in depth about the thought processes, working methods and systems of western designers. Instead, all they see are the finished products and design styling. Design methodologies and the processes of research and development usually take a long time to inculcate; at the same time the existing curriculum at Chinese colleges generally cannot meet their need for up-to-date information. Under these circumstances it is not surprising that much of the work we see is still imitative.

Without any doubt, *Get It Louder* was merely the starting point for this new generation of designers. With time they will come to understand that design is more than simply *linglei* ('alternative') and *ku* ('cool'). When planning the follow-up *Get It Louder* 2007 exhibition, Ou Ning hoped to encourage deeper discussion about the notion of design in China, organizing lectures on the history of design. The first *Get It Louder* has been recognized as an influential part of a 'new wave' of design. Now the project is trying to position itself in the longer-term development of design in China. *Get It Louder* is part of contemporary culture, crossing boundaries and seeking to create connections in the flux of contemporary China. But in time it plans to have an even greater impact – to enable young Chinese creatives to find their own design resources and their own design voice.

58. Ou Ning, *New Sound of Beijing*, book design, 1999.
59, 60. Jiang Jian, *Plugzine No.1*, magazine, Spring/Summer 2005.
61. Liu Zhizhi (MEWE Design Alliance), CCTV, shirt design, 2003.
62. Guang Yu (MEWE Design Alliance), *Heilongjiang Box*, book design, 2006.
63. (following pages) Ji Ji, Red Detachment of Women, Shirtflag collection, T-shirt design, 2005.
64. (following pages) Ji Ji, Kiss, Shirtflag collection, T-shirt design, 2005.

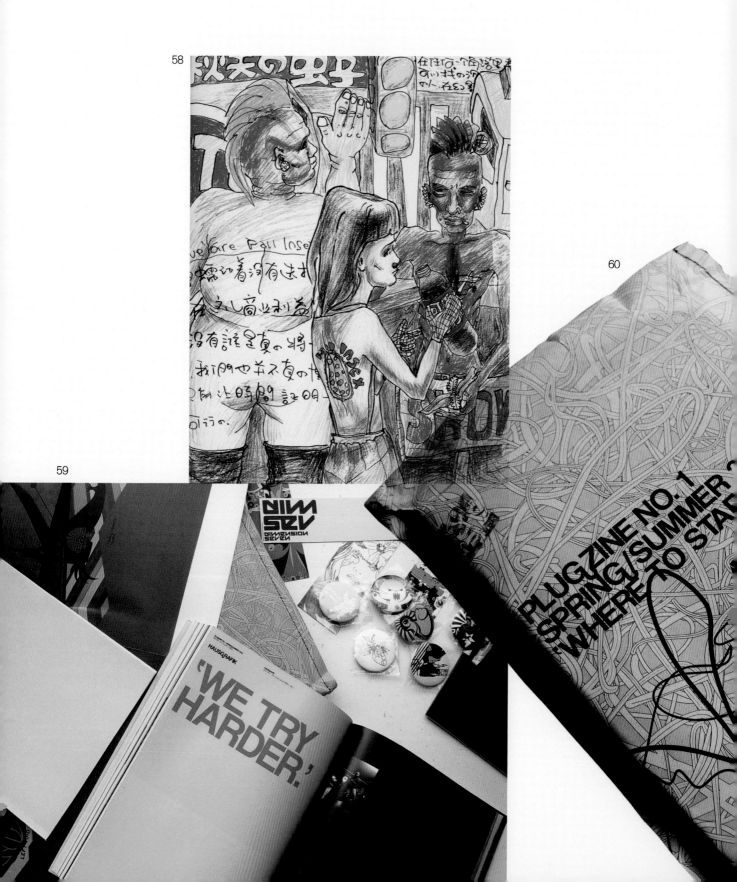

61

62

63

64

Images on the following pages:
65–69. Yu Haibo, City of Migrants, 1989–2006.
70–75. Yu Haibo, China's No.1 Art Factory – Dafen Village, 2005.

'I had been to galleries at Dafen Village before. However, when I first came to the artists' working and living quarters and stood in the factory-sized studios, I was stunned as I watched the scene in front of me: rows of oil canvases were laid on the floors and hanging from ceilings. In the narrow spaces in between were artisan-painters half-naked because of the high temperature. They were toiling over the canvases quietly and silently. What an extraordinary contradiction this was! Western masterpieces were copied by the rural boys of the East, and then exported to the West. Once I felt such contradiction existing in every inch of those studios, every frame produced a memorable image.' – Yu Haibo

SHENZHEN
WORKING
YU
HAIBO

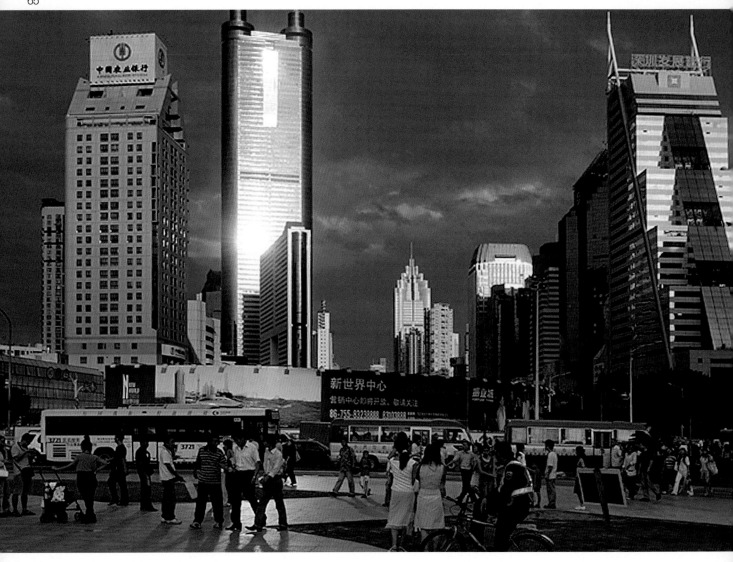

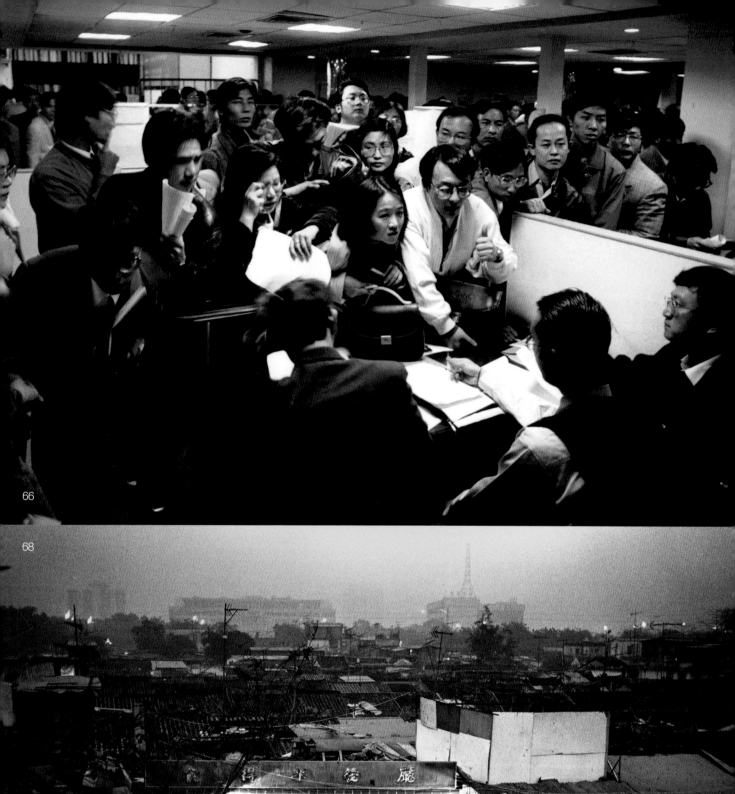

66

68

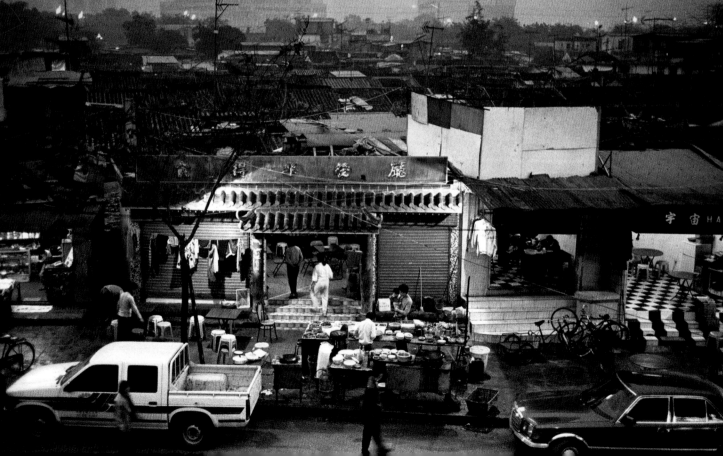

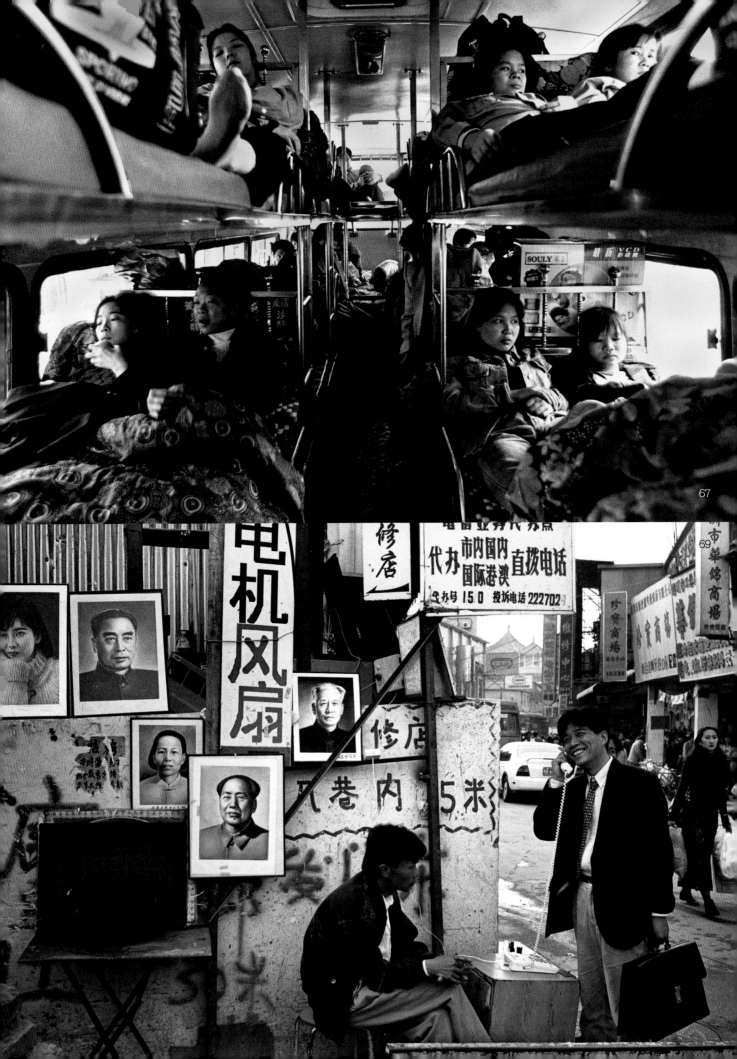

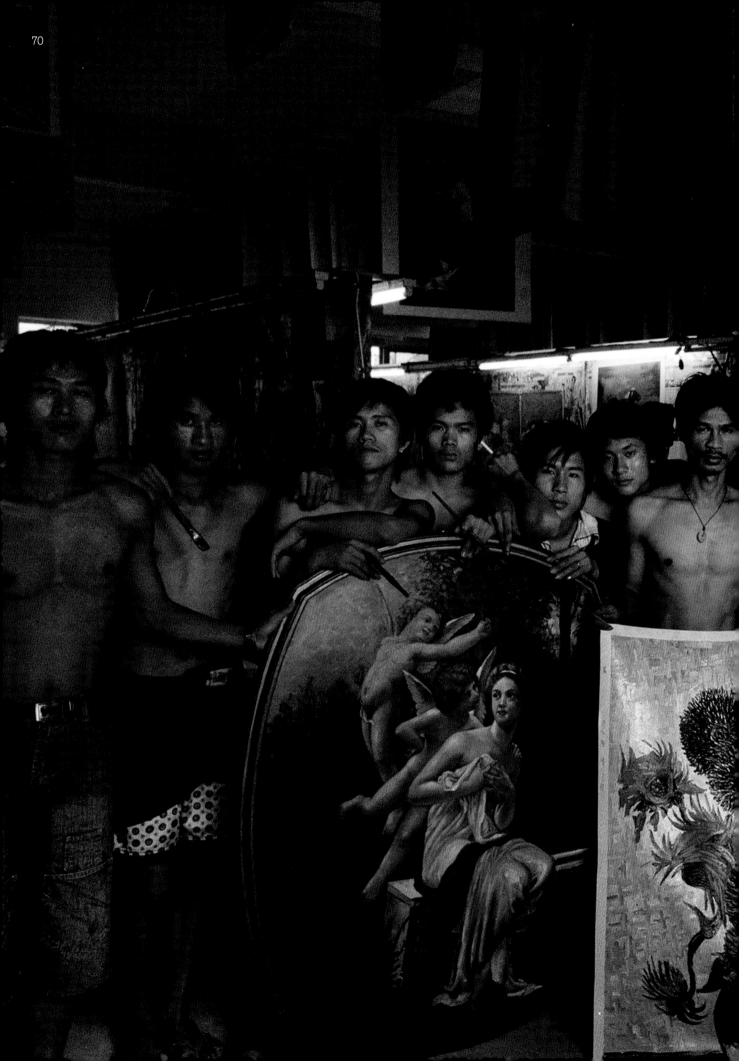

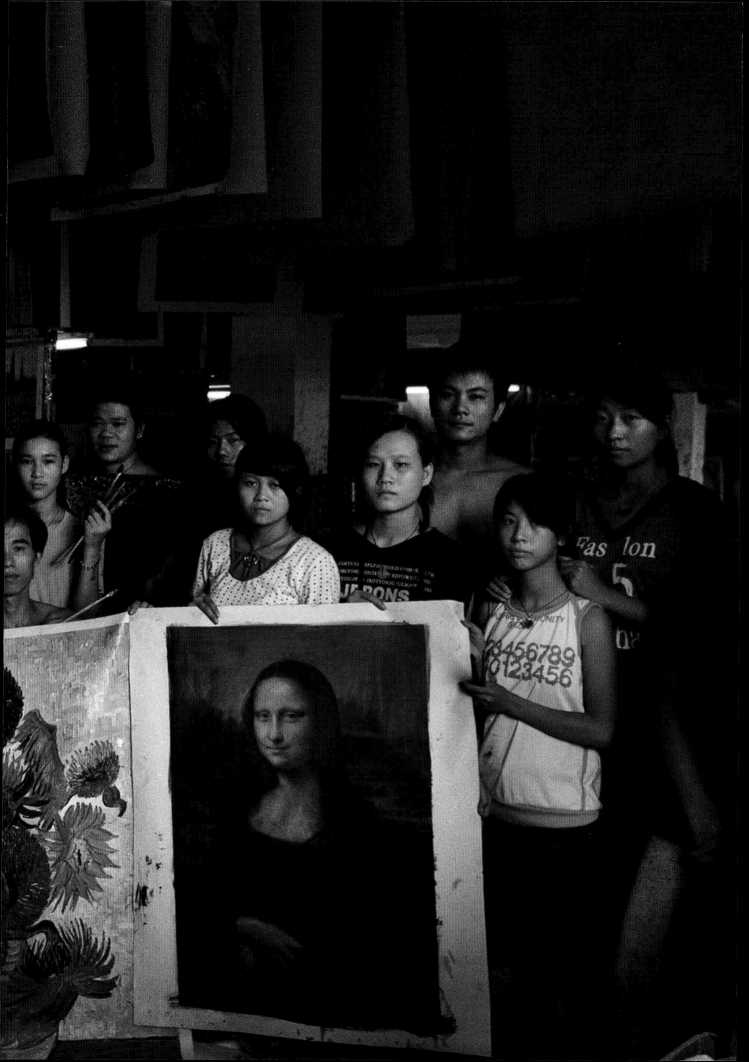

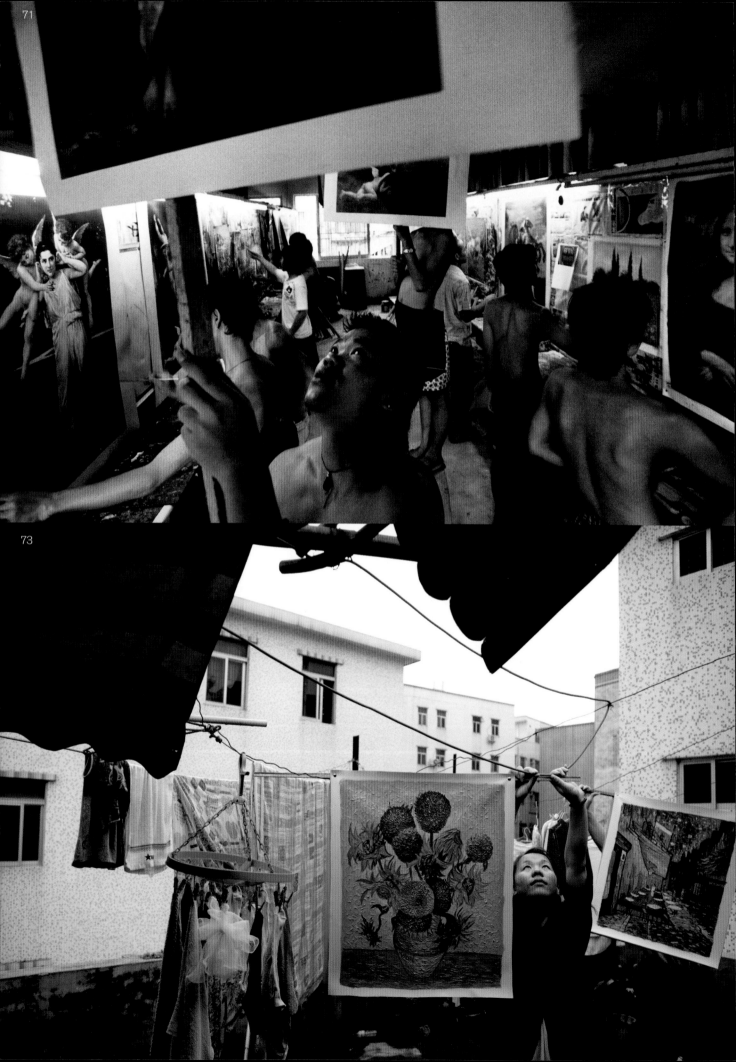

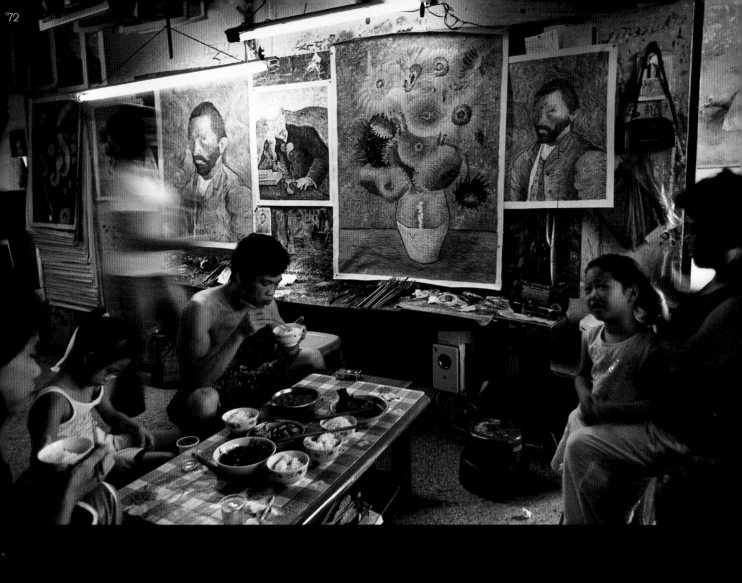

SHANGHAI:
DREAM
CITY

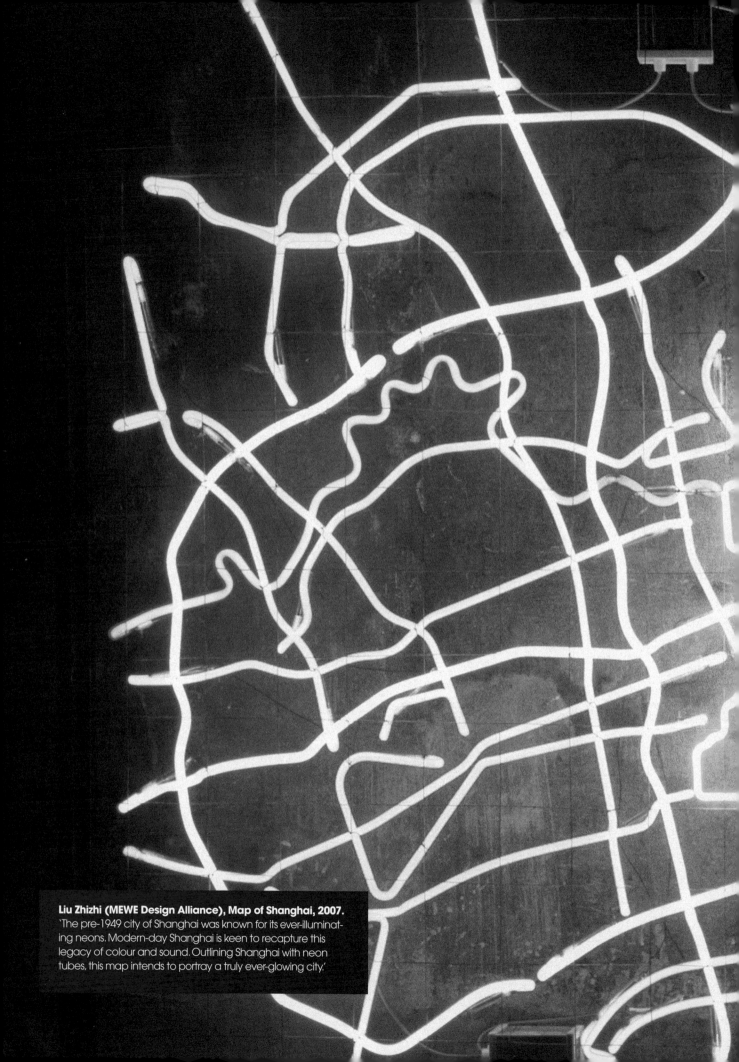

Liu Zhizhi (MEWE Design Alliance), Map of Shanghai, 2007.
'The pre-1949 city of Shanghai was known for its ever-illuminating neons. Modern-day Shanghai is keen to recapture this legacy of colour and sound. Outlining Shanghai with neon tubes, this map intends to portray a truly ever-glowing city.'

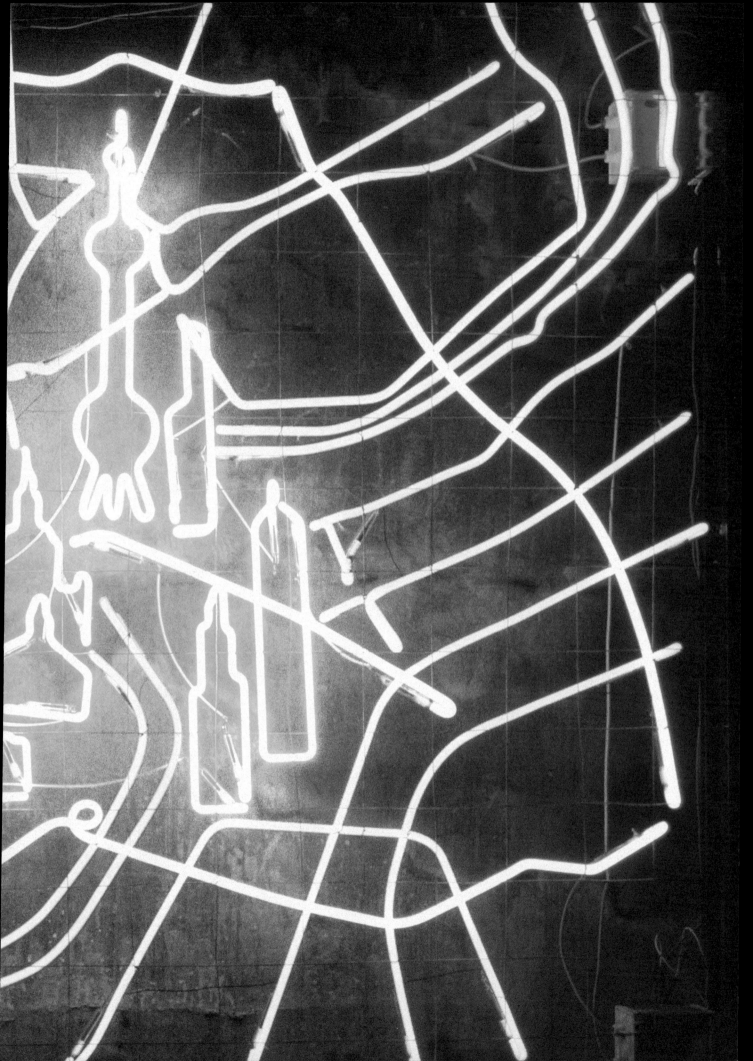

76. Wing Shya / Shya-la-la Production, The Soft Touch, Pearls of the Orient, photography series for *Time magazine supplement*, Spring 2005.
77. Chen Man, Preference, front-cover artwork for *Vision magazine*, February 2004.

78. Loretta Hui-Shan Yang, Chang Yi and TMSK Creative team, Crystal Bar of TMSK Restaurant, Xintiandi, Shanghai, 2001.
79. Jiang Qiong Er, Songs of Heart, Paradox jewellery collection, 2006.
80. Lin Jing, QiQi and KeKe tea sets, 2001.
81. Shao Fan, Ming Stool, 2005.
82. Shao Fan, Rely On chair, *Wallpaper* magazine*, December/January 2005.

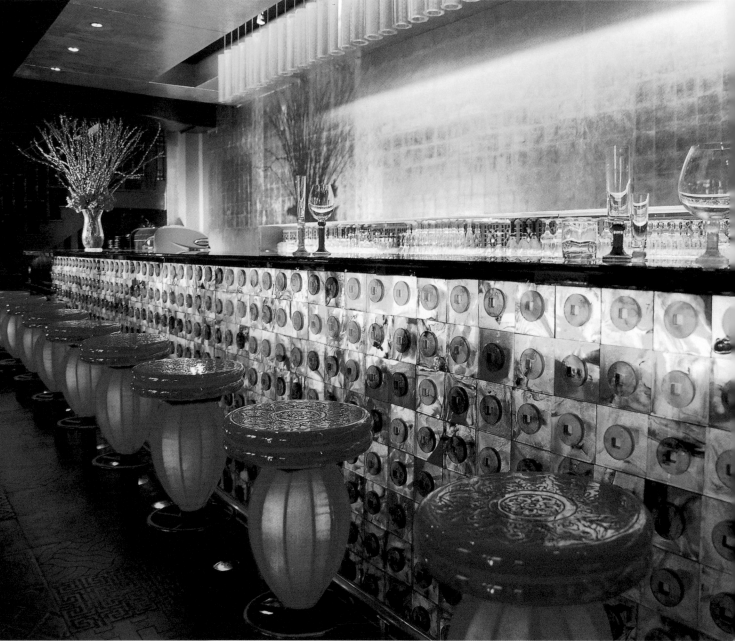

78

79

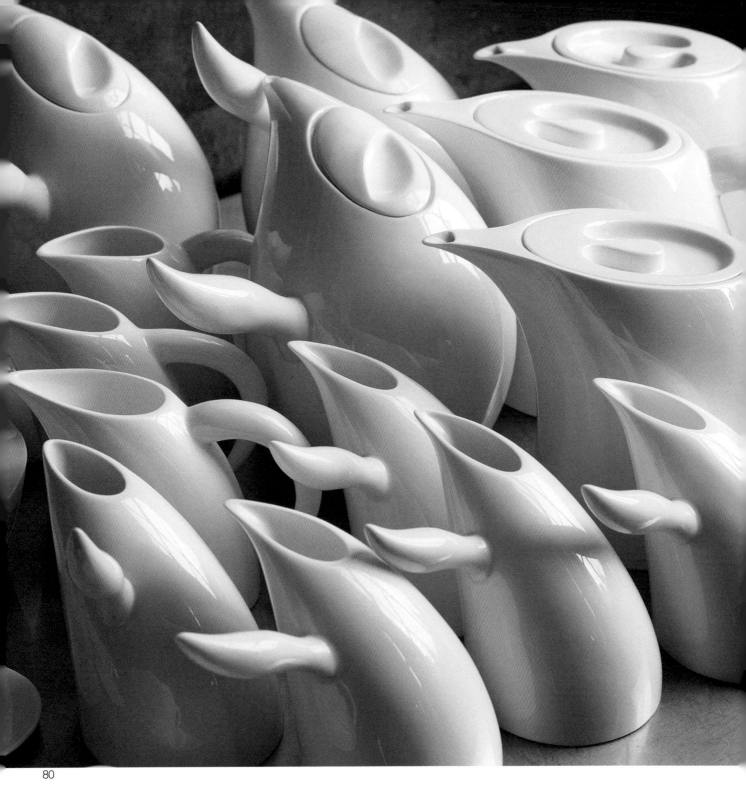

80

81

82

83. Wang Yiyang, Backpack, Cha Gang 'Street' collection, 2006.
84. Zhang Da, Dress, 'Flat' collection, 2002.

DREAM CITY

SHANGHAI: DREAM CITY
LAUREN PARKER

Shanghai modern. Arrival in Shanghai propels visitors seamlessly into a modern vision of the city, as China's burgeoning cosmopolitan, commercial and lifestyle capital. The ultra-fast Shanghai Maglev Train jets visitors from the international airport to the city at more than 430 kilometres per hour. Floating over the sprawling urban mass, you bypass the grimy factories on the edge of the city, dense forests of apartment blocks and building sites – drawn inexorably towards the downtown skyline of shining modernity. Shanghai's dense, complex street life is overlaid with the raised ribbons of urban highways that cut through the cityscape below, interspersed with gleaming shopping malls and giant advertising screens. Shanghai exudes a vertical impetus – all gleaming towers and massive infrastructure projects. The city is building more than 400 skyscrapers per year, alongside plans for 280 new underground stations and nine new satellite towns, each of more than one million residents.(1)

On the banks of the Huangpu River this futuristic vision becomes a reality. Following Deng Xiaoping's Southern Tour in 1992, Shanghai's architectural boom began – from the retro-utopian styling of Shanghai's iconic symbol, the Oriental Pearl TV Tower, and LED mega-screens of the Pudong New Area business district, to the fairyland of super high-rise developments. At night the city comes alive, an animated neon skyline reflected endlessly in the gleaming waters of the river.

Shanghai is branding itself as a global city, an international centre of commerce and capitalism on the scale of Tokyo, New York or London. Its vertical aspirations are mirrored by the city's motto for World Expo 2010 – 'Better City, Better Life' – embracing the dream of an affluent, internationalized and urban future. These ambitions are not limited solely to expression through the city's architecture – Shanghai is looking to transform itself into a cultural, economic and lifestyle centre. From World Expo and Formula One to the city's contemporary art biennale and its world-class museums and concert halls, Shanghai's governors have embraced the notion of the 'global creative city'.

Shanghai's tussle with the transformative qualities of modernity has permeated its condensed history. Developed from the 1840s as a city of international trading concessions, Shanghai was by 1930 the fifth-largest city in the world – the 'Paris of the Orient' and a 'whirlpool of revolutionary ideas, conflicting nationalist aspirations, unrestrained commercial expansion and military occupation', following the Japanese bombing of Shanghai from 1937.(2) New social, political and philosophical ideas were tested within this ferment as Shanghai became a crucible for new and conflicting national and cosmopolitan visions of modernity.

From its earliest days Shanghai was climbing towards the sky, its 'rising, jagged sky-line' a vertical demonstration of the city's striving for modernity.(3) The very notion of modernity in China became linguistically intertwined with this vertical impetus. Translated from the English, 'modern' became *modeng* – a transliteration into Chinese characters conveying both a sense of dynamic movement and an upward thrusting. This term *modeng* became rooted in the very foundations of Shanghai society, conjuring the notion of modern life and its trends, monopolizing all things fashionable and glowing in the limelight of the avant-garde tastemakers of the time.(4)

The 1920s and '30s in Shanghai were a time of rapid social and economic change – the birth of a nascent middle class – with its changing fashions blending eastern and western styles, exercise and leisure pursuits (including ballroom dancing, swimming and golf), the development of film, fashion and music industries, and the notion of the 'modern' woman – the image (if rarely the reality) of a woman, educated, in employment and freed from the twin economic and social dependencies on her husband and her role within the wider family unit. Shanghai's fashion-conscious women adopted new trends, from the hair perm to silk stockings and high heels, and followed the regularly changing styles of the *qipao* dress.

Shanghai seduced the imagination of the time with the material emblems of advancing modernity:

cars … electric lights and fans, radios, 'foreign-style' mansions (yang-fang), sofas, guns … cigars, perfume, high-heeled shoes, 'beauty parlours' … flannel suits, 1930(s) Parisian summer dresses … silver ashtrays, beer and soda bottles, as well as all forms of entertainment, such as dancing (foxtrot and tango), roulette, bordellos, greyhound racing, romantic Turkish baths, dancing girls (and) film stars.(5)

This was the first golden period of Chinese cinema. From the first Chinese feature film *The Difficult Couple*, made in 1913, Chinese film-making – with Shanghai as its centre – grew rapidly. In the decade between 1921 and 1931 studios in Shanghai produced more than 650 films.(6) Landmark films, including *The Goddess* (1934) featuring one of China's first film stars, Ruan Lingyu, and *24 Hours in Shanghai* (1933), provide vivid portraits of a claustrophobic city where excessive luxury and suffering coexist – Shanghai reduced to a street corner, a single-room dwelling, a montage of factory smoke-stacks. These films highlighted the plight of Shanghai's prostitutes, gamblers, mill workers and child labourers, those living in the darkness beneath the city's glittering surface.

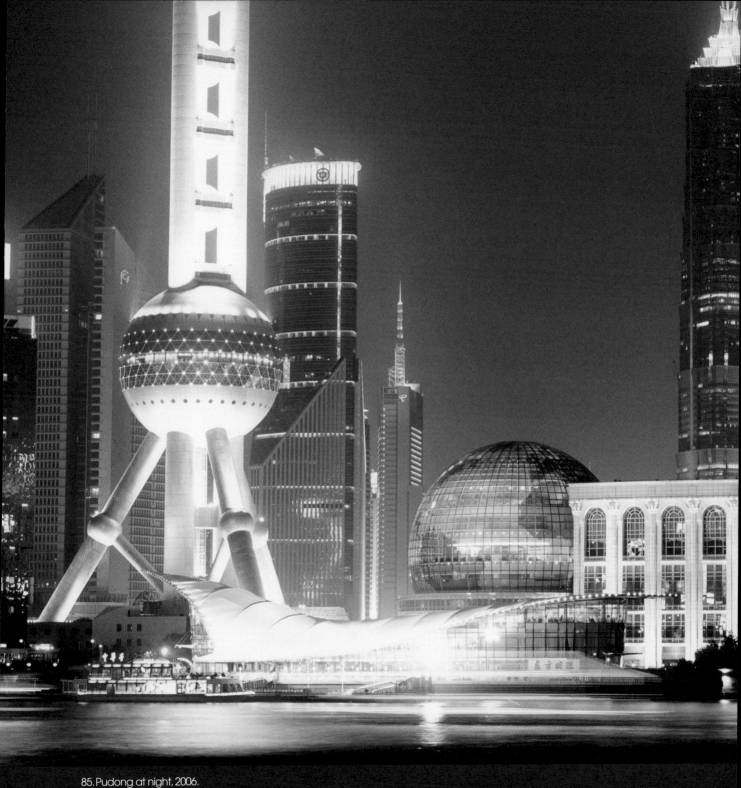

85. Pudong at night, 2006.

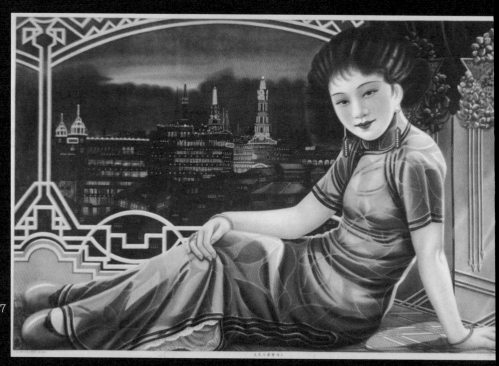

86 87

86. Ruan Lingyu, actress, Shanghai Liangyou Publication Co., 1934.
87. Yuan Xiutang, A Prosperous City That Never Sleeps, poster, 1930s, Shanghai History Museum.
88. Weimin, Nanjing Road, Shanghai, poster, 1930s, Shanghai History Museum.

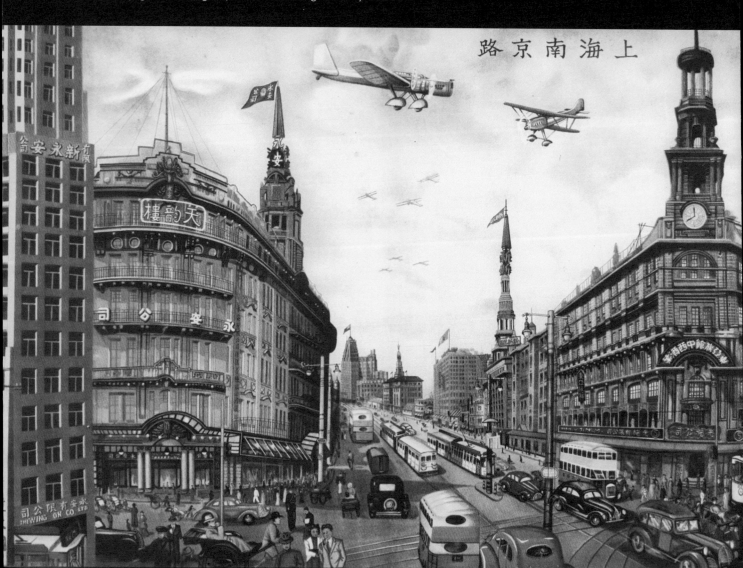

The contemporary cultural landscape of China, both within and beyond Shanghai's city limits, has been imbued in part with this 'social imagination' of the Shanghai of the 1920s and '30s, as Andreas Steen describes: 'a cult of romantic nostalgia which has accompanied the growth of modern Shanghai since the early 1990s'.(7)

Wong Kar-wai's film *In the Mood for Love* (2000) explores the intersection of Hong Kong and Shanghai – a love story taking place within Hong Kong's claustrophobic streets alongside the tight-knit Shanghainese immigrant community (inspired in part by Wong Kar-wai's own childhood experiences). The modernist notion of *modeng* – of thrusting, vertical movement and linear progression – is replaced in Wong Kar-wai's vision by a more uncertain set of values (of intensity, proximity and hybridity), replacing the fixed past with a post-modern historicism – a mood piece that reveals a Hong Kong modernity shaped by the social imagination of Shanghai – an aesthetic representation of claustrophobic desire.

The costumes that Maggie Cheung wears during *In the Mood for Love* epitomize the temporality of the film – a form of repeated 'presentness' that ritualizes the progress of time through the constant changing of her wardrobe. Popularly described as the most recognizable Asian face in the world, Maggie Cheung portrays an image as an international film star, fashion icon and advertisers' dream. For commentators and writers like Audrey Yue, *In the Mood for Love* forms part of a 'cinema of style', a recent commoditization of contemporary pan-Asian popular culture, linked to the nostalgic revival of Shanghai as a site of cultural and fashionable capital.(8)

This notion of the 'cult of romantic nostalgia' that surrounds present-day Shanghai has permeated beyond the cinema screen to the wider cultural and commercial economies. Luxury retail developments along the Bund (the riverside avenue of once-thriving Art Deco banks, trading houses and hotels) and in the new shopping district of Xintiandi blend Chinese developers, Hong Kong investment and a roster of international architects and interior designers to construct a vision of 'Shanghai modern' as a site of luxury, glamour and exotic excess.

However, these are not just modern consumer values repackaged and sold as historic. As Neville Mars of the Dynamic City Foundation points out:

Xintiandi was turned into a popular shopping district, (but) not because it revoked an historic idealized version of Shanghai. It became a trendy destination because in the first place it was a modern place ... It promises not a return to a happy past, but to an affluent future.(9)

Shanghai is a modern hybrid, and a range of fashion, furniture and interior designers who live, work or sell their designs in the city are playing with the iconography of an imagined Shanghai of the 1930s to create a modern hybrid design style – from international names such as Vivienne Tam, Han Feng and Shanghai Tang to local designer Lu Kun, they utilize elements of the 'Shanghai style' to create a modern, individualized and international design language of their own.

Shanghai style. In October 2000 the then-mayor of Shanghai, Xu Kuangdi, announced that one of the goals for the first decade of the twenty-first century was to build the city into the 'world's sixth fashion centre, alongside London, Paris, New York, Milan and Tokyo'.(10) While the domestic political climate shifts, and despite teething issues around the annual Shanghai Fashion Festival, the desire for the city to be a new centre in the global order (and for this to come at least in part from the development of an internationally known fashion industry) continues to persist. In 2005 Professor Chu Yunmao, Director of the City Image Institute at Donghua University, argued that 'Fashion is an impulse that leads the trends of the times, a banner of the cultural image of an international metropolis. In the world today, the vanguard of fashion is a city's symbol of dynamism.' (11)

The notion of fashion – and of fashionability – is used by Shanghai's leaders as a signifier of modernity and of global status, building on (or perhaps even despite) China's role as a dominant player in the international garment-manufacturing industries. In David Gilbert's thoughtful article 'From Paris to Shanghai: the changing geographies of fashion's world cities' he explores the notion of the 'fashion city' – characterized by new forms of commoditization in everyday life, but also by new possibilities for active experimentation and identity formation. Fashion capitals exist as sites of elite fashion consumption and, for Gilbert, as 'imagined spaces of fashion fantasy' mediated through high-end retailers and the fashion press. Shanghai's revived claim to be the 'Paris of the East' pervades trends and attitudes towards consumption, but also the design and branded content of the exclusive retail spaces that line the Bund. Shanghai wants to portray itself as an avatar of fashionable modernity to the growing numbers of international 'style tourists' – encouraging promotion of the city as a 'spectacle of commercial culture'.(12)

At the same time, the domestic luxury-goods market in China is tiny, but growing rapidly, expanding at approximately twice the country's GDP growth rate, with sales of luxury cosmetics and clothing growing at a rate of 20 per cent a year.(13) The consumption of luxury goods began to appear in China from the mid-1990s, as the domestic market shifted from one dominated by the requirements of producers to one oriented by the needs and desires of the customer. Today, in first- and

second-tier cities in China – from Shanghai and Hang-zhou to Beijing – the newly rich (the new stock-market and property millionaires, private entrepreneurs and the offspring of top officials) are flexing their consumer muscles. In October 2006, 12,000 visitors spent $63 million (£31.5 million) in four days at the luxury fair, Top Marques, in Shanghai – consuming the cream of the international luxury market, from Lamborghinis to South African diamonds.(14) And where the elite classes lead, the emergent and aspirational middle class follows.

According to a survey by Ernst & Young, China is expected to surpass the United States to become the world's second-largest consumer of luxury goods within a decade (closing on the front-runner Japan). And although luxury-goods companies in China still face two major problems – the proliferation of counterfeit goods and high import duties – a growing number of consumers want the real thing, with the potential for more than 250 million luxury-brand consumers by 2010.(15) For global brands such as Louis Vuitton and Chanel, brand-building in China is rapidly becoming part of their core business. Chanel has increased its presence from two cities in China in 2002 to 23 cities in 2005, with plans to retail in 40 Chinese cities by the end of 2008.(16)

Chinese readers are hungry to know more. The first edition of *Vogue China* sold out of its 300,000 print run within five days of its launch in August 2005, catapulting the China edition to second place in the world behind the circulation of its American counterpart. For its editor Angelica Cheung, *Vogue China* (along with other major fashion titles like *Elle*, *Marie Claire* and *Cosmopolitan*) offers an aspirational vision to readers – the sense that fashion can be a part of creating a better life: 'Our role is to create dreams. When a woman comes home at the end of a hard day, she wants to be able to dream, to forget her troubles. I hope that *Vogue* can make people feel that tomorrow can be better.'(17)

China's fashion industry is a recent and still-maturing phenomenon. Bao Mingxin and Lu Lijun trace in their essay (see pp.106–108) the shift in China from a state-controlled 'apparel industry' to a global notion of 'fashion design' from the 1980s onwards. Their research underlines the importance of Shanghai as an 'engine' driving these changes – the move from state enterprise to small privately owned fashion houses, and the shift from a predominantly export-oriented planned economy to a growing recognition of the potential value of China's domestic market. A generation of fashion designers living, working and selling in Shanghai are navigating these changes – balancing creative and commercial concerns, and discovering a new and individual design language that negotiates traditional cultural forms, remembrances of childhoods spent during the fall-out from the political fervour of the Cultural Revolution, and international stylistic influences – from Rei Kawakubo to Martin Margiela.

Wang Yiyang is perhaps the fashion designer best known outside mainland China at the current time, working from 1997 to 2001 as the chief designer for artist and entrepreneur Chen Yifei's lucrative Layefe fashion brand, helping Chen open 175 stores in China, Japan and South Korea.(18) In 2002 he established ZucZug, a sober, conceptual brand with retail stores in more than 20 major Chinese cities. In 2004 he launched a high-end diffusion label, Cha Gang, featuring soft-contoured, ready-to-wear garments and accessories that are more extreme in terms of form, material and scale.
Cha Gang collections feature softly draped unisex garments printed with oversized graphic letters alongside sequined amorphous toys, brightly coloured scarves and handcrafted leather versions of traditional Chinese peasant shoes.

Wang defines contemporary Chinese fashion as an 'unclear image'. His main influences lie in the past, but not in the collective imaginary of a glittering Shanghai of the 1920s and '30s. Instead, he wants to create a new Chinese style based on personal recollections – of 'strong personal convictions and personal sources of information'.(19) His sources of inspiration lie among the lives of ordinary Chinese in the 1970s when he was growing up. His collections, named simply 'Blue', 'Grey' or 'White', use the colours of clothing from the countryside, and the coarse cottons, padded fabrics and flat clothing patterns of traditional Chinese working garments.

For Wang Yiyang, the *cha gang* – the commonplace enamel container for tea – represents in a simplified form a metaphor for his memories of life in China during his childhood and provides a framework for defining his design practice. He explains:

At that time (the 1970s) everybody worked for the country so the work was not that hard and very slow. When the people were working, they read the newspaper and had a cup of tea … everybody had their cup of water or tea in a container made of different materials, some in glass, some in plastic, and with a diversity of shapes … This Cha Gang … is something that is very personal … I like this name very much, because it represents really what I want to do; the form can be free, the material can be changed and the inside can differ … but the relationship is always the same.(20)

For fellow Shanghai-based fashion designer Zhang Da, the need to find an original design voice that reflects his Chinese roots while also referencing international influences is a strong one. He derives part of his inspiration from the Chinese tradition of flat cutting without darts, producing simple, strong shapes in a muted palette of greys, blues and creams, displayed on the rails in his high-rise living room, and sold through Shang-

89. Yongfoo Elite, private members' club, Shanghai.
90. Portrait of Chen Yifei, 2002.
91. Wong Kar-wai, *In the Mood for Love*, feature film, 2000.

92

93

95

94

hai boutiques such as Younik. Since 2005 his collections 'flat', 'package' and 'arc' have included a range of more conceptual garments – skirts that drape around the body like soft boxes, or T-shirts and skirts based on circular patterns in soft jersey material.

Female fashion designer Ma Ke has perhaps most successfully balanced commercial popularity with the development of an experimental creative vision. Since 1996 she has been the creative director and lead designer for the successful fashion brand Exception de Mixmind, opening 53 stores across China and with ambitious plans to move into the international fashion arena, showing in Paris Fashion Week for the first time in 2007. Most importantly for Ma Ke, commercial success has given her the freedom to explore more collaborative and experimental models for working. She regularly works alongside graphic designers and film-makers, including Wang Xu, Stanley Wong and Jia Zhangke, to produce one-off collaborative projects, and has designed costumes for theatre and performance pieces, including experimental theatre work for performer Dadawa.

Most critically for Ma Ke, she sees the role of the fashion designer as part of 'society's conscience', retaining traditional skills and imparting Chinese 'cultural memories'. In her designs she reconceptualizes traditional materials, indigo dyes, cottons and embroideries, creating elaborate, deconstructed garments that use an international fashion language and yet retain some of these cultural memories, particularly the folk arts of the minority cultures in China's south-west.(21)

Shanghai home. While Shanghai's taste-makers and designers construct a desirable vision of modernity, the newly emerging urban middle class in China is hungry to begin consuming these dreams. Fuelled by rapid societal changes and the desire to acquire consumer goods and other more intangible markers of status, the country's 'white collars' are constructing and consuming a new China.

The new Chinese middle class is a relatively small but potent and growing force, currently constituting around 5–8 per cent of China's population of 1.3 billion. A survey from 2005 put those earning more than $5,000 (£2,500) per annum at 64 million in 2002, projected to rise to 155 million by 2010 – a level of income that would enable a Chinese consumer to buy a car and consider saving for an apartment.(22) The magazine *Beijing Review* described the newly emerging 'white-collar classes' in 2001:

They, whether men or women, are neatly attired in suits, carry Western name-brand bags, arrange their hair carefully and wear elegant perfume and top-notch shoes. Usually they arrive at their office no later than nine o'clock … this group of people usually has a good

educational background; they don't have time to watch or are not interested in soap operas; they prefer entertainment of a higher order, such as chatting with friends in a café while drinking black tea or watching non-dubbed foreign films … some are members of tennis, horse-riding or golf clubs; they are very concerned about their health, avoiding fattening foods, and they spend their holidays on long-distance trips.(23)

They are part of a 'new Chinese dream', evolving in some aspects from Deng Xiaoping's mantra 'to get rich is glorious'. Cities are being adapted to this vision – from upmarket shopping malls to raised overhead highways and gated communities. Shanghai is shaping itself to meet these desires: it has more coffee bars than any other city in China, more high-rise buildings and more supermarkets and department stores.

In part, Shanghai – and China in general – is reflecting broader changes that are taking place across the developed world and areas of the developing world. These include, as David Gilbert suggests, 'increasing consumer affluence, particularly among teenagers and young adults, changing intergenerational relationships, and new attitudes towards popular culture, leisure and the body'.(24) Across the globe, the notion of the citizen is being replaced by that of the consumer, producing new configurations of family, society and identity.

In China, these broad global shifts are colliding with state policy to produce major societal consequences – from large-scale migration to the cities to the One-Child family policy. The photographic series 'Great Family Aspirations' by artist Weng Peijun (Weng Fen) places society's dreams within this artificially created family unit, illustrating China's aspirations towards success: success at work, in health, in marriage and in education. The Chinese consumer is surrounded by intangible symbols of the 'successful life' – from celebrity-endorsed advertising (from Maggie Cheung to basketball star Yao Ming) to the rise in spending on beauty products and cosmetic surgery, and the growing popularity of international travel.

However, there are winners and losers in today's China. The media image of the 'successful man' has no room for the laid-off state factory worker or the urban migrant trying to find their place in this economic miracle. China is witnessing the greatest peacetime shift in population, as more than 100 million rural residents move to the cities to find work. In 2006 Shanghai's 'floating population' was estimated to be more than five million, and growing rapidly – an invisible army of low-paid factory workers, cleaners and massage-parlour workers.(25) Since 2004 the photographer Hu Yang has been documenting these changes in Shanghai society. His extraordinary photography series 'Shanghai Living' records more than 400 families in Shanghai – their homes, their dreams

and their experiences of living in the city – a comprehensive cross-section of life that includes the Shanghai elite, western expatriates, young middle-class couples, unemployed workers, wageless pensioners and urban migrants living far from home.

The private space of the home is a potent site for witnessing the tensions between society's constructed aspirations and everyday realities in China. Private housing in China is a recent and rapidly developing phenomenon. For cities like Shanghai the move from centralized allocation to a free market in property has taken fewer than 15 years – leading to an explosion in DIY, interior-design trends and consumer goods to fill these dream homes.

In her essay for this book (see pp.101–105), Yin Zhixian, editor of *Trends Home* – the most popular interior-design and style magazine in mainland China – explores how Chinese families are adopting and re-imagining a whole range of international interior-design trends to produce hybrid or 'mix-and-match' styles, from Italian classical reproductions to American oversized living-room suites. Yin Zhixian calls this 'both the confusing and attractive face of China' – new consumers who are willing to try out everything all at once – simultaneously absorbing influences from past and present, and from East and West.(26)

The symbols of success in the new China are both tangible and intangible. From the 1960s onwards the 'good life' has been measured, at least in part, through access to what has been termed within China the 'Four Great Things' – products that exist as objects of desire and markers of status. While a bicycle, a watch, a sewing machine and a radio were the key symbols of success in the 1960s and '70s (termed the 'three wheels and one sound'), by the end of the 1990s these had changed to incorporate a range of white goods and entertainment products, from the refrigerator to the video recorder. Contemporary China is no different; however, some of the new 'Four Great Things' – including the mobile telephone, cable television and the Internet – exist not only as potent symbols of affluence, but also as profoundly transformative tools within Chinese society, enabling powerful peer-to-peer communication, access to global and national information and to knowledge-sharing on a level unprecedented in China's history.

China has seen an influx of international brands, inexpensive copies, and ambitious local companies looking to make inroads within China's potentially vast domestic market. For China, cars and mobile phones may become the first global-design success stories. China has the largest mobile-phone market in the world, with more than 400 million users. China Mobile, the largest mobile network, gained more than five million new subscribers every month during 2005, and local companies (including TCL and Ningbo Bird) have muscled in on the leading international phone brands to win more than one-third of China's rapidly growing domestic market.(27) It is within these areas of electronic products, mobile telecommunications and computing that the importance of design and innovation is most acknowledged. For Chinese companies like Lenovo, creative design is integral to their core values and part of a strategy to become globally recognized brands, on a par with their American, Japanese and Korean competitors.

Shanghai lies at the heart of China's burgeoning car industry. The Chinese urban population is embracing car culture at a frantic rate, with more than five million private vehicles sold in 2005.(28) Despite the growing reality of gridlocked streets and polluted city centres, domestic manufacturers are continuing to feed China's insatiable desire for the car. And Chinese car manufacturers are ambitious, looking beyond China's borders to the global car market. The 2007 North American International Motor Show in Detroit, the highlight of the annual automobile calendar, saw a Chinese firm, Changfeng Motor, participate in the main exhibition halls for the first time, and other brands (including Geely and Chamco Auto) are not far behind in the race for international recognition.

Digital dreams. So what do these fundamental and fast-paced social, economic and cultural changes have in store for China's future? The '80s generation' – China's first fully consumer generation, born in the 1980s and the first products of the state-imposed One Child family policy – are trying to find out. Their search for their place and voice in this moment of change is helping to define urban China's cultural values. For writers like Li Wen, deputy editor of *City Pictorial*, China's youth are a generation of loud, independent-minded and creative people, who are ambitious and optimistic for the future.

For Helen, lead singer with Beijing band Ziyo, China's youth is looking globally for ideas: 'China is very raw and open to experimentation, (able to) stretch and grow like a big wet sponge.'(29) Young people in Shanghai and Beijing are embracing a pan-Asian youth culture reaching from Tokyo and Seoul to Bangkok and Manila – absorbing influences from Korean fashion, Manga cartoons, Tokyo's J-Pop bands, Asian soap operas and online gaming, alongside western influences – from Hollywood films to the global culture of celebrity. China's youth are re-imagining these within a local context – navigating sometimes intense family and academic expectations, the commercial pressures of an expanding market economy, and the desire to make connections and build a sense of community, associated with the sometimes lonely consequences of being an only child, the result of a state-imposed policy to control China's rapid population growth, first announced in 1979.

In music, in fashion and in design, a number of individuals are pioneering a DIY Chinese youth culture

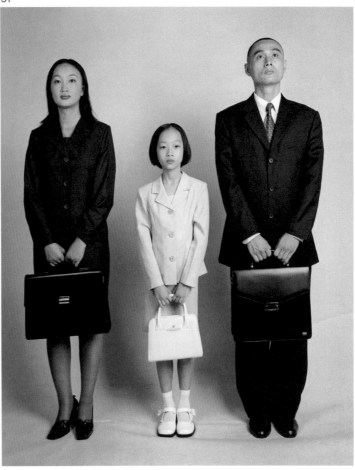

96. Weng Peijun (Weng Fen), Great Family Aspirations – Good Health, photography series, 2000.
97. Weng Peijun (Weng Fen), Great Family Aspirations – Good business, photography series, 2000.
98. *I, China* exhibition at da>SPACE, Shanghai, 2006.
99. Runyo, PK and HIMM, Nike Year of the Dog Air Force 1, shoes and shoe case, 2004.

with a collaborative and grass-roots sensibility.

In Shanghai, individuals like designer and curator Ji Ji and Hong Kong-born da>Space gallery founder Eddi Yip are helping to promote a generation of young artists and designers, including graphic designers Perk, fashion designer He Yan and urban graffiti artists and designers WZL and PEN Crew. In Beijing, loose collectives are forming around the animation, illustration and electronic music scenes, exemplified by the Green School website, which features work by cult illustrator Yan Cong and Lowfish animator Gu Fan. And in a climate of industrial-scale pirating and inexpensive recording technology, a culture of 'bedroom composers' and popular music downloads is thriving. The first major online hit, 'Mice Love Rice' by Chinese singer Yang Chengang, caused shock-waves throughout China's nascent music industry. At the height of its popularity, six million copies of the track were being downloaded every day, making this China's top hit song for 2004, subsequently covered by a number of mainstream pop artists.

At the same time Chinese 'street culture', absorbing influences from the global hip-hop and skater scene, is moving into the mainstream. As Li Wen points out in his essay 'Live and Loud' (see pp. 110–114), hip-hop singers like Jay Chou and international youth-culture events like the X Games have achieved widespread popularity in urban China, and global brands have been quick to jump onto the youth-culture bandwagon. Companies like Nike and Motorola are working closely with young Chinese designers to position their brands in the rapidly growing youth-consumer market, commissioning limited-edition products created by Chinese artists and designers and investing in creative events, such as the *Nike Free* exhibition in Beijing and Shanghai in 2005.

Television and advertising in China are not far behind. The year 2005 also saw the arrival of the *Supergirl* phenomenon in China. Launched by a television channel in Hunan province and inspired by the *Pop Idol* series of singing contests, *Supergirl* became the most-watched television programme in China, signalling the arrival of local television channels as serious competitors to the dominance of the national channel CCTV. *Supergirl* captured the imagination of its young fans, and enabled a level of mass interactive entertainment not previously seen on the Chinese mainland, with live broadcasts and a public vote by text messaging to find the winner, Li Yuchun.

At the same time, advertisers who have been taking a rather mass-culture, lowbrow approach to reaching China's vast population are beginning to court the growing urban youth-consumer market, using a range of marketing strategies familiar to agencies in the West. One of the most successful Chinese viral video clips of 2006 – a spoof of the pop group Backstreet Boys, by duo the 'Back Dormitory Boys' – has been adopted and transformed by mainstream advertisers to appeal to China's youth-consumer demographic, with humorous 'home-made' ad campaigns for products such as Mentos sweets.

But it is through the rapid adoption of the Internet in China that the most profound social and cultural shifts are taking place. China has come of 'Internet age', with more than 100 million active users – and this is set to continue growing at an enormous rate, with only around 10 per cent of the population currently online.(30) The Web does not present a wholly free space for users. The 'Great Firewall of China' and other state-controlled mechanisms place constraints on access to information and the ability for individuals to voice opinions freely.(31) However, bottom-up media such as the Web, email and text messaging have enabled people in China to self-organize and to create what the Dynamic City Foundation and others term a 'middle landscape', somewhere in between the official media channels and the private sphere.(32) This 'middle landscape' can be witnessed most clearly in the explosion of new forms of media culture in China over the past few years. The rapid growth in blogging, online forums, chat rooms and peer-to-peer networks has enabled new landscapes for discussion – suggesting the beginnings of a virtual civil society in China.

For young urban Chinese, these emergent interstitial spaces play an important role in both identity formation and nurturing a sense of community with their peers. In a market-research study from 2005, 63 per cent of young people interviewed in a number of first- and second-tier cities across China contributed regularly to their own blog.(33) Tudou.com, a Chinese version of video-sharing site YouTube, and popular Chinese webzines such as 'Coldtea', 'Pigstyle', 'Blow Up' and 'After 17', are aiding the dissemination of self-initiated creative content on an unprecedented scale – from video podcasts to home-grown music downloads.

While the Internet offers individuals the opportunity to express themselves creatively, the Chinese online and mobile gaming industries are leading the way in developing a successful virtual creative economy, grossing more than $900 million (£450 million) by 2006 and expected to grow to $2.1 billion (£1.05 billion) by the end of the decade.(34) More than 80 Chinese gaming companies, including market leaders Shanda Entertainment and Netease, are creating a vast range of multi-player online RPGs, tapping into the growing number of regular online gamers in China. Of the most successful Chinese games in the past few years, Fantasy Westward Journey attracted up to 1.3 million concurrent users, and Westward Journey Online II achieved more than 56 million registered accounts in 2005, a success story on a global scale.(35) As China's online and mobile ambitions continue to grow, will China's future dreams be digital ones?

HOME: A CHINESE MIDDLE-CLASS CONCEPT

YIN ZHIXIAN

Class is back in China. This began with the nation's farewell to the utopian idea of a classless society 30 years ago. While GDP has been going up at an astonishing annual rate of 8–10 per cent, and society's wealth has been increasing since the early 1980s, the distribution of wealth has been skewed; and class divisions are making a comeback. At the beginning of the twenty-first century the Chinese middle-class population represents about 15 per cent of society, against 5 per cent at the top and 80 per cent at the bottom.

Today the middle class is mainly an economic concept. An urban middle-class family has an annual income in the range of RMB 100,000–500,000 (£6,600–33,200). Middle-class status is also defined by the material aspects of life – the clothes they wear, the cars they drive, the holiday places they go to and, above all, the home they own. Home has become the status symbol of the urban middle-class.

During the 1980s most Chinese still lived in extended families (with three generations or more residing together, parents living alongside their sons and daughters and their spouses). This happened not only because housing conditions were poor and houses in short supply, but also because large households had historically been held in high esteem in Chinese society. The greater the span of generations under one roof, the more fortunate the family was considered to be. At that time, when the social norm was for several generations to live together, the resources of the whole family were used by all its members and were shared out in an equitable way. In those days a family, even with one member on a good income, found it impossible to improve its housing conditions. For these reasons the home was not an indicator of a person's income. When the extended family began to disappear and small households grew in numbers in the early 1990s, clear class differences began to emerge in housing conditions, even among members of the same family. For example, the parents might still live in a commune-style single-bedroom bungalow, while one of their children might have moved into a 70-square-metre flat priced at RMB 700,000 (£46,400).

The middle class in China consists of three categories of people. The first category comprises business people who were self-employed during the 1980s, when self-employment was first allowed and encouraged through the economic reform policy. In that decade such people lived mostly with their parents, and even with their brothers and sisters too. Until they became rich enough to own their own property, their house was not very different from that of people on much lower incomes. The main difference was that they preceded their neighbours in acquiring electrical appliances such as colour televisions and fridges, and could buy bigger and more expensive models. Their place of business might be just a small shop, or a rented room or flat in a residential area. Their work and home environments did not differ much, both being quite plain and non-ostentatious.

The second category of middle-class people – employees working in foreign-invested enterprises – lived in housing of a similar standard, but worked in smart hotels or office blocks during the 1980s. Their work environments were in clear contrast to their homes, something of which they were painfully aware. They went to and from their place of work in smart clothing, but their eye-catching outfits looked quite out of place in the narrow alleyways of multi-household compounds or the corridors of dormitory blocks where they lived, and against the oil-spattered walls of the shared kitchens, the filth of the communal toilets and the plainness of their living quarters. Such dissonance was one thing that made these people want to turn their lives round: they bought their own homes in an attempt to harmonize different aspects of their lives.

The third category comprised administrators of state-owned units, whose official ranks entitled them to perks such as newly built apartment blocks under the government's welfare-housing allocation system. Until the mid-1990s the right to such better-grade housing was one of the things that motivated many people to seek administrative posts in their units. These people were the first to fulfil the basic standards of the middle-class home. When private lettings became legal and the housing market completely opened up in 1998, such people were also the biggest beneficiaries and became the first people in China to sell their homes. This gave them a financial basis on which to accumulate property at great speed, and they became middle-class sooner than the first two categories.

After 1992, when the government first officially endorsed the notion of housing as a commodity, the Chinese property market expanded enormously. China's first wave of commercial house-building consisted mainly of *bieshu*, or large detached house developments, in suburbs for the rich and powerful. Later in the decade the middle classes began to buy real estate, infusing the market with a new vigour, and housing developments became more diversified.

Owning houses of their own, the middle classes make unremitting efforts to find an interior decorating style of their own. Families initially modelled their homes on ones they saw in Hong Kong and Taiwanese films in the early 1990s. Later in the decade they were influenced by the decor of new urban public spaces, such as karaoke bars and top restaurants, and later still in the twenty-first century by home-decor magazines and by looking at their friends' houses.

Take, for example, the materials they choose for the flooring or furniture in their homes: the chief material used is wood, although since 2000 glass, plastic, metal and stone have increasingly begun to make an appearance. Combinations of wood and glass, wood and metal, and plastic and metal have become common. There is even greater variety in soft furnishings: initially curtains were generally made of a single layer of fabric, whereas now curtains consisting of extravagant layers of several different fabrics are increasingly popular. And in the last five years bed linen has undergone similar changes. Bedspreads, sheets, quilt covers and pillowcases used to match, whereas nowadays each item will be in a contrasting design and fabric.

This shift in the materials used in interior decoration shows how middle-class families have become more adventurous, in terms of what they want their homes to look and feel like. Meanwhile changes in fashions for certain key spaces in the house – the living room, the kitchen and the bathroom – demonstrate an attempt to achieve a sense of self and social status through the design of their homes.

Since they are the first generation in their families (at least since 1949) to become wealthy, the house they buy will be their family's most important piece of private property. This makes the living room a symbol of great importance. It gives them social recognition, and this is followed by a sense of self. Through their home they declare, 'I am rich'– and visitors to the house can see just how rich its owner is by looking at the price ranges of the hi-fi and television, and at the quality of the sofas and coffee tables, curtains and carpets in the living room.

The second thing they say through their living room is, 'I've got taste!' In the wealth stakes, China's middle class still lags far behind the very wealthy in China. Buying property is a time-honoured Chinese tradition, which was only disrupted after 1949. Now the new wealthy will never get bored of redecorating each new home they buy, and always go for the newest, top-of-the-range materials, furniture and ornaments that no one else yet possesses. To be able to update their home regularly and with great frequency requires a rock-solid financial base: China's newly emergent middle class, which has absolutely no inherited wealth, cannot compete. However, the middle class is more sensitive to changing fashions and styles.

The influence of changing fashions on middle-class living rooms in China is most completely expressed in three areas: electrical appliances, sofas and flooring. Added to this, the twenty-first century has seen three new areas of fashion expression: lighting, curtains and wall decorations. The fact that these three new areas have become fashionable makes visible the profound change that has come about in contemporary household spending among the middle class, as they shift from simply shaping the superficial and material appearance of their homes to transforming the way their living spaces express aspects of the home-owner's sense of identity – becoming a site of emotional feeling and cultural expressiveness. This process has only just begun, but it *has* begun.

In many middle-class homes in China the kitchen does not seem to exist for its real function, because many members of the middle class do not cook or eat at home. However, the kitchen is the clearest indication of the changes that have taken place to the middle-class lifestyle.

When middle-class families buy their first houses, they prefer the kitchen to have doors and walls that separate it from the other rooms in the home. Yet a few years later, when such people buy their second house, they will happily accept the recent trend for an open-plan kitchen. The concept of an open-plan kitchen has huge significance in the lives of middle-class families in China. Firstly, it is perceived as a classic symbol of the 'western lifestyle'. Secondly, it is an important communal area for the family to meet in. And thirdly, it is a place for socializing – visitors to homes with open-plan kitchens feel very involved in family life. And that is exactly the style of social gathering that modern families are looking for.

Many middle-class families apparently ignore the problem of fumes from stir-frying spreading out of the open-plan kitchen. An extractor fan goes some way to resolving the problem, but it is a greater priority for them to be able to enjoy more communal patterns of cooking, eating and drinking. Besides, these families do not use their kitchens to cook large dinners on a daily basis, so cooking fumes are not a real problem. Where people choose to have separate kitchens, it is because they do not want cooking to interfere with the multiple functions of other living spaces, such as socializing and entertainment.

Kitchen fixtures, fittings and appliances are central to the creation of the modern look of a middle-class kitchen. And the Chinese middle class has made a huge investment in achieving a standard of living comparable to that enjoyed in developed countries. Families whose annual income is under RMB 100,000 (£6,600) can rarely afford to choose brand-name kitchen fittings, whereas those with an income of RMB 150,000 (£9,900) or more will generally go for Chinese-branded products. With an income of more than RMB 200,000 (£13,200), those families are beginning to choose branded products made by joint-venture companies, and for those with an annual salary over RMB 500,000 (£33,200) foreign branded products are the preferred choice.

100. Living Room, *Trends Home* magazine, 2003.
101. Bathroom, *Trends Home* magazine, 2004.
102. Open Plan Kitchen, *Trends Home* magazine, 2002.

The bathroom is the room that middle-class families take most pleasure in decorating. Why is that? Firstly, they are being led by fashion. Even the smallest bathrooms are done up with great care, with the middle class influenced by the tastefully decorated bathrooms created by foreign designers that they have seen on television, in films or in magazines. It is commonly accepted nowadays among the more fashion-conscious in China that changing your bathroom represents one significant way of changing your quality of life.

Secondly, the bathroom is seen as a space for enjoyment. Does the water flow gently from the tap or does it come out with force? How many water-massage settings does the shower have? How long will the bath keep the water hot? The attention paid by middle-class people to all these details reflects the ceaseless setting of new and higher standards in the quality of their personal lives. Each new upgrade or refinement is proof that they are becoming ever more cultured. This could be summed up by the middle class as: the more you demand from life, the more it shows you know about life.

Then again, self-fulfilment comes into it. Until recently the chief material used for bathroom walls and floors has been ceramic tiles, for the main reason that they are waterproof and easy to clean. Individual differences in middle-class bathrooms have usually been in the choice of the patterns and colours of these tiles, rather than in the choice of material. The vast majority of families will go for unity of colour and design in their bathroom wall tiles, with only a very few prepared to break this rule. However, recently a much greater variety of flooring has become available, with imitation traditional grey bricks and stone flooring slabs becoming very popular in the last couple of years. New materials, such as water-resistant bamboo floorboards, have also made an appearance in some middle-class homes, although they are still, of course, a rarity.

Chinese society as a whole is still ill defined, and the middle class in China is still in the early stages of its formation. The eclectic medley of influences, aspirations, styles and tastes in Chinese urban middle-class homes reflects their owners' conflicting values. Nevertheless, although middle-class households demonstrate the influence of 'getting rich is glorious' – a dominant value in Chinese society today – the eclectic style of their interior decoration points to possible alternatives. The Chinese middle class can aim to build alternative values, in which they take a more balanced attitude towards wealth, job opportunity and personal development. 'Middle' can mean balanced rather than less wealthy.

A BRIEF HISTORY OF CHINESE FASHION DESIGN

BAO MINGXIN & LU LUUN

The notion of fashion design in China can be traced back to the period of the Republic (1911–49), during which time the fashion industry in China – particularly in the so-called 'Paris of the Orient', Shanghai – played a key role in promoting a modern and urban lifestyle in the Far East. The establishment of the People's Republic of China in 1949 dramatically altered China's social conditions, and everything that related to fashion almost withered away; *Liening zhuang* or Lenin suits, *Zhongshan zhuang* or Sun Yat-sen suits (better known as Mao suits) and military uniforms became daily wear. In 1956 the 'Beautify Life Movement' briefly reawakened a deep desire for fashion and for the revival of *qipao* (also known as *cheung-sam*), the one-piece dress with significant Chinese design elements that was popular during the Republic. But the notion of 'fashionable dress' was once again suppressed during the Cultural Revolution (1966–76) when military badges and sleeve emblems became typical 'fashion' items.

Following the period of 'Reform and Opening Up' from 1978, people began to have more freedom in what they could wear, a wider choice in clothing and a growing demand for fashionable dress. Overseas products started to enter the domestic market. Hong Kong, the hub of fashion at that time, extended its stylistic influence first to the southern part of China from Shenzhen to Guangzhou, and then to the whole of China.

During the 1990s the fashion industry in China grew dramatically. Large state-owned enterprises with less 'fashionable' products began to decline, while the private trend-driven market developed rapidly. Private enterprises such as Sunshine and Sanmao started to extend their business into the fashion industry, while large apparel corporations such as Younger began to run their own textile businesses.

From the start of the twenty-first century, Shanghai – with its commercial and international characteristics – took its place as China's fashion capital, overtaking Shenzhen (the fashion centre of China during the 1980s) and Beijing (the heart of China's fashion industry in the 1990s). Both talented Chinese designers and international names were attracted to Shanghai. Fashion enterprises all over the country vied to be first to establish business centres with design, retailing, merchandising and marketing departments in Shanghai. The influential Chinese Fashion Design Association also moved its office there. At the same time international fashion companies began to develop a range of activities, from establishing design centres to brand-promotion activities, including exhibitions and collection launches, to expand their influence into China.

The early generations of fashion designers after the establishment of the People's Republic of China worked in three ways. The first comprised a group of designers who worked mainly with silks, taking inspiration from traditional motifs. The second group of designers worked chiefly in the apparel industry, focusing on design, choice of material, pattern making, and so on; they had a lowly status within these state-owned enterprises and were few in number. The final group worked within fashion retailing as dressmakers, creating garments according to their clients' requirements, but also integrating their own suggestions concerning style, colour and material. The majority of these designers had no training or formal educational background; instead they were chosen to be designers because of their skills and their sound performance. This group could be regarded as the very first fashion designers in China, even if they did not bear that title at the time.

The end of the 1970s could be described as the starting point for the development of a Chinese fashion-design education system. This new educational system began to support talented individuals and did much to help the progress of fashion design in China. In 1977 the Central Academy of Arts and Crafts (now Tsinghua Academy of Fine Arts) in Beijing and the Suzhou Institute of Silk Textile Technology started to accept students in textile and fashion design. Incorporating fashion-design courses subsequently became a widespread phenomenon for art schools in China in the 1980s.

In the 1980s, talented students with a college background took part in a number of national design competitions held mainly in Beijing, winning awards and acclaim for their striking designs. These competitions were the springboard for designers to become known nationally, gaining high reputations. Together with other state-organized fashion festivals and events, they provided a stage for the designers to show their talents and enhance their influence on the fashion scene, bringing them fame and arousing the attention of the Chinese news media.

It was at end of the 1980s that the economic reform process enabled the first true generation of Chinese fashion designers to become established. Chinese designers gained the chance to study abroad, acquiring new skills. Among this first generation of Chinese designers the most successful were Liu Yang, Mark Cheung, Wu Haiyan and Wang Xinyuan. Each achieved top status by winning the Jing Ding Award, the highest accolade for fashion designers in China. They produced extravagant 'haute-couture' catwalk shows, but were less successful commercially.

During the 1990s college-educated designers played a leading role in the establishment of a fashion industry in China. The launch of a Chinese Designers' Association in the mid-1990s bridged the divide between individual designers and commercial enterprises. The first generation of designers started to share their fame and reputation with more commercially led fashion brands. The latter part of the 1990s saw a rapid growth in a range of areas of the fashion industry – not only design, but also merchandising, promotion and fashion management. At this time a second generation of Chinese designers, mainly in Shanghai, was also beginning to emerge, chiefly by showing their work in design competitions while still at university, before establishing small-scale studios after graduation.

At the turn of the twenty-first century the first generation of Chinese designers faded off the stage as a group, except for those who managed to transfer their design skills to other areas – Wu Haiyan, for instance, established her Why Design corporation to move into home decorating, and achieved great commercial success. The second generation, on the other hand, played an increasingly important role in the making of a Chinese fashion industry. Unlike the first-generation designers, they embraced commercial opportunities in the domestic market while developing their own creative visions.

The best designers of the second generation are those who can successfully balance artistic and commercial pressures, meeting popular demand as well as showing individual creative expression. Wang Yiyang's Cha Gang collections are targeted at a niche market, instead of appealing to the Chinese mainstream. With bespoke designs and small volume, the designer is able to treat fashion design as a kind of art and enjoys the process of designing. Ma Ke initially gained fame by winning the first award in the Brother Cup, a national competition for young designers. She established her own brand, Exception, in the late 1990s with the help of external financial backers. Compared with Cha Gang, Exception takes a different business model. It is aimed at fashion-conscious middle-class consumers, and therefore at a wider segment of the market, with a greater volume of garments.

Today, fashion design is flourishing in China. The textile industry is continuing to expand. International interest in Chinese design is growing. Individual Chinese designers no longer have to rely on the official media, professional associations, the government or particular events. They are independent and have the chance to find their own way in the fashion market, whether national or international.

103. Liu Yang, collection for Stemar, 2002.
104. Wang Xinyuan, *Inspirations of Homeland*, fashion show, 2002.
105. Wu Haiyan, *Land of Silk*, fashion show, 2001.
106. Ma Ke, *Exception de Mixmind*, fashion show, 2004.

LIVE & LOUD: A TOUR OF 21ST-CENTURY URBAN YOUTH CULTURE

WEN

'A westerner would have to live 400 years to experience two such monumentally different times, but a Chinese person could live through them in just 40 years.' So wrote the famous Chinese novelist Yu Hua in 2005 in the epilogue to his first novel in ten years, *Brothers*. This was to become 2005's bestselling novel, and by 2006 its two volumes had sold more than a million copies. The 40 years referred to were those from the start of the Cultural Revolution in 1966 until after Deng Xiaoping's economic reforms, and the novel told the stories of Chinese people in these two completely different periods.

In the same year as Yu Hua's publishing success, Chinese televison saw the birth of another such phenomenon. Hunan Satellite TV's *Supergirl* contest, originally modelled on *Pop Idol*, became 2005's most-watched show nationally, challenging the dominance of the national station CCTV. The winner of the 2005 singing contest, Li Yuchun, is the Chinese mainland's first star to be elected, in a real sense, by the general public. In the finals, more than 3,520,000 people all over China cast their votes for her, making her the overall winner.

Li Yuchun looks like a bit of a tomboy, and five years ago it would have been almost unimaginable for such a 'rebel' to carry off the prize. Then there was the scale of the public's votes, the live broadcast of the contest rounds, even the belief of some excited critics that this was a rehearsal for democracy – even though it was simply an entertainment programme.

And yet *Supergirl* was not just an entertainment programme; it rewrote the rules of Chinese pop culture. In spite of rumours that the government was trying to manipulate the results, the winner was an androgynous rebel of a girl, who even made it onto the front cover of *Time* magazine (Asia edition). Huge fan clubs made up of young people born mostly in the 1980s showed their muscle for the first time, and wrested the right to speak from the generation of the 1960s and '70s. Their fanatical support for their idol, the highly effective way in which they organized themselves to vote, the rich profits that the large-scale texting of votes brought mobile-phone operators – all this made mainstream society, which had hitherto ignored them, sit up and take note.

These are just two typical examples of modern Chinese urban culture, which has developed in the wake of rapid widespread urbanization brought about by China's twenty-first-century economic expansion. A number of factors have brought this new and colourful (if uneven) culture into being:

the pursuit of wealth, the influence of the West, the growth of individualism, and new forms of communication and organization promoted by the Internet. I want to draw attention to some of those who have pioneered and promoted youth culture against this changing landscape. Amid the hurly-burly of the contemporary Chinese urban scene, they stand out for their joyful originality and can help us trace the course of its development.

Han Han: rebel writer. If we want to trace the rise of urban Chinese youth culture, apart from the *Supergirl* prize-winner Li Yuchun, there is someone we cannot ignore: a handsome, slender young man called Han Han, who, despite being a bestselling author, claims to spend more time practising his race-driving skills. Han Han is a representative of the new generation of urban youth and has succeeded in overthrowing many of the old conventions of traditional Chinese society. He first made a name for himself by winning a national essay competition and then declared, 'The Chinese educational system is like having a bath with a padded jacket on … Two years of middle-school maths is quite enough for anyone!' He turned down an offer from a prestigious university, choosing instead to leave school and become a racing driver – and every book he has written since then has been a bestseller. Finally, in August 2005, he won the China National 1600cc Grand Prix. In 2006 he used his blog to attack the 'charmed circle' of the world of Chinese fiction, with its old-fogeyish restrictions. His maxims are: 'No seminars, no cultural exchanges, no writing workshops, no signings, no lectures, no ribbon cutting, no appearances at fashion shows, award ceremonies or public readings, only a few interviews, no commissions or plays, no TV roles or writing forewords for other people's books.'

This extreme lack of cooperation has, however, done no harm to his continuing popularity among readers. In 2007 he earned nearly RMB 3 million (£200,000) in advance royalties on his book *Glorious Day*. Han Han's success symbolizes the disappearance of China's 'obedient generation' and its belief that the principle of cooperation is the highest universal value. Individualism is now in the ascendant, represented by writers like Han Han who were born largely in the 1980s and are known as the '80s generation' (although he himself would not necessarily want to be included in this group). Their writing mainly describes personal and youthful angst and indignation, or abandons reality altogether and enters a fantasy world. The majority of their readers are of school age, and make up a huge and loyal fan club. Han Han's blog has one of the highest hit-rates in China. Lying

behind the huge popularity of writers like him is the noisy, combative, consumer-led urban culture that seems to represent China's 'single-child' generation. We can expect, given time, to see these young urbanites construct new cultural values all of their own. In 2006 *City Pictorial*, an urban lifestyle magazine, produced a special edition called 'Super 80s', which showcased the fastest-rising stars of this 1980s generation – and saw its sales rocket to an all-time high as a result.

'Mice Love Rice': China's web-music craze. Before 2004 and the start of television contests like *Supergirl*, singers had to be 'packaged' by record companies if they wanted to release a song. In November of that year all this was overturned by a composer called Yang Chengang, who wrote the song 'Mice Love Rice' and then made it available on the Internet for free download. At the height of its popularity the track was receiving six million downloads a day, making this China's top hit song. In 2006 film director Jia Zhangke used the song, sung by a child, throughout his film *Still Life*, as a portrayal of life in China. Record companies began to take a chance with online music, although only a minority were successful and what the music market ended up with was mostly inferior. 'Mice Love Rice' did, however, inspire many singers to abandon record companies and publish their own music on the Internet. In 2006 the respected music critic Gong Hui provided independent musicians with a web portal for their work by setting up diymusic.com in Guangzhou. In his 'Independent Music Manifesto', published on the site, he wrote, 'We will never shake off the traditional record industry's control and achieve real freedom for independent music unless we can wean ourselves off our beloved CDs.'

Nevertheless, by comparison with music like 'Mice Love Rice' – so popular that critics have panned it as 'vulgar' – the independent music of diymusic.com is elitist, appealing just to a small minority of listeners. Only time will tell whether it will succeed in opening up new markets, although it has at least given new impetus to a culturally arid Chinese pop-music industry. As music recording technology becomes cheaper and more widely available, it has given birth to large numbers of 'bedroom composers', such as Beijing's Sulumi (Sun Dawei), who used a Nintendo Game Boy to generate an e-music album called *Stereo Chocolate*.

Web culture: voice of the young. In 2003 a young man calling himself Alex So (Su Hanguang) set up a webzine called 'Coldtea' (www.coldtea.cn),

now China's most famous webzine. Alex started by working in traditional magazine publishing, but, being keen on extreme sports and street culture, and frustrated at the lack of mainstream media coverage of his passions, set up his web publication with a friend, DR. 'Coldtea' was full of pictures illustrating the lives of young people in the cities. Alex is quoted as saying, 'I hope that soon this independent spirit of originality will become part of mainstream culture.' In fact, it took just until 'Coldtea's' third anniversary for it to become the opinion leader of city youth. The peak download rate was 500,000 visits a week, and those half-million people clearly found in this weekly webzine a sense of identity that they could not find in real life. More webzines started appearing, and independent publishing is now a reality on the Internet, making it easy for young people who have something to say to be heard.

Thomas L. Friedman, author of the bestseller *The World is Flat*, talks in his book about 'Tudou' (Chinese for 'potato') (www.tudou.com), a video website similar to YouTube. Friedman made a video for 'Tudou' when he came to China to promote the Chinese translation of his book in 2006, and said: 'A year ago, there were only 200 videos on "Tudou", now there are an astonishing 6,000 and I am delighted to be one of them.' An increasing number of young urbanites admit that they spend more time on the Web than on any other media; more and more Internet content is targeted at this huge number of young people; and the annual income of the new-wave web portals now exceeds RMB 900 million (£60 million). A hitherto unknown web video-maker, Hu Ge, made a short online digital film parodying the famous director Chen Kaige's *The Promise* – and without any effort found himself almost as famous as the director himself. In the twenty-first century young Chinese urban innovators, dissatisfied with mainstream culture, have readily adopted a range of web-based media to open up an alternative opinion space that belongs to them. At the same time the widespread use of peer-to-peer technology has meant that young Chinese are almost keeping pace with their American counterparts in their consumption of entertainment. The American TV drama series *Prison Break* had scarcely finished being broadcast in New York when it became available as a free online download in Beijing and Shanghai, already subtitled in Chinese. From this point of view, the world really is flat.

The urban subculture. Every day in our rapidly changing cities brings the possibility of another astonishing change, and the explosion of another new star on the entertainment scene. Although the

107 108

sulumi stereo chocolate

Stereo Chocolate

110

111

112

上海大众
SHANGHAI VOLK

director Jia Zhangke has said that rebel youth culture has lagged behind in the last 10 years, it is clear that these new cultural icons and new forms of expression are closely linked to, and nurtured by, the Internet. This essentially urban youth subculture is experiencing rapid and explosive growth.

When we say 'subculture', we mean that special form of culture created and enjoyed by those on the margins of mainstream culture and society, in unofficial centres in our cities. Generally speaking, a subculture is distinguished from the rest of society by an awareness that its participants' clothes, music and other interests are different from the norm. The majority passively accept commercially provided styles and meanings, while a subculture actively seeks a minority style. In China's urban pop culture, the subculture and mainstream culture are mutually interdependent. In 2000 the X Games, an early arrival in China, and a '4130' BMX street culture collective were launched in Guangzhou, but had very few supporters; yet by 2007 Chinese hip-hop singer Jay Chou had achieved widespread popularity, and in the same year the X Games Asian Championships took place in Shanghai for the first time.

The new urban subculture of China is in revolt against mainstream culture, but unlike the western concept of subcultures, it is not defined by an anti-establishment or anti-consumerist stance. These young people are the first generation with a materially advanced standard of living in China, and they grew up in a consumer society. What they care about is ensuring that as individuals they can achieve a better quality of life; this is a precondition for their enjoyment of their subculture. Respected cultural commentator, curator and film-maker Ou Ning said in an interview with me, 'They don't have leaders or stars, but this is a good thing. It means that nowadays everyone can do things, and do them with very little money. The so-called elite culture of the past has collapsed, and this has brought real social progress.'

Chinese urban subculture is constantly on the point of exploding, producing countless variations in the process. There has been a fusion of elements from the pop cultures of East and West, and it is a constant process of trial and error. Over the next 10 or 20 years China's energetic innovators will succeed in bringing into being an urban culture that is truly unique to China.

DREAM CITY

SHANGHAI LIVING

HU YANG

'I am still attached to the happiness of playing in *nongtang* and the fellowship of neighbours found in my childhood, but such happiness has become a luxury today.'

'With my camera I knocked on the doors of many Shanghai families' houses. The *Shanghai Living* series was carried out from January 2004 to February 2005. In that period I photographed more than 500 households, including those who have migrated from different parts of China and the world, as well as native Shanghainese families. Among them were millionaires, middle- class members, and simply the poor.' Hu Yang

Images on the following pages:
113–122. Hu Yang, Another Side of Shanghai, photography series, 1980–2007.
123–126. Hu Yang, Shanghai Living, photography series, 2004–2005.

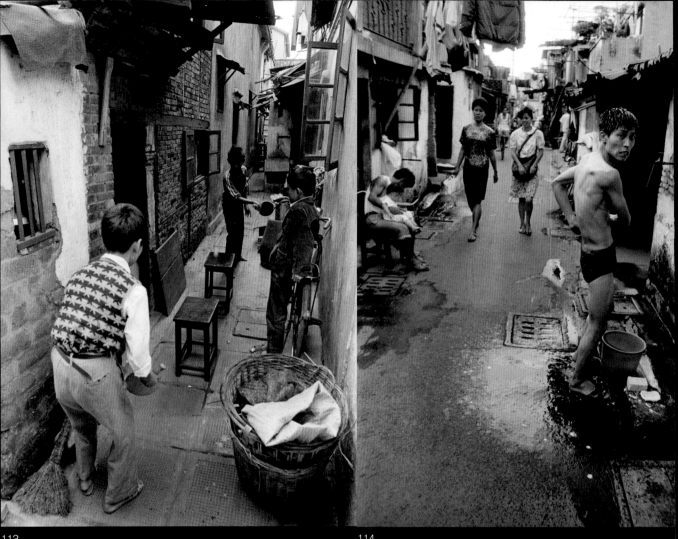

113

114

113. Playing pingpong, Putuo District, Shanghai, 1986.
114. Washing, Putuo District, Shanghai, 1982.
115. Doing homework, Putuo District, Shanghai, 1994.
116. Dogs, Putuo District, Shanghai, 2004.
117. Watching television, Putuo District, Shanghai, 1985.
118. Washing bicycle, Putuo District, Shanghai, 1990.

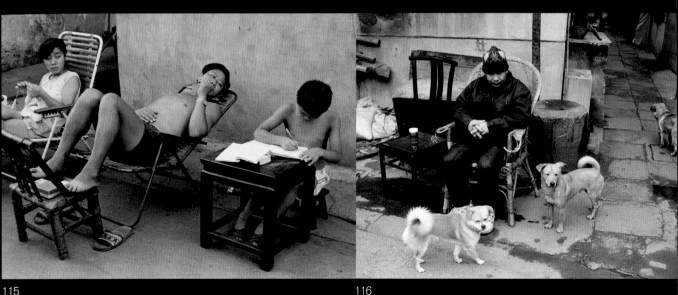

115

116

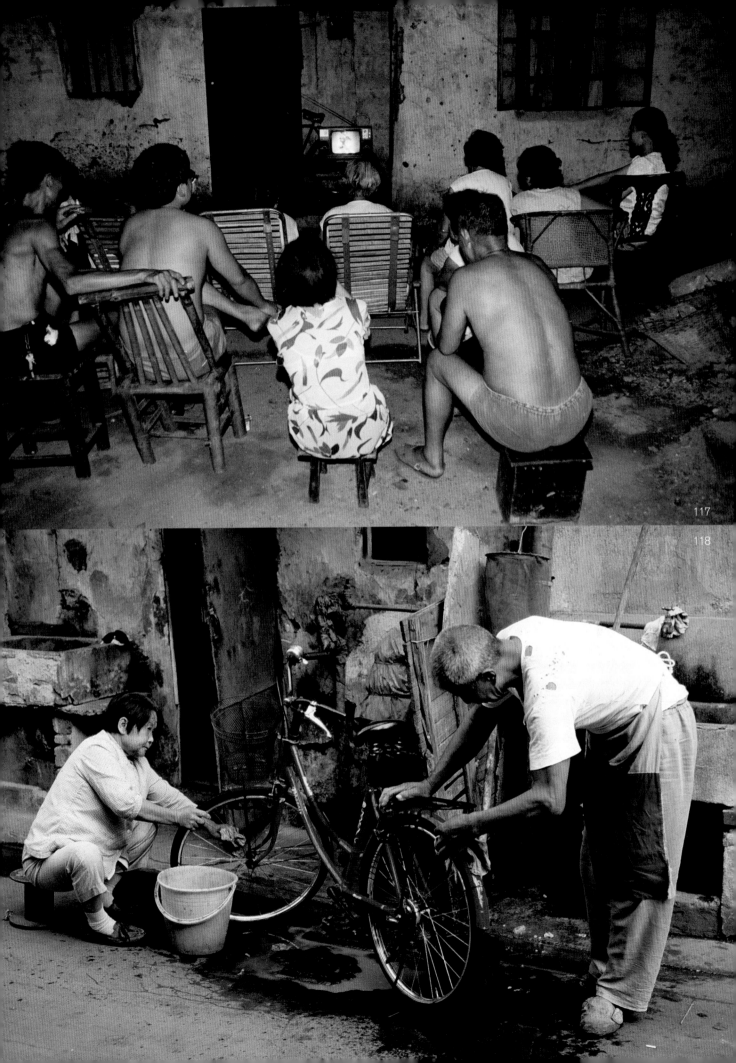

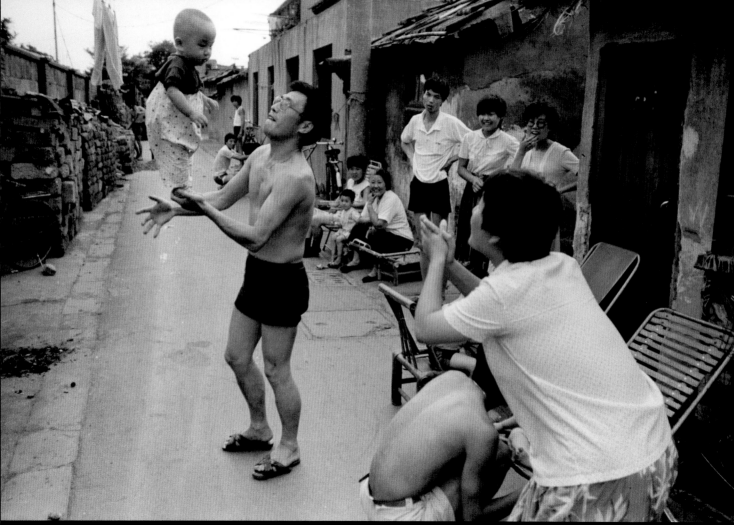

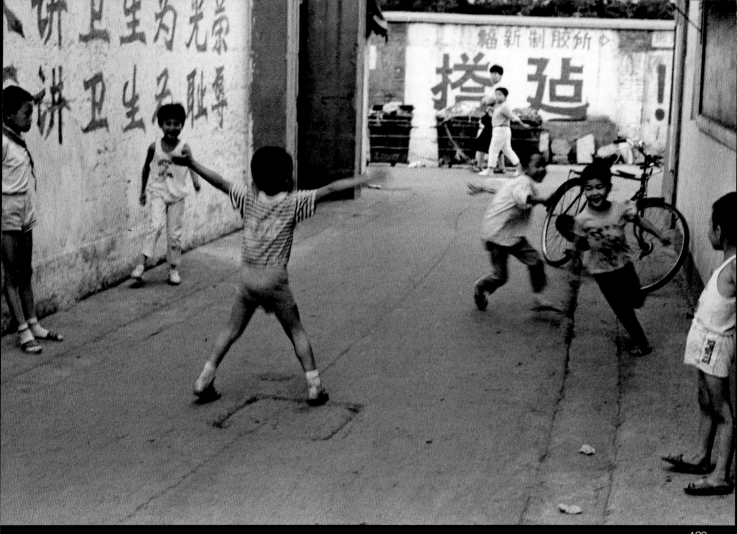

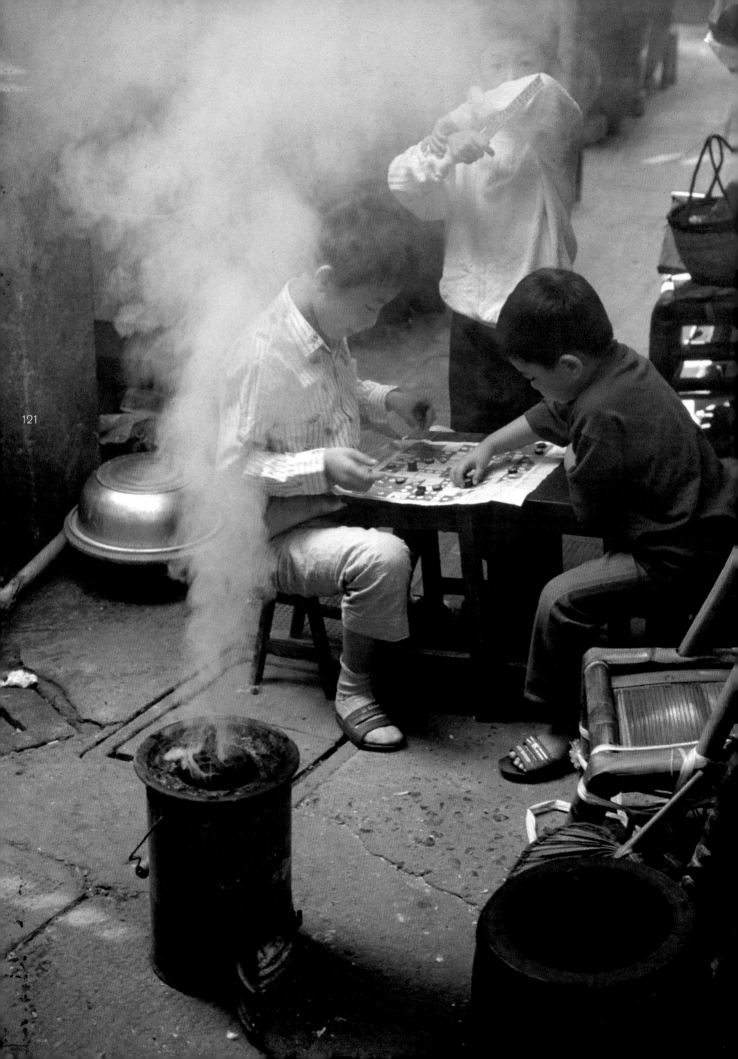

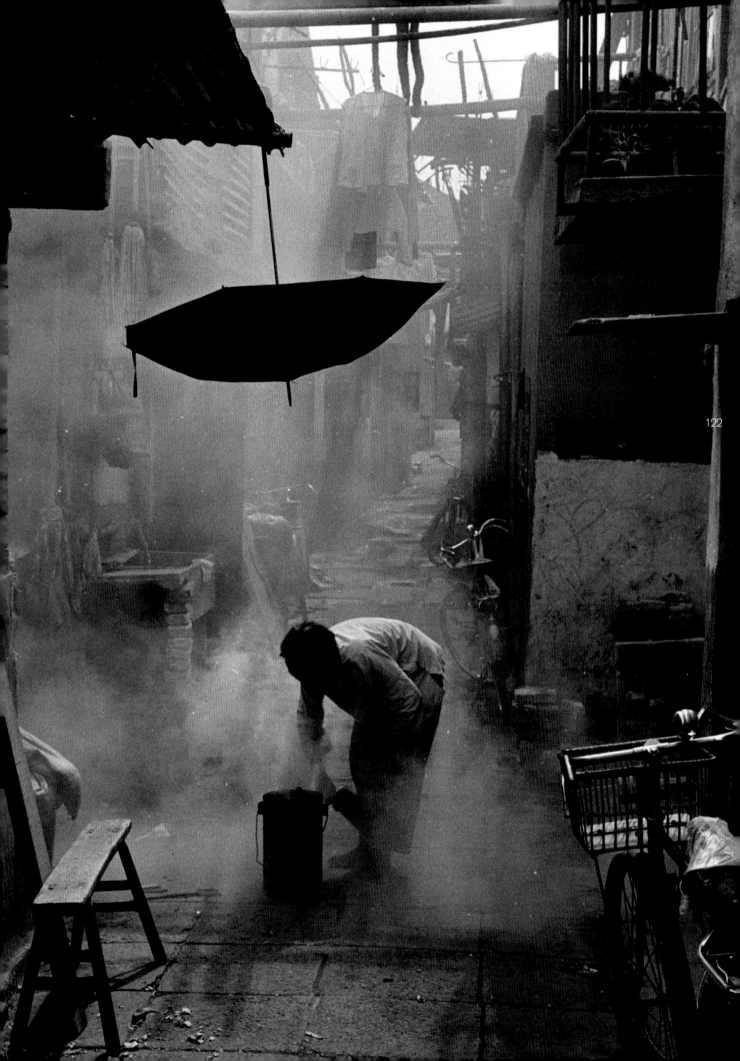

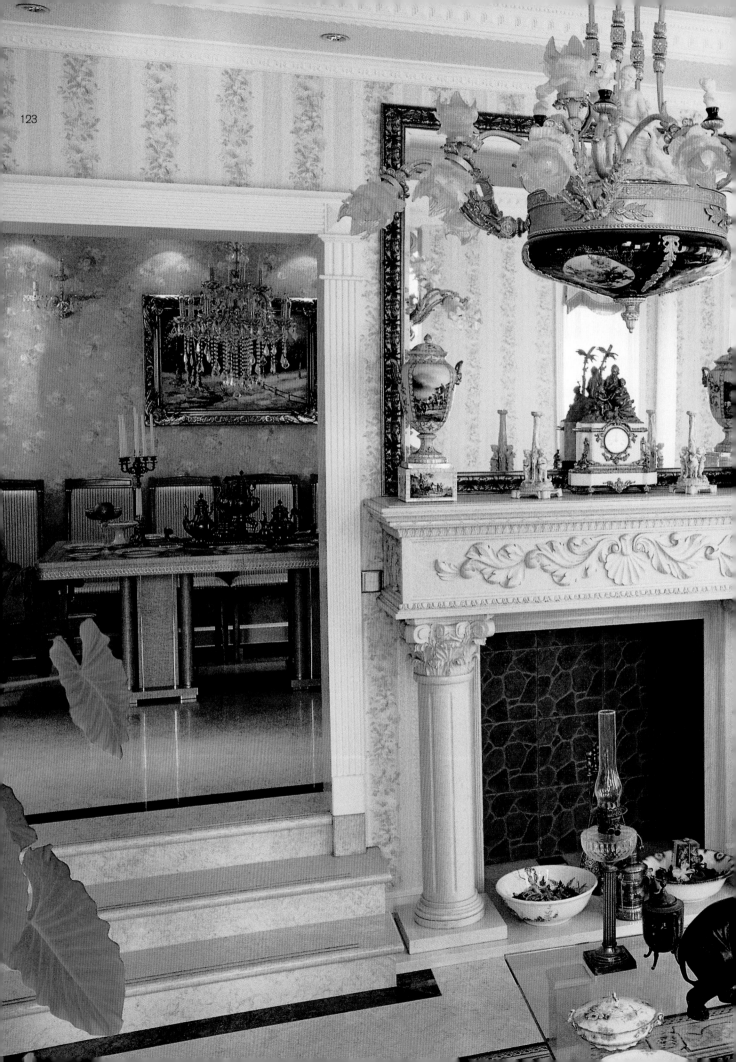

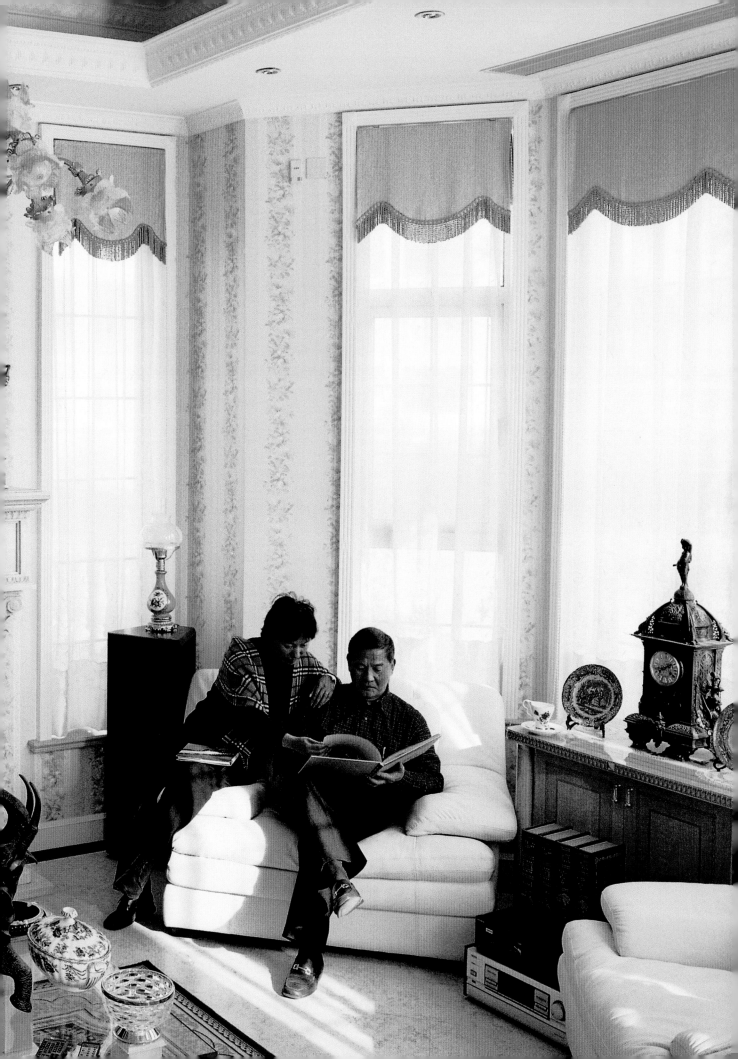

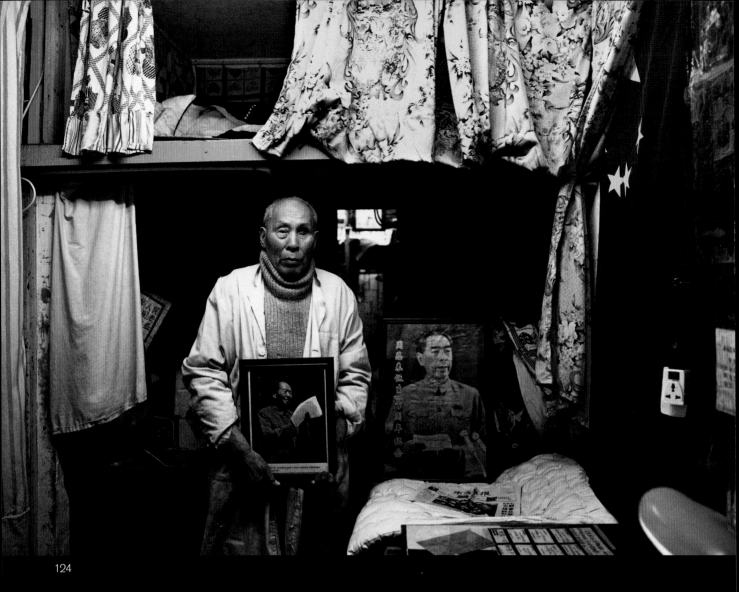

124

123. Tang Zhenan (general manager), Putuo district, Shanghai, 2004: 'Up to now, I'm satisfied with my life, and I like photographing and collecting western artware in my leisure time. I want to do something to promote Shanghai's photographing industry.'

124. Sun Bingchang (retired worker), Putuo district, Shanghai, 2005: 'I didn't have anything to do after my retirement, and therefore I started this home hotel business to provide a place to stay for those people who come from other provinces and don't have much money. I help the children in depressed areas with the money I earn. I miss the national leaders of the previous generation.'

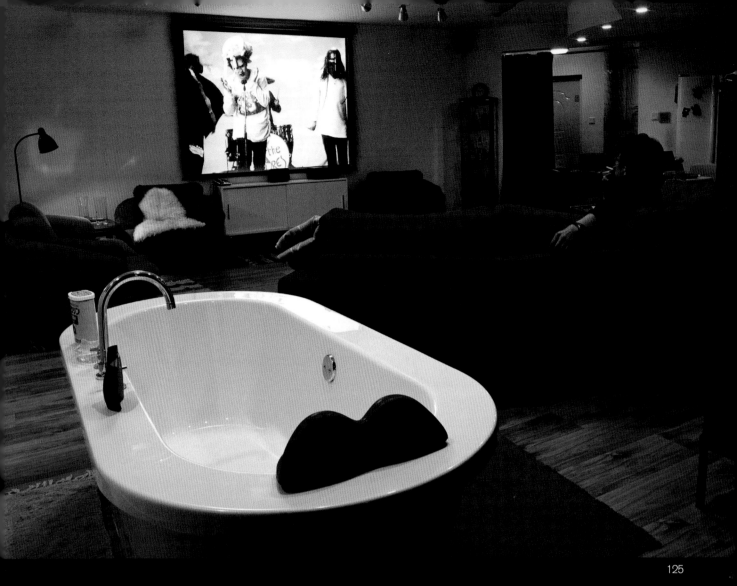

125. Li You (corporate employee), Putuo district, Shanghai, 2004: 'I work in a foreign company and have a lot of pressure. The only thing I want to do after work is to have a bath for two hours and then watch a DVD. I'm an amateur writer on the Internet.'

Following pages:
126. Hu Zhihong (unemployed), Putuo district, Shanghai, 2004: 'I didn't have anything to do when I was laid off and then I took up dancing. I take a nap every day. We live on my husband's salary and are financially depressed. We didn't want to spend money on wallpaper and we decorated the wall with posters. We hope our boy will have a bright future and earn a lot of money.'

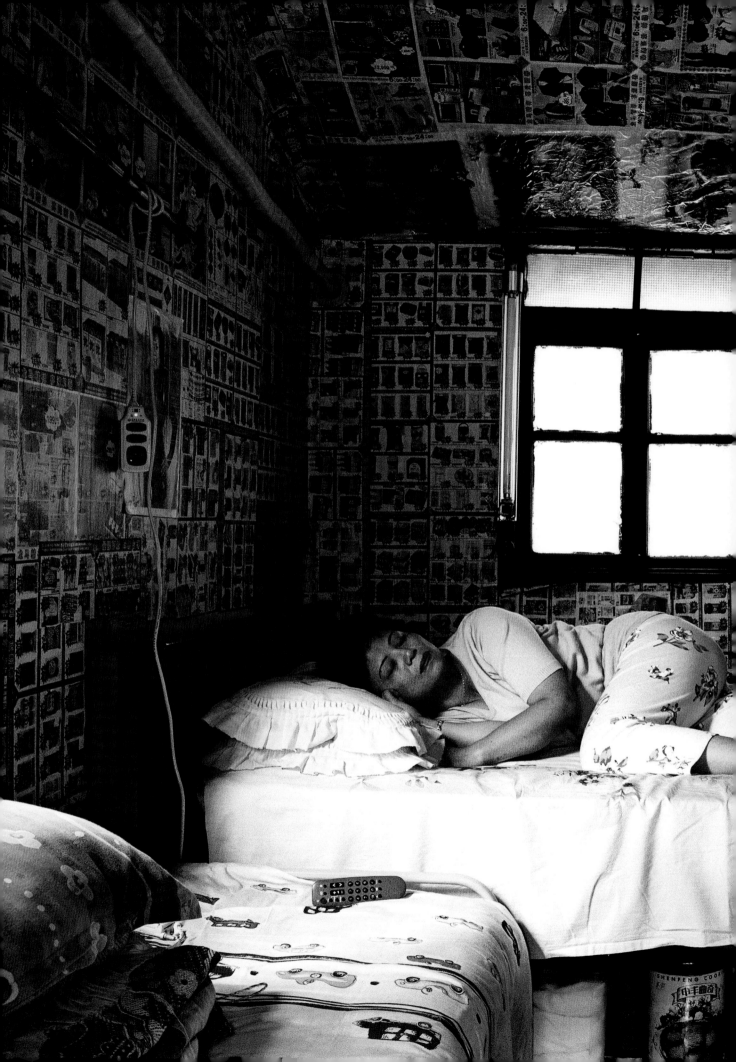

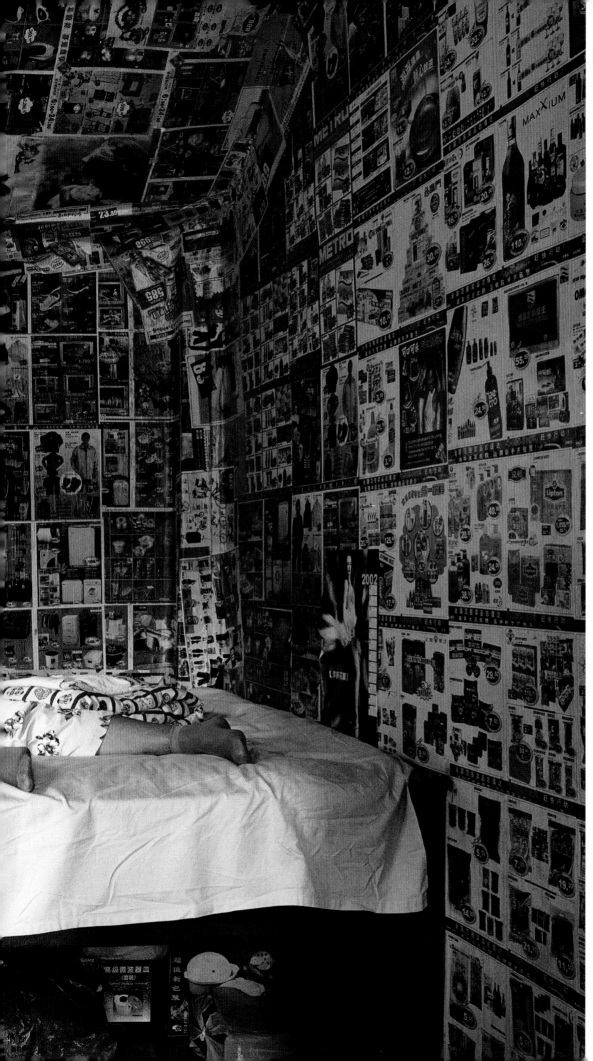

BEIJING: FUTURE CITY

Guang Yu (MEWE Design Alliance), Map of north-east Beijing, 2007. 'Beijing churns out an infinite amount of printed papers daily, a testament to the city's unprecedented speed of development. Every piece of paper on the map is collected from the exact area of the city it represents.'

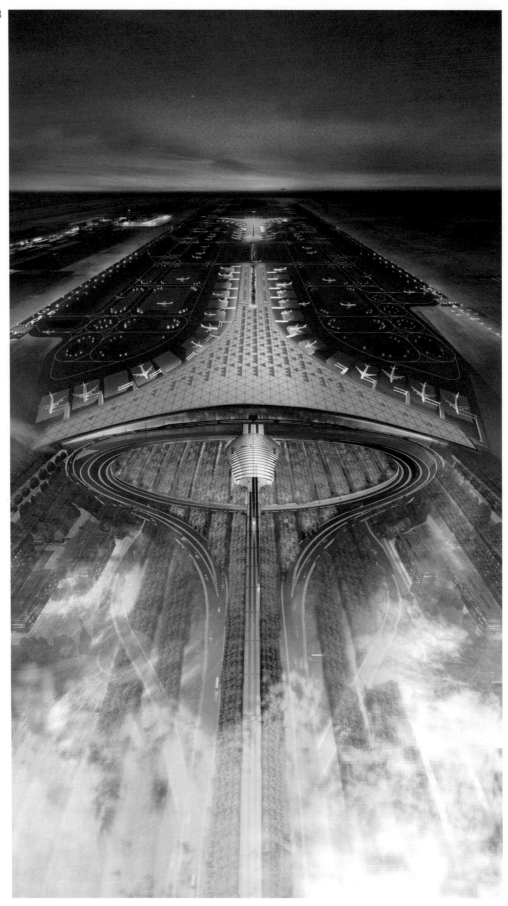

Page 128:
127. Herzog & de Meuron, National Stadium, Beijing, completion 2008.

128. Foster + Partners, artist's impression of Beijing Capital International Airport Terminal 3, Beijing, completion 2008.
129. Zhu Pei and Wu Tong/Studio Pei-Zhu and Wang Hui/ Urbanus, bird's eye impression of Digital Beijing, Beijing, completion 2008.
130. PTW Architects, National Swimming Centre, Beijing, completion 2008.

Following pages:
131. Miao Xiaochun, Celebration, photography series, 2004.

130

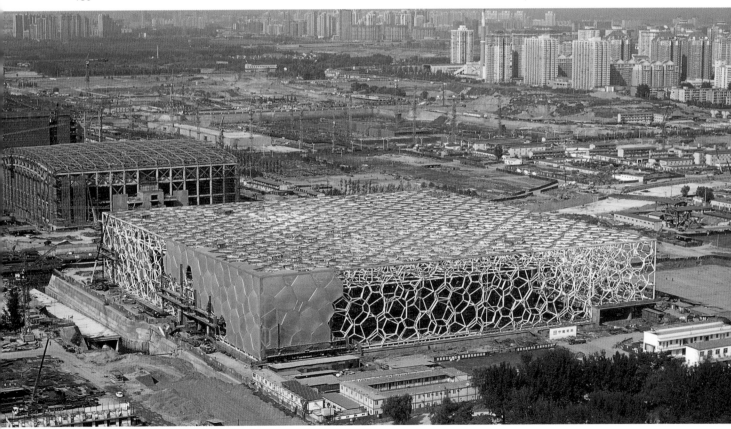

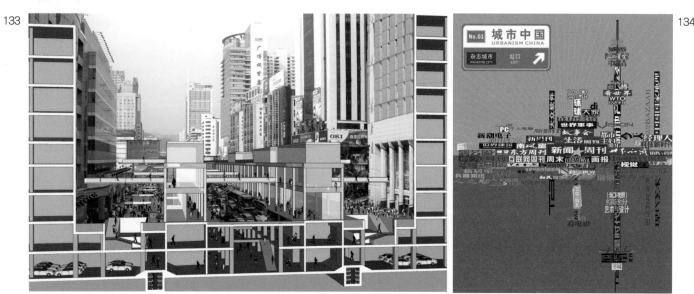

132. Artist's impression of Shanghai Expo site, completion 2010.
133. Huang Weiwen, redevelopment concept for Huaqianbei Road: three-dimensional pedestrian-only street, 2005.
134. Jiang Jun, Urban China, issue 1, magazine cover, 2005.
135. Yu Kongjian/Turenscape, Red Ribbon: Tanghe River Park, Qinhuangdao, Hebei province, 2007.
136. cj Lim/Studio 8 Architects, Guangming Smart City, Shenzhen, model, concept proposed 2007.

BEIJING: FUTURE CITY
JIANFEI ZHU

From the turn of the century Beijing's cityscape has been transformed, at least in part by the involvement of pre-eminent western architects in the design of the largest public building projects in China, creating a series of landmarks in Beijing for 2008. Behind this opening up of China to the global economy and its cultural production lies the critical role of the central government. In many ways, and particularly from 1992 onwards, the Chinese state has entered a confident and interdependent relationship with the market. This is evident in China's relations with the world economy itself, fuelled by the neo-liberal policies promoted in the UK and the United States since the late 1970s.[1] The Chinese state encouraged the nation to open up and integrate with the world economy in the 1980s and '90s, ensuring a confluence of liberal economic practice in China and the West. By joining the World Trade Organization in 2001 and winning the 2008 Olympics, China crossed the threshold of its state-led integration into the world.

Tremendous economic and social shifts are taking place in China in the wake of this process of becoming part of the global community. A market economy was consolidated; large-scale foreign investment continuously flowed in; and massive exports to the rest of the world ensued. Rural and urban reforms dismantled the Maoist-planned economy, dislocated the population and triggered migration to the cities on an unprecedented scale. Some 12–19 million people have been migrating to the cities each year since the early 1980s, creating an urban population of 530 million people (equivalent to 40 per cent of the national total), a trend that is likely to continue for decades to come.[2] Highways, airports, new towns, housing blocks, commercial and public buildings have been under construction every day and everywhere for the past three decades. This has generated a new urban world that is as destructive as it is aspirational. International architects have joined the process with great enthusiasm. At this juncture, if there is a tangible symbol in China of tremendous change, it has to be the new 'form' of Beijing as it emerges in 2008. Much can be discovered about China by reading this 'form' carefully.

Of the three urban regions in mainland China's three deltas, Beijing, Shanghai and Shenzhen are considered the leading city in each. Yet Beijing clearly stands out from the other two because of its cultural inheritance, lasting more than 800 years, as the capital of China in the Yuan, Ming and Qing dynasties (1271–1911). Beijing was an imperial city from the late thirteenth to the early twentieth century without interruption and has been the capital of the People's Republic of China since 1949. With the opening up of China during the 1980s, and the intense land speculation with foreign investment that followed in the 1990s, Beijing has become a unique city where classical Chinese tradition comes face-to-face with the latest modern architectural practices. This situation is most dramatically highlighted in 2008 as cutting-edge infrastructures and mega-buildings are completed alongside the imperial palace and as part of a large urban framework of 600–800 years' history. But before focusing on this Beijing, a brief history of the city from 1978 to 2008 is necessary.

Three phases, three plans
Although Beijing became the capital during the Mongol Yuan dynasty in 1283, it was the Ming emperor Zhu Di who developed the north–south axis and formed the city in 1420 (with additions in 1553), as it remained until modern times.[3] The shape of the city remained, surviving the 1911 republican revolution, the founding of the People's Republic in 1949 and the Cultural Revolution in the 1960s and '70s. This shape is outlined in today's Beijing by the second ring-road. What has survived until today is the overall urban framework: the north–south axis; the palace at the centre; the surrounding hills, parks, lakes and temples; areas of old urban fabric populated by small residential hutong alleys and courtyard houses; parts of two city gates; and some small sections of the city walls.

Beijing's city walls and gates have gradually been demolished since the 1910s. During the 1950s and '60s most of the remaining wall and gates were destroyed to make way for broad avenues and large imposing buildings. The tenth anniversary of the Republic in 1959 witnessed a major breakthrough in the destructive-constructive confidence of Mao's People's Republic, as displayed in the construction of Beijing's central landmark, Tiananmen Square, of 400,000 square metres, and what were termed the Ten Grand Buildings, which were completed by the National Day (1 October) of that year. The 1960s were quiet in terms of construction, as Mao's Cultural Revolution reached its apogee in 1966–9. China's early period of opening up began in the early 1970s, through key events such as China's entry to the United Nations and the development of more cordial China/US relations. At this time a kind of modernism emerged in architectural design. There was an indication by the government in 1975 that Beijing

should become a 'new, modernized, socialist city'. However, China could not fully embrace modernization until after Mao's death in 1976 and Deng's assumption of leadership in 1978.

From 1978 onwards three phases of development can be traced. The first took place from 1978 to 1992. Departing from the Maoist-planned economy model, the new economic practice was a mixed commodity economy with planning and market regulations. Foreign investment began to flow into Beijing. Hotels, offices, shopping malls, apartment buildings and exhibition centres mushroomed. Large housing districts, subway extensions and the second and third ring-roads were completed in the late 1980s in Beijing. The quantity of construction per year in the city rose from 4.5 million square metres in the late 1970s to 7 and 10 million square metres in the mid- and late 1980s.[4] It was precisely because of this 'invasion' of intense construction that the conservation of historical Beijing emerged as an urgent issue. In the planning rules for 1980 to 1983, the policy in support of expedient economic development, for engaging with overseas collaboration and for the city to be seen as comparable to other capital cities on the international stage coincided with the call to preserve the image of Beijing as a 'renowned, historical, cultural city'.[5] To protect the historical urban centre with its imperial palace, a large horizontal urban-architectural complex, the initial planning laws restricted the number of storeys that a new building nearby could adopt. The plan in 1982–3 stipulated that buildings in the 'old city' – that is, within the second ring-road – could be a maximum of four to six storeys high.[6] In 1985 the controls became more precise: height limits in areas outside the palace, the imperial temples and

lakes were set on a graduating scale at 9, 12, 18 and 45 metres in succession. In 1987 the rules became even more restrictive: no buildings inside the second ring-road could exceed 18 metres, except those along the second ring-road itself, the central east–west artery of Changan Avenue and along Qiansanmen Avenue further south, which could reach a maximum of 30 and 45 metres. In 1990 some 25 historical areas inside and around the centre of Beijing were specified as protection zones.[7]

On the political and economic front, China's modernization encountered serious difficulties late in the 1980s, when urban reform of state enterprises and price reform witnessed widespread corruption, inflation and a relative decline of income and benefits for many. And there were deeper issues regarding the economic model that China should adopt, the role of the state and issues of participation, freedom and democracy. The 1989 protests in Tiananmen Square revealed the strength of these crises clearly, which were temporarily contained using assertive force by the state.[8]

The second phase of Beijing's recent development was characterized by a reassertion of strong state rule and by a more radical opening up of China's economy to market practices and global investment. After Deng's famous speech in his tour to southern China in early 1992, the notion of a 'socialist market economy' became the set policy from late 1992. Reforms that had stopped during the late 1980s started up again, this time with success and with greater social stability. Urban land could now be rented for speculation and development using overseas capital. Beijing in the 1990s witnessed a development more intensive than that

of the 1980s. The quantity of construction per year increased to 11 to 12 million square metres (rising to 20 to 30 million square metres after 2000).[9] Invasion of the centre by massive buildings, the breaching of height restrictions and the destruction of old courtyard houses and the existing urban fabric all gained pace. The Oriental Plaza and Financial Street developments, which ought to have respected the planning height restrictions of 45 metres maximum, instead reached 68 and 116 metres in height, due to aggressive demands for profit by the developers.[10]

Calls for the increased protection of historical Beijing intensified. The Beijing Plan for 1991 to 2010, published in 1992–3, specified that Beijing should become an international city 'open in all aspects' and ready to host the Olympics in time for the 50th anniversary of the Republic (in 1999) and to become a 'modernized international city of the first rate' between 2010 and 2050. The plan then specified that the 'renowned, historical, cultural city' of Beijing must be protected, at the level of individual buildings, urban areas and the entire urban framework. Ten aspects of historical Beijing were specified for protection, including the axis, the grid pattern of streets and alleys, the horizontal profile of the city as defined by the imperial palace at the centre, the river and lake system, and the visual links between key points across the city.[11] In this ongoing battle, various conservation regulations were made in 1997, 1999, 2001 and 2002. The regulations in 2002 specified 30 areas of protection inside the old city. In 2004 this number increased to 33, claiming 29 per cent of the total area (besides the palace) within the second ring-road.[12]

From 1978 to 2008 three plans

for Beijing were made, in 1982–3, 1992–3 and 2004–5. These were ongoing expressions of consistent urban-planning principles. Policies to develop high-tech industries and the service-based economy while removing industrial activity elsewhere, to reduce the population growth and population concentration in the city (already at 15 million), to green the city and to raise its ecological qualities remained constant. In particular the emphasis on developing a modern city, while also acknowledging the need to protect the 'renowned, historical, cultural city', went hand-in-hand with a rising intensity. What was discussed in the first two plans, but given greater emphasis in 2004–5, was the idea of a greater Beijing region with two axes, two development bands and multiple urban centres, in a region beyond the conventional scope of 16,800 square kilometres, to cover potentially 70,000 square kilometres, including neighbouring cities of the region as well as Beijing. Another newly emphasized idea was the cultivation of a 'human-centric' and 'inhabitable' city in Beijing.[13] Both ideas indicated the near-saturation of major buildings inside inner Beijing, and suggested that the time had come to explore outer areas and to articulate a liveable urbanity inside. But yet another priority was to make its mark on Beijing at the same time.

Beijing's success in bidding to host the 2008 Olympic Games and China's entry into the WTO, in July and November 2001 respectively, marked the beginning of a new phase in China's development. China's long march to WTO membership, from 1986 to 2001, reflected the country's protracted period of reform towards the adoption of a market economy and its gradual integration into the

world economy, which was going through its own process of globalization. It was a dual journey for China and the West, for both to accept each other with open-market rules. The WTO entry secured two-way trade across Chinese borders and permitted China's participation on a level playing field on the world stage. It 'accelerated China's pace of building a market economy opening to the outside, and its effective participation in economic globalization'.[14] Apart from an increased volume of trade across China's borders, the staging of the 2008 Olympic Games in Beijing has provided an opportunity for China to demonstrate its commitment to open trade and international rules. The Action Plan in 2002 specified that preparation for the Games would be 'open to the nation and the world in all aspects with international regulations and modern standards'. The hosting of the Olympic Games would 'raise the level of openness in all aspects of the city of Beijing, and display to the world the new image of the nation after reform and opening up'.[15]

This plan is important as it reveals the key principles behind the building of Beijing as it now appears in 2008. According to the plan, the strategic approach includes the theme 'New Beijing, Great Olympics'; the idea of the Games being based on 'green', 'science and technology' and 'humanism' principles; and a commitment to showcase the image of a 'renowned, historical, cultural city', and to build a highly modernized Beijing by 2008, within the 'framework of a large, modernized, international metropolis'. The plan also specifies that the event is one organized in tandem by the whole nation, with modern methods and with open policies 'in all aspects'. One of the guiding

principles of the plan was to create world-class sporting facilities, 'classics in sports architecture'. The Olympic sites were to be based around 'one centre' and 'three other zones' – the first being the Olympic Green on the northern section of the extended central axis of Beijing, and the other three located in the west and north of the city. In the central Olympic Green plans were made for three primary buildings: the National Stadium, the National Gymnasium and the National Swimming Centre, to accommodate 80,000, 1,800 and 1,700 spectators respectively (alongside another 10 sports buildings in the Olympic Green, 15 in other areas in Beijing and five outside the city). To improve Beijing's ecological environment and infrastructure, the plan proposed extensive greening of the city, with 'green barriers' between urban areas. Infrastructure projects included four subway lines, a light railway around the city, a high-speed train and a second highway to the airport, the construction of fifth and sixth ring-roads and an extension to the Capital Airport itself. The plan also included the construction of a 'social environment' for the Olympic Games; it specified the planning of a broader cultural setting, including the opening, closing and torch-relay ceremonies; the building of landmark 'modern cultural facilities' in the city, such as the Grand National Theatre, China Central Television (CCTV) Headquarters, the Capital Museum and National Museum; and the protection and display of the 'renowned, historical, cultural city' of Beijing with its axis, the palace city, the historical urban framework, the great imperial parks nearby and the Ming-dynasty Great Wall further outside Beijing.

In 2008 the 'form' of Beijing has become a symbol of a China in transformation, highlighting the

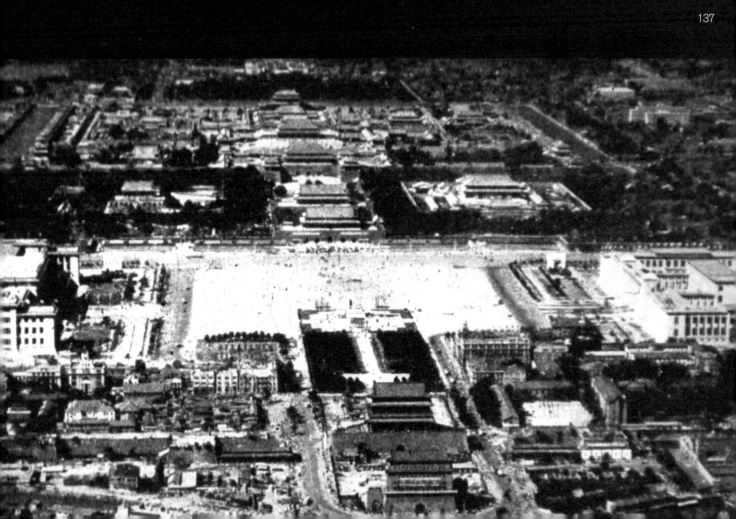

137. Li Jiu, aerial view of Tiananmen Square from the south, photograph, Jianzhu Xuebao, September/October 1959.

Following pages:
138. Frank P. Palmer, China Central Television (CCTV) Headquarters, construction site, Beijing, photograph, November 2006.
139. Office for Metropolitan Architecture, artist's impression of China Central Television (CCTV) headquarters, Beijing, completion 2008.

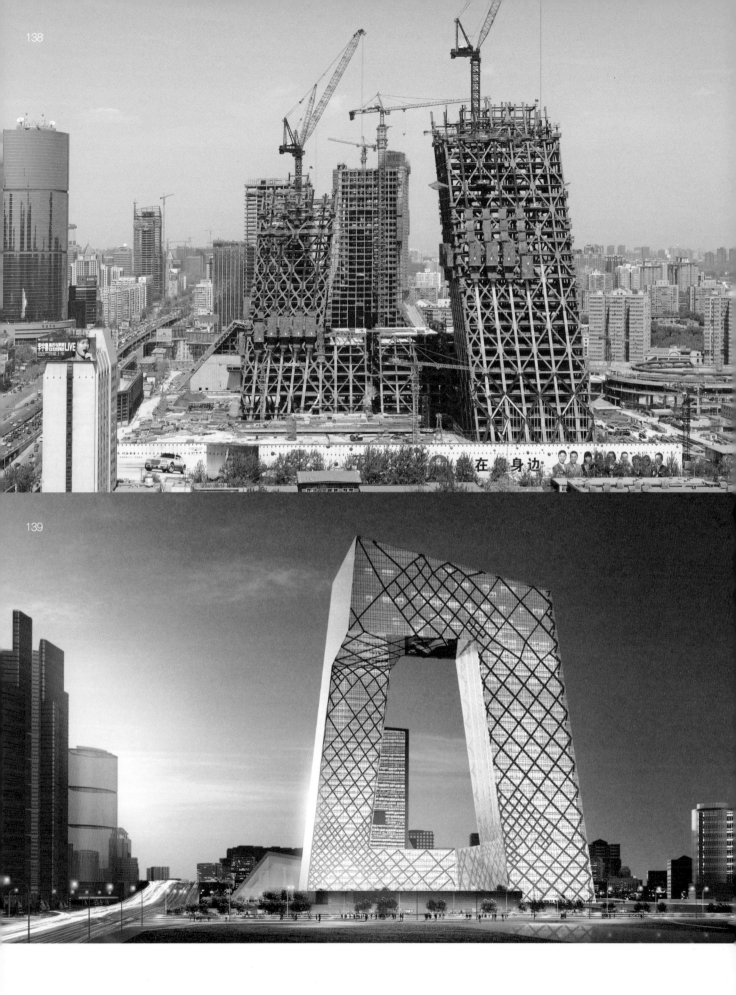

138

139

FUTURE CITY

political nature and subjectivity of Beijing as a city – the conservation of the city to revive an imperial grandeur, the nature of Beijing as a representation of the nation-state from 1959 to 2008, and the political conditions of the state at this historical juncture.

Form and spirit

Following Beijing's successful bid for the Olympic Games in 2001, a stronger current has emerged. State investment in large public buildings, sports facilities and infrastructural projects has increased; and the architects for these projects were selected through international competitions. The first such competition was for the Grand National Theatre in 1998. The process was lengthy, but the commission was made in July 1999 to French architect Paul Andreu for the design, which was accordingly built from 2001 to 2007.

In 2002 competitions for the Olympic Green, the Wukesong Sports Centre and the new CCTV headquarters were held, and the commissions were awarded to Sasaki Associates (USA), Burckhardt & Partner AG (Switzerland) and Office for Metropolitan Architecture (Rotterdam) respectively. In 2003 competitions for the National Stadium, National Swimming Centre, the Capital Museum and the Capital Airport extension were won by Herzog & de Meuron (Switzerland), PTW Architects (Australia), AREP Group (France) and Foster + Partners (UK) respectively. In 2004 the design for the extension of Beijing's National Museum was awarded, after an international competition, to Von Gerkan, Marg & Partners (Germany).[16] Construction started one after another and, in the process, all these groups collaborated with Chinese architects to enhance their cultural awareness and to increase their knowledge of the building capacity available

in China. Many also worked with the British engineering firm Ove Arup on the structural design for these large projects.

What has subsequently emerged in Beijing in 2008 is a special landscape in which the Chinese state has invited the 'best' architects around the world to build the landmarks of a new open, modern, international city, which also then exist as the new images of the nation after reform and opening up. This landscape is inevitably a spectacle for international visual consumption, yet it also incorporates the real transformations that are taking place between China and the rest of the world. At this level, the Beijing of 2008 marks a moment of confluence between China and the western world in terms of the nature of the architectural and urban forms that are being conceived. It reveals a collaboration between 'western' ideas and Chinese materiality, between western intellectual and technological innovations and Chinese building techniques as part of a massive process of modernization. Most importantly, it embodies the 'marriage' between a new notion of modernity developing in the West during the past few decades and a socio-economic drive towards modernization in China in the same period since 1978.

Of these extraordinary Beijing landmarks, the CCTV headquarters and the National Stadium perhaps require analysis first. Although both display the latest western explorations in tectonics and formal dynamism that have developed since the late 1970s, the Stadium is particularly astonishing in its seamless integration of new structure, material, form and space at a vast scale, facilitated by new material science, CAD programs and local building capacities. The CCTV headquarters, on the other hand,

reveal a specific critical enquiry of modernism. If we review Mark Wigley's statement on Deconstructivist Architecture – an exhibition in New York in 1988 in which OMA's Rem Koolhaas was included – reads exactly like a footnote to the CCTV buildings that were completed some 20 years later. Wigley says:

The frame is warped ... The structure is shaken but does not collapse ... These buildings are extremely solid. The solidity is just organized in an unfamiliar way, shifting our traditional sense of structure. Though structurally sound, at the same time they are structurally frightening.[17]

What is interesting, however, is not a Chinese or western development on its own, but the confluence of a neo-modern and Deleuzian dynamism from the West with the world's largest urbanization and modernization project, which is unfolding on this Asian continent with energy and sheer magnitude.[18]

Furthermore, it is seemingly ironic, but this confluence in form-making has created an environment in which small local independent architectural practices are able to grow more easily. While architects educated before 1978, often based in state design institutes, continue to play a leading role today in most of the public and commercial projects taking place in Beijing and across China, younger generations of architects who graduated after 1978 began to assume important roles with greater exposure after 2001. Starting in the mid-1990s, with independent studios and with greater access to international ideas, they have brought a purist modernism with regional sensitivities to China, as manifested in the work of Yung Ho

Chang, Cui Kai, Liu Jiakun, Wang Shu, Ma Qingyun and many others.

These and other 'avant-garde' architects have been invited by Chinese developers, using domestic capital, to produce commercial projects with a current of interesting forms. Examples include the villas of the hotel complex Commune by the Great Wall (such as that by Yung Ho Chang) and the Jianwai SOHO office blocks (by Riken Yamamoto) – in both cases the client was SOHO China, one of the leading property developers inside China. These projects are predominantly modernist, sometimes with a tectonic or regional sensitivity.

The horizontal vs the vertical

Although Beijing has witnessed two waves of modernization (during the 1950s and the present time), within a Maoist and a market-socialist programme respectively, the second wave far outstrips the first in intensity. And it is in the current, market-oriented modernization that its heritage is under the most serious threat of destruction. China's conservation efforts have been escalating to face the challenge, as evidenced in the plans of 2002 and 2004–5, thanks to the effort of intellectuals, social activists and municipal and state bodies. There is an ongoing determination in society and from the state to protect tradition, culture and national identity against the consequences of market capitalism and global homogenization, even though China's reform aims to attract foreign investment.

Beijing as it stands now survives with its grand palace at the centre, and its imperial parks, hills and lakes in a horizontal profile visible within the city centre, while large modern buildings are being constructed in a ring around the centre and further outside. In this sense, an imperial Beijing is being re-invented. When tall buildings are kept at bay outside the second ring-road, and when large modern buildings inside the ring-road are kept within a statutory maximum height, the imperial palace at the centre acquires an unprecedented power and grandeur.[19] This is an expression of the power of a horizontal landscape against a vertical metropolis. As it is visible today, the horizontal city of the imperial tradition has managed to limit the vertical capitalist metropolis at a distance and with height restrictions. Beijing thus imparts a certain horizontal Chineseness across the whole urban landscape.

Looked at more closely, this Chinese or 'imperial' grandeur is articulated within a larger system, comprising the horizontal centre, the surrounding lakes and hills, the ancient bell and drum towers, the axes linking the centre to the city gates, with the Temple of Heaven in the south, the Western Hills further away, and the Ming-dynasty Great Wall to the north-west. This urban system is then further articulated by later and more recent structures: Tiananmen Square with its buildings of 1959 (and 1977), the landmark monuments added to the west and east of the square (the Grand National Theatre in 2007 and National Museum in 2010), the east–west Changan Avenue with its massive, horizontal buildings, and the entire Olympic Green and its great horizontal structures on open landscape in the northern section of the central axis. Even the CCTV headquarters outside the ring-road takes the form of a horizontal-vertical articulation, instead of that of a conventional vertical skyscraper. Almost all major landmarks in Beijing are now predominantly horizontal in composition. In this way, the imperial city of horizontality with its north–south axis, which first appeared in 1283 and was further developed in 1420, has survived to 2008 in a modern guise.

It must be added that the notion of horizontal space and the concept of a vast universe were closely interrelated in the Chinese cosmic order. This is clearly visible, whether in a horizontal scroll painting or an urban-architectural composition, or a cross-section of the axis and the overall layout of the city itself.[20] If this analysis is correct, this Chinese order – this 'horizontal immensity' – has survived today, somehow 'hovering' over central Beijing (62 square kilometres), 'soaring' up in the surrounding metropolis (324 square kilometres) and, finally, 'undulating' further in all directions in a greater region of 16,800 square kilometres.

1959 vs 2008

As a state project to create a vision of Beijing as a representation of the nation, the construction of Ten Grand Buildings and of Tiananmen Square in 1959 is comparable to the building of the large cultural and sports facilities for the Olympics in 2008. But there are both differences and consistencies that can be traced.

On 1 October 1959 the occasion was the National Day celebration of the tenth anniversary of the Maoist People's Republic, defining itself against Khrushchev's USSR and the imperialist capitalism of Cold War USA. In 2008, on the other hand, the occasion is China's hosting of a celebrated global cultural and sports event participated in by all nations, at a time when China as a market-socialist state is engaging with almost all countries around the world. In 1959 architectural forms were employed for political critique, as the national style was adopted to oppose capitalist

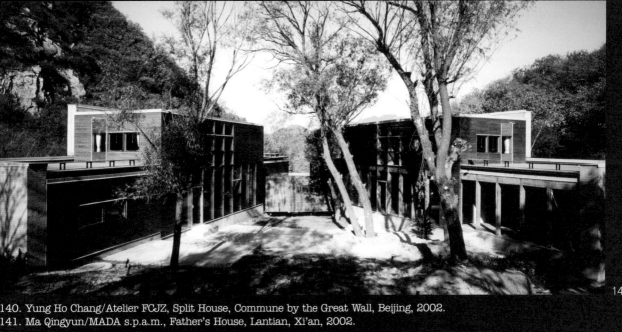

140. Yung Ho Chang/Atelier FCJZ, Split House, Commune by the Great Wall, Beijing, 2002.
141. Ma Qingyun/MADA s.p.a.m., Father's House, Lantian, Xi'an, 2002.

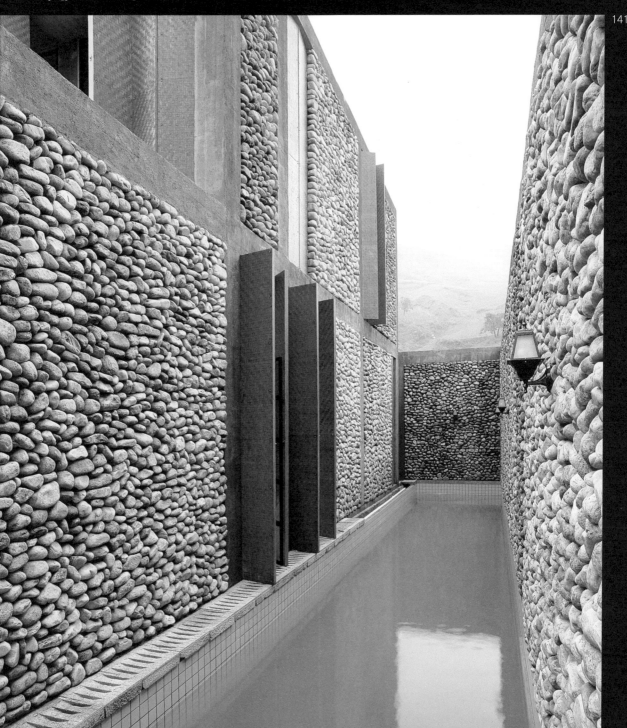

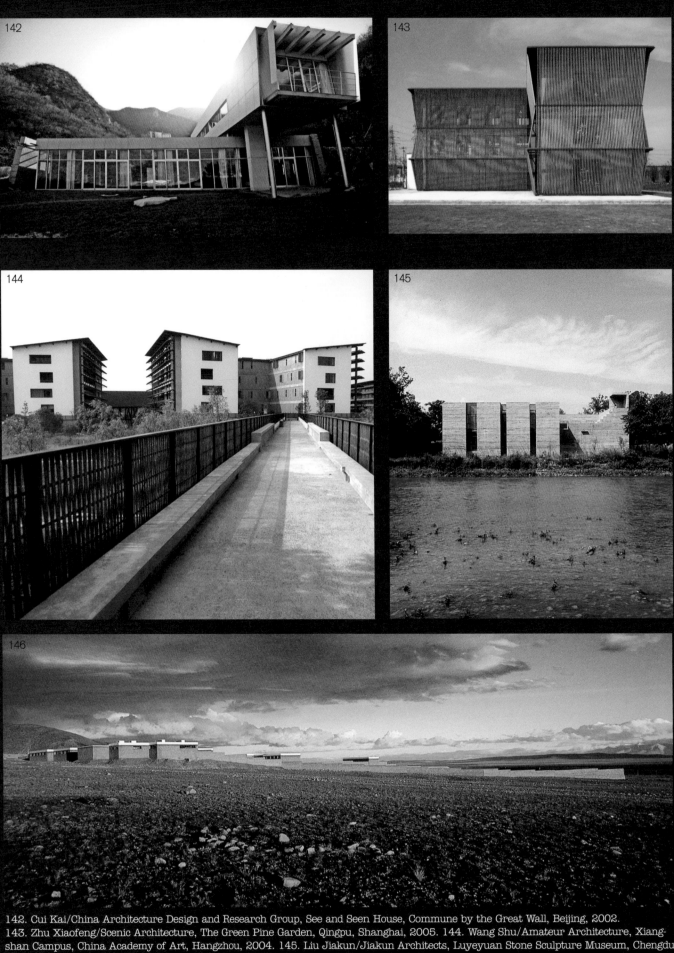

142. Cui Kai/China Architecture Design and Research Group, See and Seen House, Commune by the Great Wall, Beijing, 2002.
143. Zhu Xiaofeng/Scenic Architecture, The Green Pine Garden, Qingpu, Shanghai, 2005. 144. Wang Shu/Amateur Architecture, Xiang-shan Campus, China Academy of Art, Hangzhou, 2004. 145. Liu Jiakun/Jiakun Architects, Luyeyuan Stone Sculpture Museum, Chengdu 2002. 146. Wang Hui/Limited Design, Apple Elementary School, A'li, Tibet, 2006.
Following page: 147. Zhu Pei and Wu Tong/Studio Pei-Zhu, Blur Hotel, contextual model, 2006.

modernism or the International Style. In 2008 modern forms are adopted to express the progress of a nation after opening up. Buildings become icons, instantly visible in a homogenizing global market.[21] In 1959 the Ten Grand Buildings and Tiananmen Square were designed in a decorative Beaux Arts language with literal Chinese details and Chinese roofs. The Chineseness was tangible, yet conservation of the historical city was ignored. The architects were all Chinese, and the constructions were completed in 11 months by late September of that year. In 2008 the planning process has been more open. The forms are modernist; the architects, selected through international competition, are predominantly European. Chineseness is an abstract quality, present in the horizontal projected roofs and in the overall horizontality of the cityscape in the centre, as the heritage conservation of the historical city becomes a crucial concern. In 2008 more than 20 projects are taking place, although the list is open-ended. Construction has taken around four to six years to complete. The scale and investment are much larger. There are also significant infrastructure projects going on at this time, most notably the extension of Capital Airport by Sir Norman Foster, 'the single largest airport expansion project the world has ever seen, as well as the fastest ever built'.[22]

In both cases there are consistent threads. In the 1950s, as in China today, the state has led the national modernization project – whether this is defined as 'socialist' or 'market-socialist'. In both 1959 and 2008 the state organized the event with widespread national support. And in both the great architectural landmarks are expressions of a modern China displayed for international vis-

ibility, although the meaning of being modern and the condition of that visibility have certainly changed greatly.

State, market and society
The relationship between the state and the market in China is central in the making of the Beijing of 2008. On the one hand, the Chinese state is actively opening up to international capital and development. On the other hand, it retains powers when necessary to limit international investment and to resist what it perceives as the invading homogenization of a global economy. The key issue is that the state retains a level of governing authority, above capital and the market, which is fundamentally important to the nature of urban planning in China. This makes possible progress towards heritage protection, ecological urban living, and large-scale physical and social habitability. We can cite the examples of Arup's Dongtan Eco-city and other large-scale urban models. If the Chinese state continues to develop in this direction, where collective and long-term interests are considered independent of purely economic factors, then a new balance in the state–market relationship can emerge with a certain credibility. At the same time, the relationship between state and society must be closely observed. The Chinese state is certainly concerned with the well-being of the population in a long-term perspective. However, what can be observed today is often a monopolistic alliance of the state with global capital, and with international systems of cultural production. This reduces the space for small-scale and local practices. The issue here goes beyond the role of the architect in shaping these discourses to a larger area of socio-economic and political life, where the fair distribution of wealth

and greater room for participation and expression for all are desired. Issues of equity, participation and democracy are likely to be a focus of state reform in the years and decades to come and will have a fundamental impact on the way that Chinese cities continue to develop.

The 'form' of Beijing in 2008, in the long term, has crucial implications for the future. For a nation that has travelled over centuries from an Asian agricultural empire to a mercantile modern republic with western elements, the capital at this moment reveals the possibility of a synthesized new path. In this changing landscape we find a polity that combines liberal and collective interests, and an architectural and urban aesthetic that is modernist, mass-based, large in scale and capacity, and hybrid in cultural content.

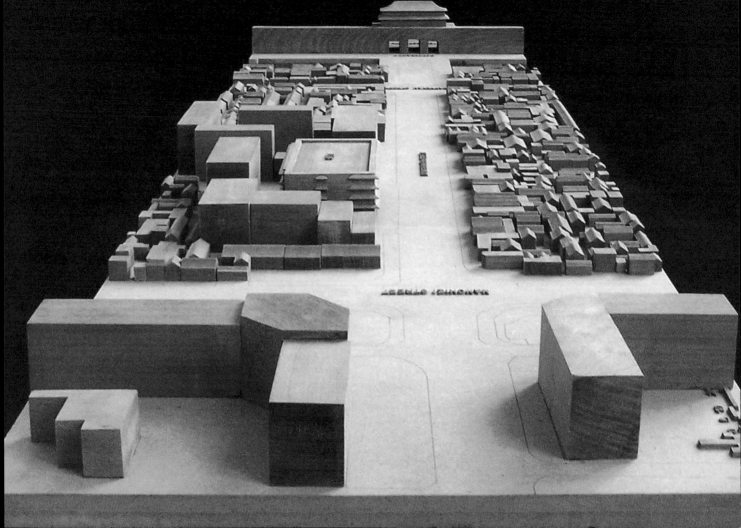

URBAN ARCHIPELAGO, CITY OF MERIDIANS

SHI JIAN

Beijing as urban archipelago

Beijing has become an urban archipelago – a collection of islands, each with its own distinct character, history, culture and residents, disconnected from each other. They have become individual islands floating in Beijing's fast-sprawling urban space. In a sense, each island is a city in itself.

1 The old city

The central area of Beijing is the old city, encircled by the broad second ring-road that runs along the course of the old city wall from the Ming and Qing dynasties. The traffic jams on the road have made the area within into an island in a very real sense, and the ring-road itself has become a modern form of city wall. Humans and vehicles in central Beijing can only connect with the outside by means of bridges. In fact, national heritage status has never covered the entire old city within the second ring-road, an area composed of the Forbidden City, hutong alleys and court-yard houses (si he yuan). From the so-called Ten Grand Buildings of the 1950s – the massive construction project in the capital in 1958 and 1959 – to the Grand National Theatre (Paul Andreu), the headquarters of the Bank of China (I.M. Pei) and the Oriental Plaza and Financial Street developments of the 1990s, this is where the biggest and most avant-garde of Beijing's buildings of the time are on display.

2 The new-old city

In the ever-expanding urban spaces between the second and fifth ring-roads lie scattered more recent historical vestiges showing the changing nature of the city of Beijing: compounds of Soviet-style buildings, industrial complexes, office buildings, military and central-government offices. These compounds, which stud the city like independent islets, often resemble cities in microcosm. In the last ten years, as manufacturing has fallen into decline or moved elsewhere, and

with the dramatic restructuring of industry, the original buildings and compounds have by and large been replaced by real-estate developments, transformed into luxury communities, 'islands' for the newly emerging middle classes instead. These are usually managed as closed communities, with their road networks and green spaces severed from the rest of the city – making this new-old city surrounding the old city one of the areas where the most extreme changes are taking place in Beijing.

3 The new new-old city

Both the Financial Street and Qianmen areas of the old city were originally candidates to become the site of Beijing's Central Business District (CBD), but the CBD was eventually assigned to the area beyond the eastern second ring-road, where the third ring-road passes through and the China World Trade Centre of the 1990s is located at its heart. Prior to the twenty-first century this area was mainly the city's industrial land, on which factory works were scattered around. In 2001 the plan to build a CBD on this land was drawn up by the municipal government in order to improve the investment environment for the city's international business activities. Currently the nature of this urban space is being completely rewritten. Manhattan-style high-rises are replacing the former factory buildings; and not only the Office for Metropolitan Architecture's CCTV headquarters, but many other large world-class architecture firms are leaving their mark here. However, unlike Shanghai's Pudong development (which was imagined as a visionary new urban area), the CBD in Beijing seems not to be planned with a coherent spatial philosophy, but simply to be a matter of layering and juxtaposition of old and new; in a way, it expresses the sheer power of development.

4 New cities

The most rapidly expanding urban spaces are homogenous 'ordinary' residential districts, such as the Outer Deshengmen area by the north second ring-road and Badachu at the fifth ring-road. With no particular political or cultural characteristics, these districts have gradually been forming themselves into new urban cores of road hubs and centres of consumerism, providing shopping, food and drink and entertainment malls. That is to say, Beijing is being driven by the desire to consume, and consumerism is becoming the vital force behind the capital's liveliest districts. It is these ordinary districts, with their kitsch spaces, over-the-top advertising hoardings and huge throughput of human traffic, that reflect the everyday aspect of urban life in Beijing.

From urban archipelago to city of meridians

Unlike western medicine, with its foundations in scientific exploration, Chinese medicine uses the concept of 'meridians' to treat problems in the body, according to which bodily disorder and bad health are caused by disruption of the energy flow along the meridians (a series of interconnected channels) around the body. This disruption can be corrected if specific points, so-called acupoints, on the meridians are stimulated.

If we look at Beijing as a human body, then Beijing's fragmentation and the problems within its parts are the result of the disruption of the city's energy flow. To solve the problem, architecture in the city has to be treated like acupoints on the city's meridians. Individual building projects, however small they are, can bring energy flow to the urban space. The following three architecture projects undertaken by Beijing-based Chinese architectural studios, located respectively in the old city, the CBD and the Outer Desheng-

men area, can be seen as using this meridian approach to solve urban spatial problems.

1 Hotel Kapok (Zhu Pei, Studio Pei-zhu, 2006)

The old city was once a well-preserved medieval town. After 1949 new government buildings were built in this area, but with no regard for the rhythm of the old city. Current economic and political reforms have left many of these buildings lying empty and redundant. At the same time, massive economic growth has created more leisure time for an increasingly affluent society, which in turn necessitates more service facilities in the city centre. As a result, the former government buildings have often become major sites for new hotel projects.

The site of Hotel Kapok was a large government building, located just a few hundred metres away from Donghuamen, or the Eastern Flower Gate of the Forbidden City. At its planning stage, the hotel project was conceived as the renovation of an existing building, rather than the construction of a new one. For this renovation project, the architect has developed a series of concepts aimed at harmonizing the building with its surroundings. Several strategies are employed. Firstly, the architect successfully establishes a dialogue between this building and the local building typology by developing a system of si he yuan or courtyards stacked vertically across the floors of the building. Secondly, the exterior of the building is wrapped in a continuous and translucent fibreglass net, so that the whole building becomes a permeable space.

2 Pingod Sales Centre and Art Museum (Yung Ho Chang, Atelier FCJZ, 2004)

As recently as three or four years ago the large area of the CBD was an industrial site and factories were still in operation. Now it is home to some of the most spec-

tacular and extravagant structures in the city: the white peaks of the Jianwai SOHO buildings, the Yin Tai Centre, the China World Trade Centre Phase 3 building, as well as the CCTV headquarters. The dramatic growth of new structures in this area makes it almost impossible to rescue any old industrial buildings.

The Pingod Sales Centre and Art Museum is located on the southern edge of the CBD, part of a large residential development. While being commissioned to work on the master-plan, Yung Ho Chang and Atelier FCJZ were also asked to turn an existing heating plant on the site into a sales showroom that was serving as a temporary art space, on a very tight schedule and a low budget. The architect's approach involved two interrelated operations: cleaning up the existing spaces and introducing new architectural elements. Cleaning up was kept to a minimum to save the original industrial features; the new architectural elements were developed from the notion of perspective boxes. These box structures, in various sizes and shapes, were then placed in locations such as the entrance, the window areas, the stage and the reception area where a new spatial relationship could be created. The result produced playful interactions between the interior and the exterior, transforming the industrial site into an animated space and stimulating life in this part of the CBD.

3 Desheng Uptown (Cui Kai, China Architecture Design and Research Group, 2006)

The Outer Deshengmen was formerly a residential area on the north side of the Deshengmen, only one of a few surviving city gates in Beijing, full of narrow alleys and crowded courtyard houses. At the turn of the new century all the houses and lanes were razed to the ground; in their place a huge traffic junction was built with several highways running across it. As a result,

the original urban fabric and scale were completely lost. At the north-west corner there was an empty space in which the Desheng Uptown office project would take place.

When Cui Kai began the commission, he decided to use it as an opportunity to recover the original urban scale and retain the memory of the lost residential area. To start with, all the trees that had fortunately survived the demolition were kept intact. During the development of the master-plan, alongside the courtyard typology being adopted for the overall layout of the buildings, the ancient city gate in the south of the area became the key point of reference. The height of buildings in the whole office compound was made uniform, limited to five storeys. An oblique pedestrian street was also conceived in such a way that the city gate became the backdrop to people's activities along the street.

Each of the three projects briefly described above is located in a specific urban context, and as such adopts a different strategy and tactics in an attempt to solve a problem specific to that context. But behind these different strategies and tactics lies a unified attitude – a positive response to Beijing's hyper-speed urban growth, viewing its problems as an opportunity for architects to intervene. Currently such interventional architecture projects in Beijing are few, but growing in number. Before too long, I hope, they will not only reanimate life within the boundaries of their individual areas, but will also channel life between these islands, transforming Beijing from an urban archipelago into a city of meridian paths where the energy flows freely.

148

149

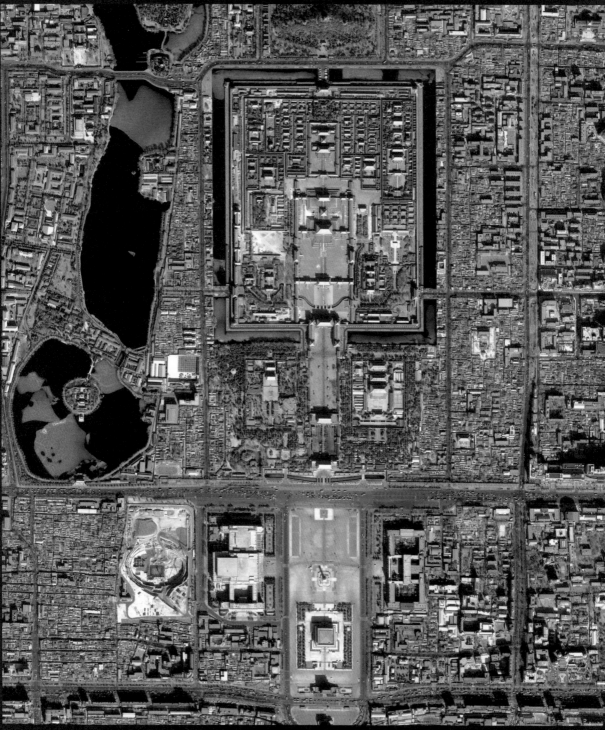

150

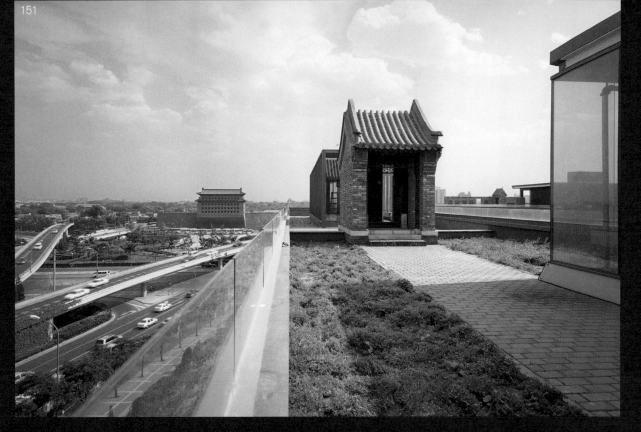

151

148. Zhu Pei and Wu Tong/Studio Pei-Zhu, Hotel Kapok, Beijing, 2006.
149. Zhu Pei/Studio Pei-Zhu, Hotel Kapok, Beijing, sketch, 2005.
150. Satellite photograph of central Beijing, with the indication of the location of Hotel Kapok, 2005.
151. Cui Kai/China Architecture Design and Research Group, Desheng Uptown, Beijing, 2006.
152. Yung Ho Chang/Atelier FCJZ, Pingod Sales Centre and Art Museum, Beijing, 2004.

152

In China people get around by bike – don't they? Rivers of bicycles, carrying hundreds of thousands of people (men and women, young and old, for work and leisure), represent one of the strongest images of Chinese life for many non-residents. Yet if you travel to China today you are more likely to be confronted by traffic jams of Shanghai-designed and -built Volkswagens. Increasingly cars produced by China's home-grown brands of Chery, Shanghai Auto and Great Wall fill the newly extended network of roads and highways. In the summer months you can literally see the side-effects of this growing traffic and witness an exodus of resident foreigners, the wealthy and all those who are able to escape the pollution, fumes and smog of China's cities.

China's economy is accelerating, and Chinese society is driving forward with the motor car at centre-stage, acting as a symbol of the rapidity of change within what is now estimated to be the world's fourth-largest economy – and potentially the world's largest customer for cars. Chinese cities are developing at an alarming rate and the necessity to keep people moving within and between them is intense. In the coming two decades 300–450 million people will migrate from the countryside to China's metropolises.[1]

The situation demands alternative models of urbanization and transportation. Madame Nie Meisheng, president of the China Housing Industry Association, recognizes that China's urbanization rate – at almost 2 per cent per year – means that 'China's energy, material and natural resources are inadequate to sustain this growth using conventional development models.'[2] The sustainable design of urban centres is therefore of vital importance, not only to China, but also to the rest of the world. Economically, the size of

the Chinese market is exciting to international firms. However, the reality is that Chinese firms are gearing up to satisfy much of their own demand and to export at cheap prices.

In China there are still millions of people who do not own a car, and in a single year only about one-tenth of 1 per cent of the Chinese people will buy a new car. There is the potential for massive growth. The still-enormous agricultural sector is counterbalanced by the demand in Chinese cities, where a new generation of car owners is celebrating the opportunity of accessible car ownership. The possibility of mass car ownership was first envisaged by Henry Ford a century ago – in 'any colour so long as it's black'. Now new technologies and the massive scale of the Tiger economies mean that China's response to automotive mobility can be much more colourful.

History often repeats itself and Li Shufu, chairman of Geely,[3] promotes with Fordist zeal his mission to 'create good cars that the average Chinese person can afford'.[4] The domestic motor industry may have got off to a slow start, but it now has the potential to leapfrog the more developed models of the West. China is already the world's third-largest car market, after America and Japan, and forecasters and economists are predicting that it will become the biggest at some point between 2010 and 2015. China has made no secret of its ambition to become not just a major consumer, but also a major international car-making nation like its Asian neighbours Japan and Korea.[5]

China's soaring ambitions for the growth of its domestic motor industry are being satisfied, with the Shanghai Automotive Industry Corporation making 840,000 vehicles annually, including brands like Buick and

Shanghai's VW Santana taxis. It will not be long before the ubiquitous 'Made in China' label on so many products becomes predominant in the automotive sector too. Sales of home-grown Chinese cars, many of them made by small manufacturers, are already soaring. In 2006, 26 per cent of passenger cars sold in China were Chinese brands – more than double the share in 2001.[6]

At this stage one can only speculate about the longer-term impact of the rapid transformation of the global motor industry and the role that China will play in that transformation. Undoubtedly China is a massive market for car sales, and international brands are fighting to get a foothold within China from which to promote their wares. General Motors planned to introduce 10 new or upgraded models in China in 2007 and estimates that its market share in mainland China now stands at 11.8 per cent.[7]

As the first foreign firms to manufacture in China, General Motors and Volkswagen AG worked with the government-owned Shanghai Automotive Industry Corporation on world-class assembly lines to build cars for the Chinese market. Now the giant car manufacturer is ready to use the technical expertise and experience it has gained to make further progress.

The promotion of Chinese-designed and -made cars is finally beginning to have an impact at international motor shows, and the Chinese motor shows in Shanghai and Beijing have quickly become an important part of the industry's calendar. As a report by leading car-industry website, cardesignnews.com, stated: when Auto China 2006 opened at the China International Exhibition Centre in Beijing, it was the 19th Auto Show and 'the largest auto show in the history of China'. More than 90 vehicles

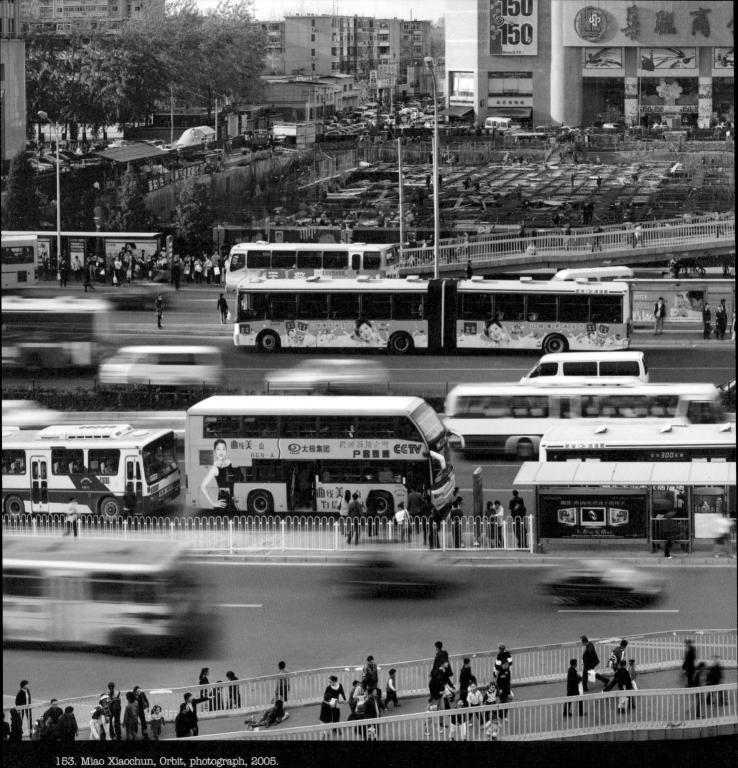

153. Miao Xiaochun, Orbit, photograph, 2005.

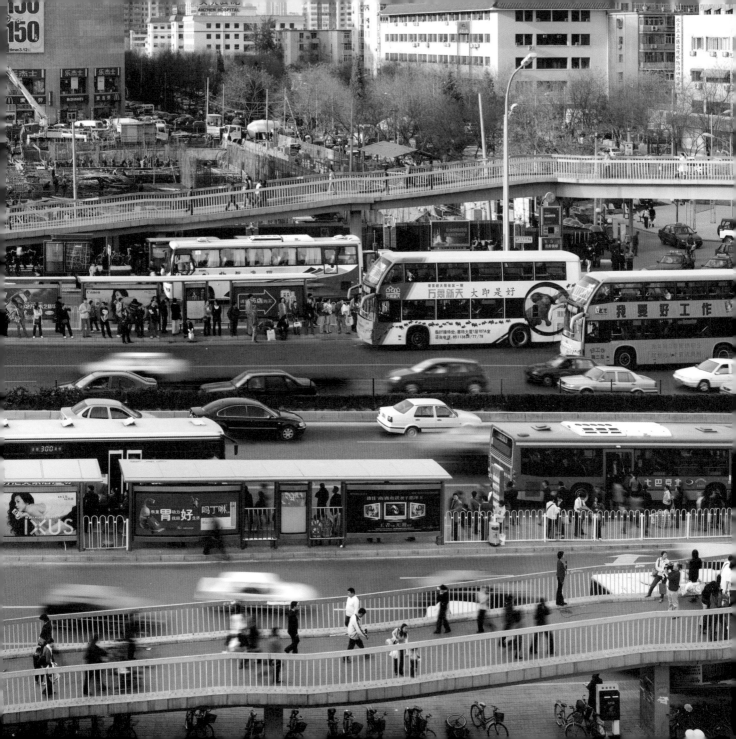

from 30 manufacturers were present, including global car manufacturers such as Volkswagen, Hyundai and GM.

Many of the new cars actually being made in China are not the newest models and are not bespoke to the Chinese market. They are off-the-peg western models that have been repackaged as 'Made in China' cars. The interesting design issue is what Chinese home-grown cars will look like, and the nature of the Chinese motor industry as China becomes a bigger exporter of cars than an importer.[8] If we are looking for radical new design, eco-vehicles or any of the trends that we, as westerners, expect in new concept cars, then we might be disappointed. Currently there are a lot of copies of existing models, at times with modifications so slight that design-ownership issues are problematic. For example, industry magazine Auto News Europe reported that the Chinese company Shandong Huoyon Electromobile 'stopped production of a minicar that looks like the Smart ForTwo' when Smart's parent company DaimlerChrysler threatened to sue.[9]

Developing specific design identities for Chinese cars is most likely to be evident in government-owned firms, where the drive for cars that reflect national culture and tradition is strong and the possibility for the large-scale investment necessary to develop a bespoke design language is more likely to be invested at this stage. For example, the government-owned Chery Motors showed three concept cars at Auto China 2006, each displaying its own distinct characteristics. 'Chery's V5, an "adequately styled" MPV-type [Multi-Purpose Vehicle] CUV [Crossover Utility Vehicle], might have been the least eye-catching car at the Chery display in terms of styling, but to many professionals present, the V5 was the

most significant of the cars on display.'[10] Despite the support that Chery receives from the government, currently running at $3 billion per annum, ultimately it and other government-owned firms will have to produce attractive road-going cars in order to be profitable. New market areas such as the CUV are competitive, and up-and-coming brands can slip right into the mix of things with a relatively good chance of success.

Geely Automobile's Geely 'CK' sedan (meaning 'Freedom Ship' or 'Free Cruiser') holds the distinction of being the first Chinese car ever shown at an American auto show, the 2006 North American International Auto Show in Detroit.[11] The CK is based on a South Korean design by Daewoo, Tower Metal, Wooshin Systems and CES, which Geely licensed, although the automatic transmission is built in China (the first to be manufactured there).

Ironically, the so-called 'new car' from Shanghai Automotive, China's largest passenger-car maker, will be a modified version of failed British MG Rover Group's Rover 75, a luxury four-door sedan.[12] The impact of the Chinese approach to learning and then taking over is not limited to manufacturing, and Chinese investment in research and development and design is increasing. We are getting closer to seeing authentically designed and made Chinese cars. Foreign designers are following the potential growth with keen interest. Italian firm Pininfarina – with 75 years in the car-design business – has a Beijing office, where it has already developed a number of models for the Chinese market.

In the near future this trend is likely to change as Chinese graduates from transportation-design courses, such as the one headed by Tingbin Tang at the Central

Academy of Fine Arts (CAFA), begin to make their mark in the car-design world. At this early stage the strategy is to establish constructive relationships with existing international centres of excellence and run joint projects. For example, in 2006 CAFA hosted a project to 'design an innovative transportation tool for Olympic 2008', co-hosted by Detroit's College for Creative Studies and London's Royal College of Art. The design entries were expected to creatively solve the Beijing traffic problem, by introducing a new type of transportation tool or a new way of transportation, either to transport people or objects or both.

The Olympic Games are an important catalyst for changes in transport and infrastructure – think of Sydney 2000 or of the plans for London 2012. For the twenty-ninth Olympiad in 2008, Beijing has implemented a number of impressive measures. Its new international airport terminal by Foster + Partners has been designed and built in just four years (2003–7) and is the world's largest and most advanced airport building – not just in terms of technical innovation, but also in terms of passenger experience, operational efficiency and sustainability.

The vast terminal has a soaring aerodynamic roof and dragon-like form, celebrating the thrill and poetry of flight and evoking traditional Chinese colours and symbols. Like Foster's design for Chek Lap Kok airport in Hong Kong, the new Beijing terminal is open to views to the outside and has been planned under a single unifying roof canopy, whose linear skylights are both an aid to orientation and a source of daylight, with the colour-cast changing from red to yellow as passengers progress through the building.

Another British architectural practice to benefit from the

Beijing Olympics is Terry Farrell and Partners, architects of Beijing's South Railway Station. Here another vast roof, more than 500 metres long, covers an intermodal passenger interchange between metro, bus, car and taxi transport. Farrell's also won the competition for a new station at Guangzhou, billed as the largest new station in Asia.

Another part of China's preparations to host the 2008 Olympics is the development of an Intelligent Transportation System (ITS). Beijing's public-transport system is expected to convey 4.5 billion passengers each year, using 18,000 buses travelling on 650 bus lanes. The number of cars in Beijing is now close to two million, with around three million drivers; add to that the estimated 11 million non-motorized vehicles and a vast number of transit vehicles,[13] and it is clear that the streets of Beijing are incredibly busy. Thankfully, the 120,000-strong fleet of Olympic buses will run on compressed natural gas.

China's most promising environmental plans are for sustainable and walkable new communities. American architect William McDonough, known for his 'green' regeneration master-plan at Ford's River Rouge Plant, has been working on projects with the China-US Center for Sustainable Development, such as the Guantang Chuangye Park Master Plan, where within the 22 square kilometres all workplaces and residences will lie within a five-minute walk of a transportation hub and within 500 metres of an interlinked network of habitats.[14] The China-US Center for Sustainable Development's strategic goals are to 'set the standards for sustainable development and build the human and organizational capacity to achieve them', and its mission 'is to accelerate sustainable development so that commerce, communities and nature can thrive and prosper in harmony – what China is now calling a "circular economy".'[15]

The way in which China responds to the car issue, and to the wider issue of modern mobility, will have such a strong environmental impact that the solutions it finds will be critical to us all. The level and nature of production are one key issue; the level and nature of consumption are another. How many cars will China need? How many cars will it make? What kind of cars will it promote? What will the future of commuting in China entail? The implications of the answers to these questions are critical to us all.

154. Auto Shanghai car show, 2005.

CHANGING CHANGE
THE THE
AMAZING BEGINNING
OF BEING CHANGED

China is showing amazing energy and, as part of its economic growth, is speedily becoming a consumer society.[1] In 2004, 82 per cent of Chinese households had a colour television, 63 per cent a landline telephone and 50 per cent a mobile phone; this is in stark contrast to the figures in 1994, when 40 per cent of families had a colour television, 10 per cent a landline telephone and just 3 per cent a mobile phone.

Judged by its current pattern of development, China's economic growth is by and large a quantitative one, based on a massive output of products. It follows the traditional model of industrialization, but in a much faster and cheaper fashion. Is this model sustainable? The gaps in wealth distribution are increasing. In 2005 the richest 10 per cent of the population owned 45 per cent of the country's wealth, whereas the poorest 10 per cent owned just 1.4 per cent of the country's wealth.[2] The degree of pollution and other environmental problems is high. Roughly 70 per cent of China's rivers and lakes are polluted. China's emissions of sulphur dioxide are the highest in the world, and about 30 per cent of China is affected by acid rain. The same degree of concern applies to health: in 1997 the World Bank reported that 178,000 premature deaths in China each year are caused by poor air quality; in 2005, 346,000 hospital inpatient and 6.8 million outpatient visits were due to respiratory ailments.[3]

Like everything else in China, design is also changing rapidly. The number of designers in companies and design consultancies is growing fast each year. The same is true of design schools: today in China there are some 400 schools offering industrial-design classes, which together produce 10,000 industrial-design graduates every year. What are these designers doing now, or what will they be doing in coming years? Judging by what is usually said at design conferences, the answer seems clear: they have to meet what appears to be the biggest Chinese industrial challenge, making the shift from 'Made in China' to 'Designed in China' – that is, from being 'the factory of the world' to becoming 'world-class brands'. But without a commitment to solving the growing environmental and social problems, China's current design expansion will be more a part of the problem than an agent for their solution. If nothing else, China's growing design competence could contribute to oiling the wheels of ongoing unsustainable development, rather than helping to bring about a systemic change towards sustainability.

Can China's energy be reoriented towards a qualitative and sustainable development – that is, one that values social harmony and the environment? Can Chinese design be a positive agent in reorienting this energy in the direction of sustainability? We argue for this possibility. We do so by offering a variety of observations, ranging from divergent signals that are emerging from Chinese society, to design for sustainability. But first let us take a theoretical look at what qualitative and sustainable development means to emerging economies like China, and why it is desirable from their perspective.

The leapfrog. For an emerging economy, taking the route of qualitative and sustainable development means leapfrogging – that is, moving directly to the most advanced sustainable systems of consumption and production, skipping what might be called the intermediate (and unsustainable) phases of the material-intensive industrial economy. Leapfrogging as a development strategy might involve creating both new technological systems (from power generation to food chains, housing and mobility) and social ones (from welfare services to new patterns of consumption and new ways of living). For power generation, it might include the development of innovative technologies for the use of renewable resources, particularly the idea of the 'distributed power-generation' system (an economical and environmentally friendly method of electricity generation from numerous small sources, including solar panels, wind turbines, natural gas-fired micro-turbines and locally sited fuel cells). For mobility, it might refer to developing innovative products and services to promote new transportation systems. In fact, the areas for technological leapfrogging could expand endlessly – for instance, to include agriculture and food (such as organic farming and innovative food chains).

As a development strategy, leapfrogging could in principle be applicable to all emerging economies, but is particularly suitable for China. Being an energetic country with a large internal market and a deep-rooted culture, China has the potential to become a real champion in this kind of leap. In all the areas mentioned above, China also has a real possibility to discover innovative solutions, which can both meet the demand of its domestic market and, in so doing, inspire other countries to tackle similar problems.

Apart from technological leapfrogging, it is also desirable for China to make a social leap, by changing its mode of consumption and ways of living. Social leapfrogging is a non-linear modernization process, in which people move directly from traditional forms of a collaborative way of life to new ones. In this way they can skip the phase of extreme and unsustainable individualization that characterizes western industrial societies today.

Divergent signals. Let us now look for signals that diverge from unsustainable and quantitative economic development in China. The most evident divergent signals, strangely enough, come from the top. While Chinese society as a whole appears more and more unsustainable, the notion of sustainable development is on the official radar and has been translated into actual programmes. In the 11th Five-Year Plan in 2005, sustainable

development even found a Chinese expression: building a 'Harmonious Society'. In our view, the use of this phrase was a significant signal for change. By referring to the need to move towards a harmonious society, the Chinese authorities implicitly acknowledged that the present situation is not harmonious and that a different model is needed.

Are these mere words? Maybe, but as we can observe, something else is happening, in a typically Chinese top-down fashion. The Dongtan Eco-city project, which brings in the expertise of the British engineering group Arup, is one of the best-known examples of the local application of this kind of central directive. In early 2005 Shanghai's municipal government set aside Chongming Island (which is one-fifth the size of Shanghai) to build a new city for ecological and recreational purposes, from eco-tourism to organic agriculture, designed to be the first ecocity in the world.[4] Other government-initiated projects in the same direction are also taking place. The General City Planning for Beijing Municipality, approved by the State Council in 2005, declared that Beijing had set as its goal to become the first municipality to be a 'liveable city', out of a total of four cities (the other three being Tianjin, Shanghai and Chongqing). And in the same year the Urban Greening Committee of Guangzhou municipal government launched a 'garden in the air' programme, aiming to cover 60,000 square metres of roofs with plants.

Grass-roots social innovation. Are there promising signals also emerging from the bottom of Chinese society? The answer is a positive one. A recent consumer survey indicated that 74 per cent of urban consumers would reject environmentally unfriendly products and services.[5] Associations of citizens protesting against pollution are multiplying, and new forms of grass-roots organizations are appearing. Furthermore, several interesting cases suggest that examples of social innovation are also

emerging in people's daily lives.

For instance, a group of young people in the city of Liuzhou in Guangxi province set up a network called Ainonghui, connecting local urban communities who would like to buy organic produce (such as rice, vegetables and poultry) with farmers who prefer traditional farming methods. It's a typical case of bottom-up self-management, whereby the trust between farmers and urban consumers can be recovered. In Shanghai the Luoshan Community Service Centre (a centre for older people) is being run by the people of Luoshan community and supplying social services to them. The centre is currently combining the service for older people with care for young children, creating an opportunity for contact between the generations and for older people to communicate with people from outside. Both communities deliver services based on the notion of self-empowerment and collaboration.[6]. One may dismiss these examples as side-effects of the rise of the urban middle class, as a reflection of the country's recent socialist history, or simply as marginal and insignificant phenomena. But in our view they have to be considered as early cases of a new way of living. They appear mainly in the urban environment because it is there that people face more acute everyday problems. We believe that in the future the numbers of these cases will grow. And once they do – as so often happens with many other Chinese new developments – they will surprise us with their speed and scale.

Design as an agent of change. In the case of design too, in order to see what future China will have, it is necessary to look at some minor, but encouraging, signals. In 2001 a network of Chinese design schools launched a programme to explore the potential of using design as a tool to develop sustainable solutions to problems of everyday life in Chinese cities. Jointly initiated by Hong Kong Polytechnic University, the INDACO Department of

the Politecnico di Milano and the School of Design at Hunan University in Changsha, the programme consisted of a series of workshops held in a number of design schools across China.[7] The results of these workshops were some promising proposals in the areas of work, health care, food and clothing, leisure, house maintenance and community building. The proposed solutions ranged from a preventive health-care service providing the elderly with tips on health maintenance to a seasonal food-delivery service. Given that a great number of young people were involved in the programme, we believe that the potential value of the workshops is more than a simple collection of proposals; rather, it offers real possibilities for the future.[8]

To conclude, in order to follow the direction that China might take in the future, one needs to break away from the mainstream rhetoric about the Chinese economic boom and the social and environmental consequences it has incurred – not because it is not true, but because China is not simply this. As the above observations have shown, one has to be sensitive to emerging signals that diverge from the unsustainable mode of development. We believe that the Chinese future is not closed, but is still open to the possibility of change. We wish to finish our essay with a quotation from Miaosen Gong, a Chinese design student in Milan:

People judge according to what they see. What they see are the tips of icebergs ... in China now, the tips are the people who, due to wealth disparity, are living in very particular conditions and are driven by particularly unsustainable ideas on well-being. But if we really look at families who are in average living conditions, they often perpetuate traditional Chinese virtues like temperance, saving and restraint in their everyday life. For me, it is easy to recognize such people. I only need to look at my family and at the families of my friends around me.[9]

155. Arup, artist's impression of Dongtan Eco-city, phase one completion 2010.
156. Ainonghui, Local Produce Museum, Liuzhou, Guangxi province.
157. Jenny Ma, Agnes Siu, Catherine Mui, Communal washing service, illustration, 2006.

155

156

157

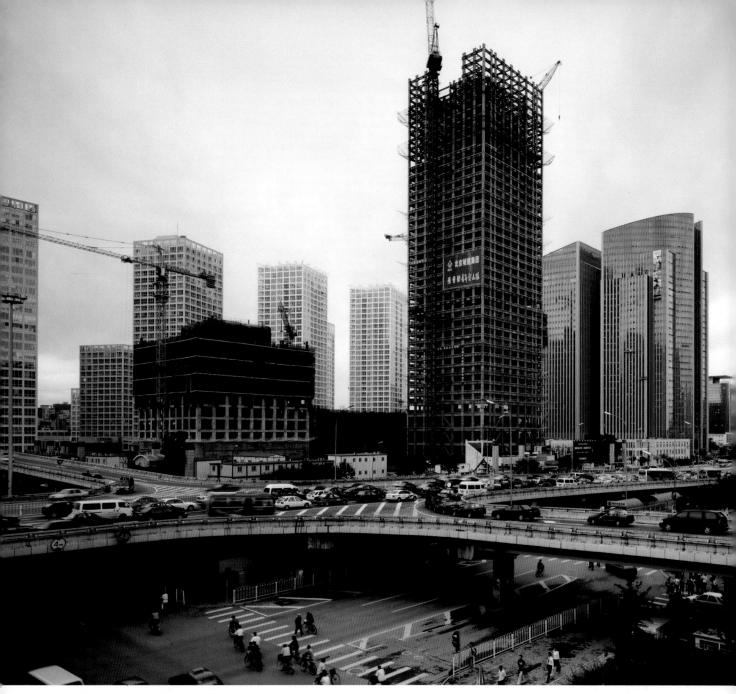

158. Guomao Bridge, Beijing, 2006.
Images on this and following pages: Zeng Li, A China Chronicle, photography series, 1998–ongoing.

BEIJING BUILDING

ZENG LI

'There are always some annoying people asking me: "Your profession is miles away from architecture. Why do you do this?" What a superficial question it is! I take or show my photographs [of the city], because the camera can force me to look at the environment I am living in with clear eyes, and force others to care about it too.' Zeng Li.

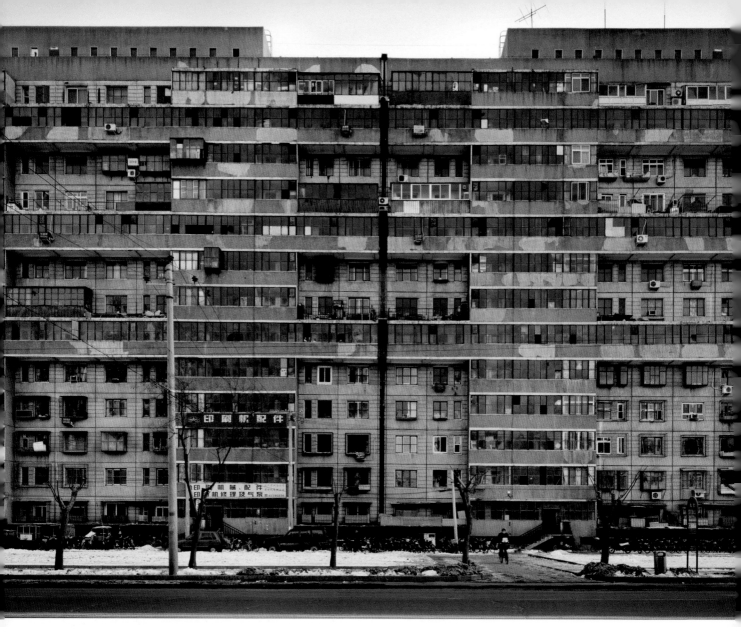

159. 46 Guangqu Road, Beijing, 2001.

FUTURE CITY

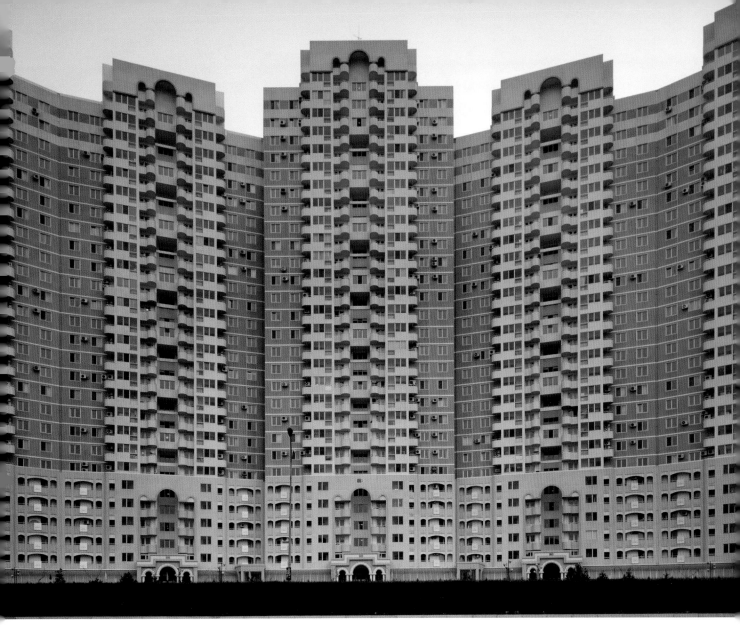

160. Lianhua Estate, Beijing, 2001.

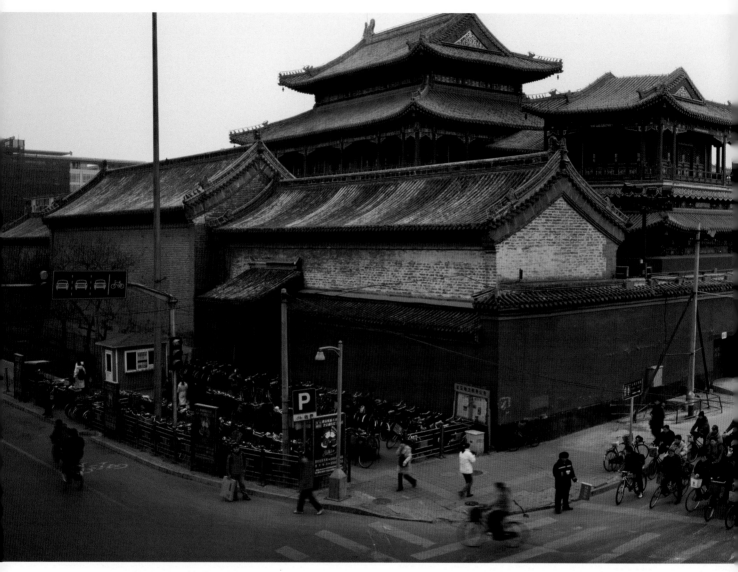

161. Yonghe Temple Road, Beijing, 2005.

FUTURE CITY

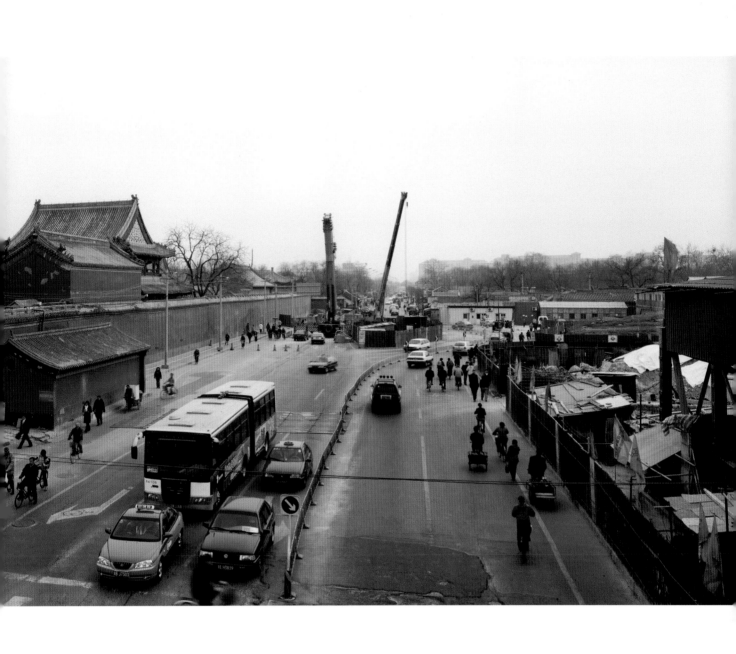

162. Caochang Qi Tiao, Beijing, 2006.

FUTURE CITY

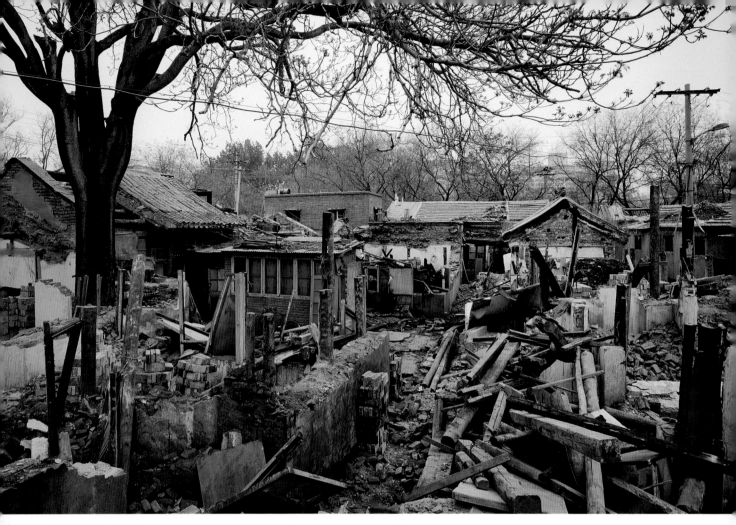

163. Chayuan Hutong, Beijing, 2006.

FUTURE CITY

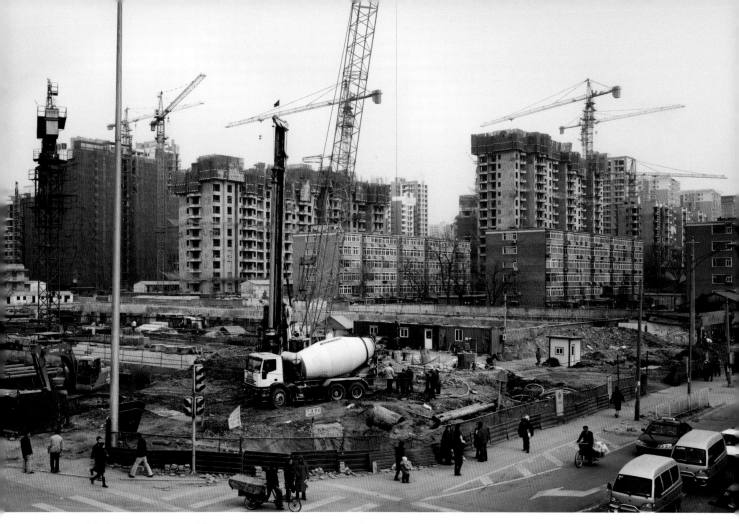

164. Construction site of Shuangjing Bridge Metro Line 10, Beijing, 2006.

165. Outside Chongwenmen, Beijing, 2001.

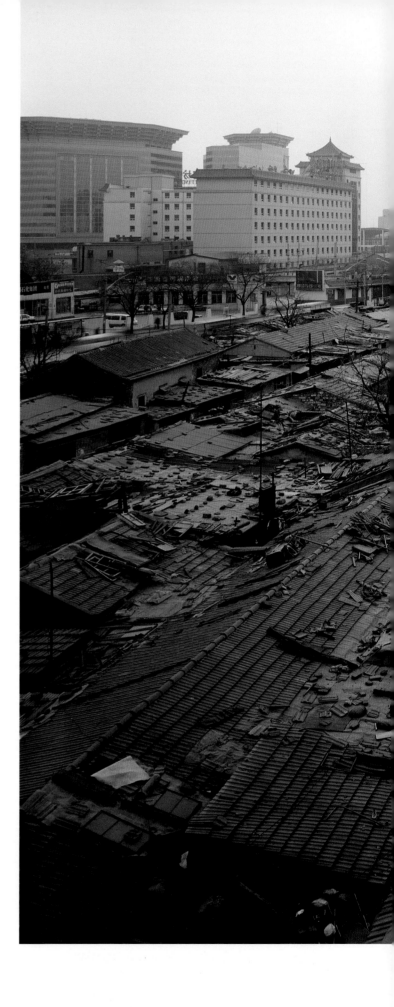

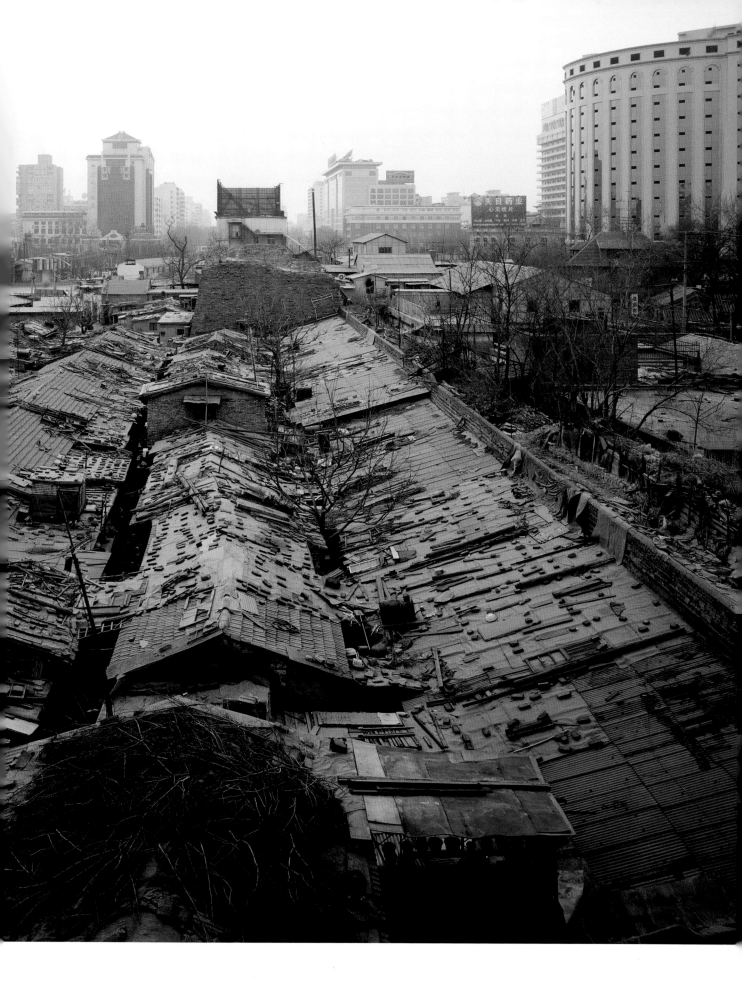

166. Kang Ling, Ming Tombs, Beijing, 1998.

FUTURE CITY

NOTES

Chronology: 1949–2008. Sources:
Edward L. Davis, *Encyclopedia of Contemporary Chinese Culture* (London and New York, 2005)
He Jiaxun and Lu Taihong, *Zhongguo yinxiao ershiwu nian 1979–2003* [*Twenty–five Years of Chinese Marketing*], (Beijing, 2004)
Liu Libing (ed.), *Zhongguo guanggao mengjin shi 1979–2003* [*A History of Chinese Advertising*], (Beijing, 2004)
Robert John Perrins, *China: Facts and Figures Annual*, vols 1–30 (Florida, 1978–)

Introduction – Zhang Hongxing and Lauren Parker
1. Joshua Cooper Ramo, *Beijing Consensus* (London, 2004), p.3
2. Peter Nolan, *Transforming China: Globalisation, Transition and Development*, quoted in Sheila Lewis, 'China: Threat or Opportunity?', *Spiked*, 13 October 2005; www.spiked-online.com, consulted 1 July 2007
3. Cooper Ramo (2004), p.10
4. Peter Nolan, *China at the Crossroads* (Cambridge, 2004)
5. Cooper Ramo (2004), p.7
6. Isabel Hilton, www.chinadialogue.net, consulted 1 July 2007
7. Tony Blair's speech to the EU Parliament, 23 June 2005, www.number-10.gov.uk/output/Page7714.asp, consulted 1 July 2007
8. Ole Bouman, editorial, *Volume 8: Ubiquitous China*, no.2, 2006, p.6
9. For instance, UK Trade & Investment, *Changing China – The Creative Industry Perspective: A Market Analysis of China's Digital and Design Industries*, 2004; *Cox Review of Creativity in Business: Building on the UK's Strengths*, 2005, pp.6–8; UK DCMS, *Staying Ahead: The Economic Performance of the UK's Creative Industries*, 2007, pp.37–9
10. Clive Dilnot, 'Which Way Will the Dragon Turn? Three Scenarios for Design in China Over the Next Half-Century', *Design Issues*, vol.19, no.3, Summer 2003, pp.5–20
11. John Heskett, 'Design in China', paper given at the 'China Design Now' workshop, co-organized by the V&A and the Central Academy of Fine Art, Beijing, 12–14 October 2005
12. Ibid.
13. Chen Zhili, 'Science & Technology and Talent: The Two Pillars of a Well-off Society', *Qui Shi*, no.18, 2006, pp.19–22
14. *Cox Review* (2005), p.6
15. Hu Angang, 'The Emergence of Informal Sector and the Development of Informal Economy in China's Transition: A Historical Perspective (1952–2004)', May 2006, www.siteresources.worldbank.org, consulted 1 May 2007; see also Hasan Kaplan and David Peterson, 'Informal Entrepreneurs', *Chengshi zhongguo* [*Urban China*], no.9, 2006, pp.117–18
16. Saskia Sassen, 'Why Cities Matter' in Richard Burdett (ed.), *Cities: Architecture and Society* (Venice, 2006), p.43
17. Qingyun Ma, 'Chaogeng', in Chuhua Judy Chung, Jeffrey Inaba, Rem Koolhaas, Sze Tsung Leong, *Great Leap Forward*, Harvard Design School Project on the City (Cambridge, MA, 2001), p.183
18. Nancy Lin, 'Architecture: Shenzhen', in ibid., p.183
19. Li Yuanchao, Governer of Jiangsu Province, 'New Concepts of Socialist China', speech to All Party China Group, House of Commons, March 2007
20. Lewis (2005); Stephanie Hemelryk Donald and Robert Benewick (ed.), *The State of China Atlas: Mapping the World's Fastest Growing Economy* (Sydney, 2005), p.26
21. Jay Merrick, 'Are you ready for take-off?', *Art Review*, November 2004, pp.116–9
22. Donald and Benewick (2005), p.49
23. China Central Television, *Shangpin de gushi* [*The Story of Commodities*], (Beijing, 2001)
24. UK Trade and Investment, *Changing China – The Creative Industry Perspective: A Market Analysis of China's Digital and Design Industries*, 2004
25. Li Yuanchao (2007)

26. Mark Ward, 'China's Tight Rein on Online Growth', www.bbc.co.uk/news, consulted 1 December 2006
27. Richard Taylor, 'China Wrestles with Online Gamers', www.bbc.co.uk/news, consulted 5 May 2006
28. Peter Rowe, *East Asia Modern: Shaping the Contemporary City* (London, 2005), p.18
29. Arif Dirlik and Zhang Xudong (ed.), *Postmodernism and China* (Durham and London, 2000)
30. Zhang Yiwu, 'Xin shiji wenxue: kuachu xin wenxue zhihou de sikao' ['Literature in the New Century: A Reflection beyond "New Literature"], *Wenyi Zhengming*, no.4, 2005, pp.7–14
31. Hu Jintao, Speech to Party School quoted in *People's Daily* editorial, www.48groupclub.org, consulted 1 July 2007
32. Ezio Manzini, 'Products in a Period of Transition', quoted in Guy Julier, 'The Bigger Future of European Design', abstract of a paper given at the Escola de Disegni i Art, Barcelona, 2004

Shenzhen: Frontier City – Zhang Hongxing
1. Leung Ping Kwan, 'Border', in Kai Vöckler and Dirk Luckow (ed.), *Peking Shanghai Shenzhen: Städte des 21. Jahrhunderts* (Frankfurt and New York, 2000), p.553
2. Due to its large land and population, China's administrative structure has always consisted of several levels of division since ancient times. Currently there are four practical levels of local government: the province, prefecture, county and township. Under this structure, a provincial-level city reports directly to the central government.
3. The commune was a large administrative unit in China's countryside from the late 1950s to the early '80s, with its average size equivalent to that of a *xiang* (township) after the reform.
4. Ezra F. Vogel, *One Step Ahead in China: Guangdong under Reform* (Cambridge, MA, and London, 1989), p.136
5. Ibid., pp.135–40
6. For a full explanation of 'city of exacerbated difference', see Chuhua Judy Chung, Jeffrey Inaba, Rem Koolhaas, Sze Tsung Leong, *Great Leap Forward*, Harvard Design School Project on the City (Cambridge, MA, 2001), p.9
7. For a good survey of modern Chinese graphic design up to the early 1980s, see Shou Zhi Wang, 'Chinese Modern Design: A Retrospective', in *Design History: An Anthology, A Design Issues Reader*, ed. Dennis P. Doordan (Cambridge, MA, and London, 1995), pp.229–32
8. The term *meigong* lies deep in the memory of the designers who have gone through the period. See Han Zhanning's interviews with Wang Xu and Chen Shaohua, originally published in *Shenzhen shanghbao* [*Shenzhen Commercial News*], 10 and 18 November 2004, www.dolcn.com, consulted 25 November 2004
9. Ji Long (ed.), *Dangdai zhongguo de gongyi meishu* [*Contemporary Chinese Applied Art*], (Beijing, 1984), pp.390–93. Chinese universities were closed down during the first half of the Cultural Revolution and partially reopened in 1972; the university entrance examination system was not fully restored until 1977.
10. See illustrations in Liu Libing (ed.), *Zhongguo guanggao mengjin shi 1979–2003* [*A History of Chinese Advertising 1979–2003*], (Beijing, 2004), pp.8, 10, 12, 15
11. As the antithesis of state-owned enterprises, township and village enterprises were entrepreneurial entities based in townships and villages in the 1980s. This unique system has declined since the mid-1990s.
12. For Guangzhou Academy of Fine Arts' leading role in the reform of design education in the 1970s and '80s, see Shao Hong and Yan Shanchun (ed.), *Suiyue mingji – Zhongguo xiandai sheji zhilu xueshu yantaohui lunwen ji* [*Documenting the Past – Essays Presented in the Conference 'The Chinese Road Towards Modern Design'*], (Changsha, 2004), preface, pp.3–5
13. For the introduction of Bauhaus design principles and debates, see Yuan Xiyang, *Zhongguo yishu sheji jiaoyu fazhan licheng yanjiu* [*A Study in the*

Development of Chinese Art and Design Education], (Beijing, 2003), pp.257–9
14. Chen Ruilin, *Zhonguo xiandai yishu sheji shi* [*A History of Modern Chinese Design*], (Changsha, 2003), pp.172–3
15. He Jiaxun and Lu Taihong, *Zhongguo yingxiao ershiwu nian 1979–2003* [*Twenty-Five Years of Chinese Marketing 1979–2003*], (Beijing, 2004), pp.104–105
16. See the director of the Baima Advertising Company Han Ziding's interview in the TV series *Zhongguo guanggao ershi nian* [*Twenty Years of Chinese Advertising*], (Beijing, 1999), episode 15
17. Han Zhanning interview with Wang Xu
18. Author interview with Wang Yuefei, April 2006
19. Author interview with Wang Yuefei, March 2007
20. Ibid.
21. Han Zhanning interviews with Chen Shaohua, Han Jiaying, Bi Xuefeng, Zhang Dali
22. Han Zhanning interview with Wang Xu
23. Wendy Siuyi Wong, 'Detachment and Unification: A Chinese Graphic Design History in Greater China since 1979', *Design Issues*, vol.17, no.4, Autumn 2001, p.53
24. Wei Yew, 'Graphic Design in China Show', *Communicate Arts*, September/October 1992, p.50
25. Han Zhanning's interviews with Han Jiaying, Bi Xuefeng, Wang Yuefei, Zhang Dali, Chen Shaohua
26. Committee of *Graphic Design in China 96* (Guangzhou, 1996), preface
27. Shenzhen Graphic Design Association, *Communication: Poster Exhibition 1996* (Shenzhen, 1996), p.9
28. Zdzislaw Schubert, 'Poles & Posters', *Print*, March/April 2001, p.159
29. Siuyi Wong (2001), p.67
30. Author's interview with Jiang Hua, one of the organizers, October 2006
31. Tan Ping, 'Zhongguo dandai qianwei yishujia zhaotie zhan 2001' ['An Exhibition of Posters by Contemporary Chinese Avant-garde Artists 2001'], *Art and Design*, no.2, 2001, pp.92–6
32. Among many websites, the article (with original Chinese title 'Shenzhen – Ni bei shui paoqi') can be found on www.china.org.cn/chinese/zhuanti, consulted April 2007
33. Han Zhanning's interview with Ou Ning on 26 December 2001, www.dolcn.com, consulted November 2006
34. Liu Qiongxiong, '1994–2004 zhongguo chengshi xin wenhua qianxing kuangbiao' ['1994–2004 new cultural whirlwind in urban China'], *Chengshi huabao* [*City Pictorial*], no. 16, 2004, www.gotoread.com, consulted April 2007; see also Ou Ning, 'Guangzhou chuanmei and xin sheying' ['Influence of the Media Industry on the New Photography in Guangzhou'], www.alternativearchive.com/ouning, consulted October 2006
35. Ou Ning, *Beijing xinsheng* [*New Sound of Beijing*], (Changsha, 1999)
36. For the history of the *dakou* CDs, see Yan Jun, 'Tie xue huo huo daohan: zuiyi shinian yaogun' ['Iron and blood or night sweat: recalling the ten-year rock and roll'], ed. Li Hongjie, in *Zhongguo yaogun shouce* [*Encyclopedia of China Rock and Roll*], (Chongqing, 2006), pp.357–8. For an interpretation of the cultural significance of the *dakou* generation, see Jeroen de Kloet, 'Popular Music and Youth in Urban China: the *Dakou* Generation', *The China Quarterly*, September 2005, pp.609–626
37. You Dali, www.guangzhou.elong.com/theme/themei48.html, quoted in de Kloet (2005), p.617
38. Ou Ning, 'Zhongguo xin sheji de fasheng' ['New Voice of Chinese Design'], special issue, supplement of *Modern Weekly* magazine, no. 32, 2005, p.3
39. Lvxiao calendar, 15 February 2007, www.lvxiao.com, consulted April 2007
40. Yan Jun, 'Shougong zuofang de kuaile' ['The Pleasure of Tambourine'], *Art and Design*, no.58, October 2004, p.74

Try the Crab – Huang Zhicheng

* The title of this essay derives from the Chinese saying 'The First Man to Eat Crabs', which refers to a man who is brave enough to try something for the first time.

Shanghai: Dream City – Lauren Parker

1. Richard Burdett, 'City-building in an age of global urban transformation', *Cities: Architecture and Society* (Venice, 2006), p.6
2. Jo-Anne Birnie Danzker, 'Shanghai Modern', *Shanghai Modern 1919–1945* (Munich, 2004), p.18
3. As described by visiting Seattle artist Mark Tobey in 1934; ibid., p.62
4. A description of the term *modeng* is given by Xu Jiang in his essay 'The "Misreading" of Life', *Shanghai Modern 1919–1945* (Munich, 2004), p.72
5. Birnie Danzker (2004), p.18
6. Zheng Dongtian, 'Films and Shanghai', *Shanghai Modern 1919–1945* (Munich, 2004), p.300
7. Andreas Steen, 'Tradition, Politics and Meaning in 20th-century China's popular music. Zhou Xuan: "When Will the Gentleman Come Back Again?"', *Chime*, 14–15 (1999–2000), p.150
8. Audrey Yue, 'In the Mood for Love: Intersections of Hong Kong Modernity', *Chinese Films in Focus* (London, 2003), pp.128–34
9. Dynamic City Foundation, 'Beijing and Beyond', www.dynamiccity.org, October 2005
10. David Gilbert, 'From Paris to Shanghai: the changing geographies of fashion's world cities', *Fashion's World Cities* (Oxford, 2006), p.3
11. Ibid., p.3
12. Ibid., p.20
13. Charlotte Windle, 'China luxury industry prepares for boom', www.bbc.co.uk/news, December 2006
14. 'Shanghai Princesses', *Lifesigns Network Newsletter*, February 2007
15. Gilbert (2006), p.32
16. Charlotte Windle, 'China luxury industry prepares for boom', www.bbc.co.uk/news, December 2006
17. Jane Macartney, 'So this year', *The Times Magazine*, 17 September 2005
18. Edward Cody, 'In China, Dream of Big Ideas', www.washingtonpost.com, June 2006
19. Interview with Wang Yiyang, www.peoplesarchitecture.com, January 2007
20. Ibid.
21. Author interview with Ma Ke, September 2006
22. Jane Macartney, 'So this year', *The Times Magazine*, 17 September 2005
23. Huang Wei, 'China's Urban White-Collar Class', www.bjreview.com.cn, June 2006
24. Gilbert (2006), p.18
25. Richard Burdett, 'City-building in an age of global urban transformation', *Cities: Architecture and Society* (Venice, 2006), p.6
26. Author interview with Yin Zhixian, October 2006
27. Jing Wang, 'Youth culture, music, and cell phone branding in China', *Global Media and Communication*, vol.1 (2), pp.185–201
28. Hannah Macmurray, 'China Auto Show: Beijing 2004', www.cardesignnews.com, January 2006
29. 'New China', *Amelia's Magazine*, 06 A/W 2006, p.216
30. Mark Ward, 'China's tight rein on online growth', www.bbc.co.uk/news, December 2006
31. In 2004 more than 47,000 Internet cafés were closed down for breaking guidelines, and in 2006 Amnesty International identified 54 people imprisoned in China for distributing 'illegal' information via the Internet; ibid.
32. Dynamic City Foundation, 'China's emergent media culture', www.dynamiccity.org, March 2006
33. Author interview with P.T. Black, October 2006
34. Allen Verney, 'Red Blindness', www.escapistmagazine.com, December 2006
35. Ibid.

Beijing: Future City – Jianfei Zhu

1. David Harvey, *A Brief History of Neoliberalism* (Oxford, 2005), pp.1–4
2. Huang Ping and Zhan Shaohua, 'Internal migration in China: Linking it to development', *Regional Conference on Migration and Development in Asia* (Lanzhou, 2005), p.3; and 'China's Urbanization, 10 Per Cent Higher within 10

Years', *People's Daily Online*, http://english.peopledaily.com.cn/200212/06/eng20021206_108064.shtml, consulted 13 February 2007

3. Jianfei Zhu, *Chinese Spatial Strategies: Imperial Beijing 1420–1911* (London, 2004), p.29

4. Dong Guangqi, *Beijing guihua zhanlue sikao* [*Thoughts on planning strategies for Beijing*], (Beijing, 1998), pp.404–5

5. Dong (1998), pp.386–8, 393–5

6. *Jianguo yilai de Beijing chengshi jianshe ziliao, di yi juan: chengshi guihua* [*Documenting materials of urban construction of Beijing since 1949, vol.1: Urban planning*], (Beijing, 1987), pp.88–9

7. The regulations in 1985, 1987 and 1990 are found in Dong (1998), p.400

8. Wang Hui, 'The Historical Origin of China's Neo-Liberalism', in Tian Yu Cao (ed.), *The Chinese Model of Modern Development* (London, 2005), pp.61–87

9. Dong (1998), p.417, and Ma Guoxin, 'Santan jiyu he tiaozhan' ['Three comments on opportunities and challenges'], *World Architecture*, 169, July 2004, pp.19–21

10. Fang Ke, *Dangdai Beijing jiucheng gengxin* [*Contemporary renewal of the old city of Beijing*], (Beijing, 2000), p.52

11. Dong (1998), p.413

12. Beijing Municipal City Planning Commission (ed.), *Beijing lishi wenhua mingcheng Beijing huangcheng baohu guihua* [*Conservation plan for the historical city of Beijing and the Imperial City of Beijing*], (Beijing, 2004), p.12; and Wang Jun, 'Zhengti baohu tichu zhihou' ['What happens after the release of the comprehensive conservation plan'], *Outlook Weekly*, 19, 8 May 2006, pp.20–21

13. 'Guowuyuan huiyi yuanze tongguo Beijing chengshi guihua 2004–2020' ['The State Council has approved in principle the Beijing Plan 2004–2020'], sina.com.cn 12 January 2005, http://news.sina.com.cn/o/2005-01-12/21284810260s.shtml, consulted 7 February 2007

14. Interview with Long Yongtu on 18 September 2001, available at *Xinhua News*, http://news.xinhuanet.com/fortune /2001-09/25/content_42797.htm, consulted 13 February 2007

15. The Action Plan for the 2008 Olympics discussed here was obtained from www.china.com.cn/chinese/zhuanti/177019.htm, consulted 13 February 2007

16. Ma Guoxin (2004), pp.19–21; and Li Bing, '1978 Nian Yilai Wailai Jianzhushi zai Beijing Jianzhu de Xiangguan Yanjiu: Projects Designed by Foreign Architects in Beijing since 1978', T+A, (1-2005), 14-8

17. Mark Wigley, 'Deconstructivist Architecture', in Philip Johnson and Mark Wigley, *Deconstructivist Architecture* (New York, 1988), p.19

18. Jianfei Zhu, 'Criticality in between China and the West', *Journal of Architecture*, 5, November 2005, p.485

19. Anthony D. King and Abidin Kusno, 'On Be(j)ing in the World: "Postmodernism", "Globalization" and the Making of Transnational Space in China', in Arif Dirlik and Xudong Zhang (eds), *Postmodernism and China* (Durham and London, 2000), p.61

20. Jianfei (2004), pp.222–34

21. David Harvey, *Spaces of Capital: Towards a Critical Geography* (Edinburgh, 2001), pp.394–411; and Charles Jencks, *The Iconic Building* (New York, 2005), pp.7–19, 101–12

22. Statement available at www.designbuild-network.com/projects/terminal-5-beijing/, consulted 7 February 2007

Commuting in China – Helen Evenden

1. 'Demonstration New Towns in South, East and West China', www.chinauscenter.org/organization/newsdetails.asp?NewsID=41&NAV=1, consulted March 2007

2. Madame Nie Meisheng, president of the China Housing Industry Association, at a presentation of the development plans for Ningbo and Liuzhou, 19 May 2005: www.chinauscenter.org/organization/newsdetails.asp?NewsID=48&NAV=1, consulted March 2007

3. Li Shufu came to public attention with the start-up of the first private car manufacturer in China. He was born in Zhejiang province (often referred to as the 'cradle of capitalism' in China) and started his first refrigerator company in 1986, then launched into the manufacture of interior materials in 1989, motorcycles in 1994 and passenger cars in 1997. Geely now operates four car-assembly plants in Zhejiang province and Shanghai, with a production capacity of 250,000 units per year.

4. Chunli Lee, 'China targets Detroit', *World Business*, April 2006, p.30

5. 'Cars in China', *The Economist*, June 2005

6. According to Automotive Resources Asia, http://en.chinabroadcast.cn/855/200 6/04/05/501@71813.htm, April 2006

7. By Ward's Staff From Wires, WardsAuto.com, 5 February 2007, © 2007 Prism Business Media, Inc.

8. Chunli Lee, 'China targets Detroit', *World Business*, April 2006, p.29

9. 'Chinese company halts production of ForTwo lookalike', *Auto News Europe*, November 2006

10. S.J. Choi, 'Beijing Motor Show 2006 – Highlights', www.cardesignnews.com, 22 November 2006

11. www.edmunds.com/insideline/do/News/articleId=108526, consulted June 2007

12. Shanghai Automotive bought the plans for the cars and the rights to make them from MG Rover Group, before the British company filed for bankruptcy in April 2005.

13. www.roadtraffic-technology.com/projects/real-time, consulted March 2007

14. www.mcdonoughpartners.com/projects/liuzhou/default.asp?projID=liuzhou, consulted March 2007

15. Madame Nie Meisheng, 19 May 2005, www.chinauscenter.org/organization/newsdetails.asp?NewsID=48&NAV=1, consulted March 2007

Changing the Change – Ezio Manzini and Benny Ding Leong

1. The background to this essay is a long collaboration between the two authors in the promotion of *design for sustainability* in China. The essay itself was jointly conceived and framed.

2. 'Income gap in China widens in first quarter', *China Daily*, 19 June 2005

3. Jim Yardley, 'China's next big boom could be the foul air', *New York Times*, 30 October 2005; Hamish McDonald, 'China clears the way for Kyoto trade', *Sydney Morning Herald*, 15 February 2005

4. Herbert Girardet, Chairman of the influential Schumacher Society, presents it in this way: 'Dongtan is a local project with a global perspective to ensure that China will play a key role in the emergence of a world of ecologically and economically sustainable human settlements.' See Z. Yan and H. Girardet, *Dongtan Eco-city* Shanghai, 2006)

5. Hollyway Consult, *The 60th New Thinking Methods for SME* (Beijing, 2004)

6. These examples were found in the first, exploratory phase of an ongoing research project called 'Creative Communities for Sustainable Lifestyle' (CCSL). The project has been developed in Brazil, India and China. More examples can be found in the 2006 CCSL working documents, and on its website: http://www.sustainable-everyday.net

7. These schools were Hong Kong Polytechnic University School of Design in Hong Kong, Guangzhou Academy of Fine Arts in Guangzhou, Hunan University in Changsha and Tsinghua University in Beijing.

8. Some of the workshop results are now published; see B.D. Leong and E. Manzini, *Design Vision: A Sustainable Way of Living in China* (Guangzhou, 2006)

9. Miaosen Gong, *Introduction to a Thesis on Sustainable Design in China*, internal document (DIS-Indaco, Politecnico di Milano, 2006)

PICTURE CREDITS

Images and copyright clearance have been kindly supplied as listed below by institution or surname. Numbers refer to plate references.

Page 10: Maleonn
1 *Business Week*, European edition
2 *Business Week*, Asian edition
3 © Gilles Sabrie
4 Luo Kaixing
5 Freeman Lau
6 Taddy Ho
7–9 Kan Tai-keung
10–11 Wang Xu
12 Alan Chan
13 Kan Tai-keung
14 Wang Xu
15 He Jianping
16 Han Zhanning
17 Wang Yuefei
18–20 Han Jiaying
21 MEWE Design Alliance
22 Guan Xiaojia
23 Ji Ji
24 Qian Qian
25 Fang Er/Meng Jin
26 Fotoe.com
27–8 He Huangyou
29 Nanfang Food
30 Guangzhou Libai/*Tianjin Daily*
31 Guangdong Apollo
32 Luo Kaixing
33 Wang Yuefei
34 Ahn Sang-soo
35 Chen Shaohua
36 Han Jiaying

37 Wang Xu
38 He Jianping
39 Bi Xuefeng
40 Chen Feibo
41 Feng Jiangzhou
42 Modernsky
43 Modern Media
44 Yan Cong
45 MEWE Design Alliance
46 Gu Fan
47 China Communist Youth League and CCTV
48 CCTV Mass Media International Agency and CCTV Advertisement Division
49 Mengniu Dairy and CCTV Advertisement Division
50 Hao Xueli
51 Minist ry of Health and Durex
52 Han Jiaying
53 Wang Yuefei
54 Chen Shaohua
55 Wang Yuefei
56 Huang Yang
57 Jiang Jian
58 Ou Ning
59–60 Jiang Jian
61–2 MEWE Design Alliance
63–4 Ji Ji
65–75 Yu Haibo
76 Shya-la-la Production/*Time* magazine
77 Chen Man/*Vision* magazine
78 Liuligongfang/photograph: Lin Fu-Ming
79 Number D/Jiang Qiong Er
80 Lin Jing/photograph: Mei Yuangui
81 Shao Fan/photograph: Zhang Zhaozeng
82 © Jan Siefke/*Wallpaper**/IPC Syndication
83 Wang Yiyang

84 Zhang Da/photograph: Peng Yangjun
85 Jerry Driendl/Getty Images
86 V&A Images/V&A: 2006AL3457
87–8 Shanghai History Museum
89 Yongfoo Elite
90 Chien-Min Chung/*Time* magazine
91 Tartan Films/Jet Tone Production/Shya-la-la Production
92 Julian de Hauteclocque Howe/*Vogue China*
93 Han Feng
94 Ma Ke/photograph: Shu Lei
95 Chien-min Chung/*The Times* magazine
96–7 Weng Peijun (Weng Fen)
98 adFunture
99 Nike/HIMM
100 *Trends Home* magazine/photograph: Li Zhibin
101 *Trends Home* magazine/photograph: Ma Xiaochun
102 *Trends Home* magazine/photograph: He Sien
103 Liu Yang/photograph: Zhuan Zhi
104 Wang Xinyuan
105 Wu Haiyang
106 Ma Ke/photograph: Shu Lei
107 Alex So/'Coldtea'
108 Alex So/'Coldtea'
109 Han Han/photograph: Wang Jiemin
110 Modernsky
111 JVR Music/photograph: Shao Tinghui
112 *Time* magazine, Asia edition/photograph: Cancan Chu
113–26 Hu Yang
127 Iwan Baan/Herzog & de Meuron
128 Foster + Partners
129 Studio Pei-Zhu
130 PTW Architects © Sinopictures/Ma Wenxiao
131 Miao Xiaochun
132 Bureau of Shanghai World Expo Coordination,
 Communication and Promotion Department

133 Huang Weiwen/Atelier FCJZ
134 Jiang Jun
135 Turenscape/photograph: Yu Kongjian
136 cj Lim/Studio 8 Architects
137 *Jianzhu Xuebao*/photograph: Li Jilu
138 Frank P. Palmer/Office for Metropolitan Architecture
139 Office for Metropolitan Architecture
140 Atelier FCJZ/Soho China/Kempinski Hotels/
 photograph: Satoshi Asakawa
141 MADA s.p.a.m./photograph: Zhan Jin
142 China Architecture Design and Research Group/Soho China/
 Kempinski Hotels/photograph: Florent Nicolas Wendling
143 Scenic Architecture/photograph: Shen Zhonghai
144 Amateur Architecture
145 Jiakun Architects/photograph: Bi Keijan
146 Limited Design/photograph: Cao Youtao
147 Studio Pei-Zhu/photograph: He Shu
148 Studio Pei-Zhu/photograph: Zhu Pei
149–50 Studio Pei-Zhu
151 China Architecture Design and Research Group/
 photograph: Zhang Guangyuan
152 Atelier FCJZ/photograph: Sze Tsung Leong
153 Miao Xiaochun
154 China photos/Getty Images
155 Arup
156 Image courtesy of Ezio Manzini
157 Jenny Ma/Agnes Siu/Catherine Mui
158–66 Zeng Li

GLOSSARY

The Bund: The waterfront area of Shanghai, on the western bank of the Huangpu River, facing Pudong. The Bund usually refers to the buildings and wharves on the section of Zhongshan Road within the former International Concession. Since the 1990s its colonial buildings, including the Peace Hotel, have been re-invented as high-end business, retail and entertainment destinations.

City Registration: The personal identity document required by Chinese citizens to live and work in Chinese cities legally. It is part of a residency permit system implemented from 1958 onwards, which classified individuals as 'rural' or 'urban' residents. Since the mid-1990s the system has been relaxed, so that rural migrant workers can get temporary residence permits.

Cultural desert: This phrase first acquired popularity when New Culture ferment erupted around 1917. Iconoclastic intellectuals and students claimed that traditional China was a cultural desert, and called for total westernization. The Pearl River delta is often referred to as a cultural desert for its geographical distance from alleged cultural centres such as the Yangtze River delta and Beijing, and for the social values of the region, based on money and commercial success.

Cultural Revolution: The period of turmoil and political upheaval from 1966 to 1976, instigated by Chairman Mao Zedong. The Cultural Revolution was Mao's attempt to drive Chinese society towards Marxist, ideologically led values. Its duration, aims and legacy are all disputed. Factional struggles and civil disorder led to great loss of life and social and economic violence during the Cultural Revolution. Schools and universities shut for several years, and the period was characterized by strong nationalism and anti-intellectualism. In China today, Cultural Revolution motifs have been replicated and commercialized, as a self-consciously nostalgic or ironic aesthetic.

Eight Trigrams: The Book of Changes, a philosophical and divination classic possibly dating to the ninth century BC, uses designs composed of groups of three lines to interpret events and predict the future. These sets of three lines, consisting of broken and unbroken parts, are known as trigrams.

Eighties generation: A generation born in the 1980s, mostly the 'only child' of their parents. Growing up in the 'Reform and Opening Up' period, they are under the influence of China's rapid economic growth, urbanization and commercial culture. People of the Eighties generation in big cities are characterized by the public and press as fashionable, self-centred, fame-seeking and carefree; always ready to challenge traditional values.

Five-Year Plan: China's economy has been centrally planned since the foundation of the communist state, the People's Republic of China, in 1949. The first Five-Year Plan ran from 1953 to 1957; currently the 11th Five-Year Plan (2006–10) guides the country's modernization drive.

Floating population: Mostly migrants from rural areas carrying out low-paid construction, manufacturing and service-sector jobs in the cities. Official estimates set the floating population at 140 million people in 2005, representing more than 10 per cent of the Chinese population.

Forbidden City, Beijing: The former imperial palace of Ming and Qing emperors from 1420 to 1911 in Beijing, is generally known in modern Chinese as *Gugong*, 'Former Palace'. Located in the centre of the city, it is a

UNESCO world heritage site. Measuring 961 metres from north to south, it is 'Forbidden' because, in the past, ordinary people could enter only with the emperor's permission.

Four Great Things: Before 1980, well-to-do Chinese families aspired to own a bicycle, a watch, a sewing machine and a radio. Later the list changed to a refrigerator, a television, a tape-recorder and an electric fan. By 2000, economically successful people could expect to acquire a different four: a car, a mobile phone, a laptop and an apartment.

French Concession: An area of Shanghai formerly under French rule. It lies to the south of International Concession and to the west of the old Chinese city. Today it includes the Huaihai Road shopping area, the Jinjiang Hotel, with its fine Art Deco features, and Zikawei Cathedral.

Greater China region: This term is used by economists and journalists to refer to Taiwan in addition to the People's Republic of China, including Hong Kong and Macao. Occasionally Singapore, with its large Chinese community, is also included.

Harmonious Society: Since about 2005 the top leadership of the Chinese Communist Party has proposed a shift from all-out economic growth towards greater emphasis on social well-being. The phrase 'Harmonious Society' can be understood as shorthand for the urgent need to address a raft of social and economic problems, including unemployment, environmental degradation, corruption and increasing social inequalities.

Hutong: Narrow lanes and streets formed by lines of traditional courtyard houses in Beijing. The word derives from the Mongolian *hottog*, meaning 'water well'. A few areas of the city have been designated conservation zones, in order to preserve the traditional courtyard architecture.

Maglev: The Shanghai Maglev, with a top speed of 431 kilometres per hour, is the world's first high-speed magnetic-levitation train line. German-made, it has run since 2004 between Pudong airport and central Shanghai.

Mainland China: A term used to indicate the People's Republic of China, excluding Taiwan, Hong Kong and Macau.

One Child family policy: To limit population growth, regulations began in 1980 to control family size. In many cities a strict family-planning regime allowed only one child per couple, while in rural or ethnic-minority areas two or more children were permitted. The One Child family policy has attracted praise for its demonstrable achievement in reducing population pressure. It has been criticized for causing gender imbalance, since many Chinese people in rural areas continue to favour boys, and the practices of female abortion, infanticide and abandonment continue.

'Opening Up' policy: See Southern Tour and Special Economic Zone.

Pearl River delta: The low-lying coastal area alongside the Pearl River estuary where the river flows into the South China Sea. Geographically it covers nine prefectures of the Guangdong province, but economically and culturally it also includes Shenzhen and Hong Kong.

Qipao: A one-piece garment for women, also known as *cheong-sam*, had its origin in the dress worn by Manchu women in the Qing dynasty. The modern version of the *qipao* was first developed in Shanghai after the fall of the Qing dynasty in 1911, and its form is slender, more fitted and revealing. It became popular again after Wong Kar-wai's film *In the Mood for Love* (2000).

Shanghai World Expo: In 2010 Shanghai will host the World Expo, adopting the motto 'Better City, Better Life', which signifies the city's aspiration as a major economic and cultural centre in the twenty-first century. Seventy

million visitors are expected to visit the Expo site in the Pudong area of the city.

Southern Tour: In 1992, five years before his death, the reformist Communist Party leader Deng Xiaoping made a series of visits to Shanghai, Shenzhen, Zhuhai and Guangzhou. During his journey he reaffirmed the importance of opening up the Chinese economy to foreign capital and reinforced the Party's commitment to growth through speedy development in advanced areas, despite the wealth disparities this engendered. Deng's speeches and actions in 1992 proved essential to the consolidation of China's economic reforms.

Special Economic Zone (SEZ): In China, SEZs are areas granted special tax, export and foreign investment regimes by the Central Government. The first SEZs, including Shenzhen, were established in the early 1980s in Guangdong province, and have adopted an export-oriented development strategy with substantial numbers of joint-venture companies. Other SEZs are in Fujian and Hainan provinces.

Ten Grand Buildings of Beijing: Erected to give expression to the idealism and self-confidence of 1950s China, the Ten Buildings of 1959 – including the National Museum of China, the Great Hall of the People and Beijing Railway Station – are now dwarfed by the architectural mega-structures built since the early 1990s.

Xintiandi: A redeveloped historical area of Shanghai attracting international and local visitors to numerous shops, cafés and restaurants. Hong Kong developers Shui On Land Limited transformed a decaying area into a high-end destination, highlighting the historical and atmospheric associations of the district, which contains the location of the founding meeting (1921) of the Communist Party of China.

CONTRIBUTORS

Bao Mingxin is Professor of the Fashion Institute at Donghua University. He has published widely on historical and contemporary textiles and fashion, authored more than 30 books and penned many fashion critiques for major periodicals in China. He is also on the returning jury of the Ten Best Fashion Designers in China Award and has judged many fashion-design competitions.

Helen Evenden is Tutor in Vehicle Design and Critical and Historic Studies at the Royal College of Art, London. Formerly Head of Education at London's Design Museum, she has written, curated and lectured widely on architecture and design. Her recent research includes a study of the interaction between moving objects and the built environment, and her publications include *Moving Forward* (V&A, 2007).

Hu Yang originally trained as a musician, taking up documentary photography in 1980. Since the 1980s he has been documenting the city of Shanghai, resulting in three unique photography series: *Shanghai Living* (January 2004–February 2005), *Another Side of Shanghai* (February 1980–May 2007) and a yet to be titled series (July 2007–ongoing).

Huang Zhicheng is Director of the Research and Collection Department of Shenzhen Guanshanyue Art Museum, with a special interest in modern and contemporary art history and graphic design. He has written widely on the development of graphic design in Shenzhen and has published in *Art Monthly* and *Art and Science*.

Stefan R. Landsberger is the Olfert Dapper Chair of Contemporary Chinese Culture at the University of Amsterdam and is Lecturer at the Sinological Institute, Leiden University. He obtained a PhD in Sinology from Leiden University. He has one of the largest private collections of Chinese propaganda posters in the world, has published widely on topics related to Chinese propaganda and maintains an extensive website exclusively devoted to this genre of political communications (http://www.iisg.nl/~landsberger).

Benny Ding Leong is Assistant Professor of the School of Design at Hong Kong Polytechnic University. Having trained and practised as an industrial designer, he began research into reviving traditional Chinese culture in sustainable design, and into contemporary design strategic thinking and practice since 1994. He co-founded with Ezio Manzini the Network on Design for Sustainability (DfS), and they have co-published a book about DfS in China.

Li Wen is Deputy Editor-in-Chief of *City Pictorial* magazine. Having graduated from Jinan University in journalism, he was a journalist and Editor for *Golden Age* magazine. He joined *City Pictorial* in 2000, since when he has been dedicated to mapping out and promoting youth culture and trends and researching the phenomenon of city-based magazines in China.

Lu Lijun is a Masters candidate in the history of textiles at the Fashion Institute of Donghua University. She specializes in the modern and contemporary history of Chinese textiles and fashion. Her research was published in the 2006 International Forum on Textile Science and Engineering for Doctoral Candidates.

Beth McKillop is Keeper of Asia at the V&A. Previously a curator in the Asian Collections of the British Library, her publications include *Korean Art and Design* (1992) and *North Korean Culture and Society* (2004). Her contribution to the 2003 British Library exhibition catalogue *Chinese Printmaking Today* reflects a longstanding interest in the book and print cultures of East Asia. Current projects include Chinese and Korean elements of the V&A's new ceramic galleries (opening 2009) and research into the V&A's outstanding collection of early Chinese sculpture.

Ezio Manzini is Professor of Design and Director of the Unit of Research Design and Innovation for Sustainability at the Politecnico di Milano, Italy. He specializes in strategic design and design for sustainability, with a focus on design for social innovation. He also coordinates Creative Communities for Sustainable Lifestyles, a research programme on grass-roots social innovation in China, India and Brazil. His publications include *Sustainable Everyday* (2003) and *Design Vision: A Sustainable Way of Living in China* (2006).

MEWE Design Alliance was initially an informal organization of designers with the common goal of changing the landscape of contemporary design. The name signifies the coming together of individuals ('me') and the collective ('we'). The first design studio of the Alliance is MEWE Graphic Studio, formed by members **He Jun, Guang Yu** and **Liu Zhizhi** in 2002.

Lauren Parker is Head of Contemporary Programmes at the V&A and has curated several exhibitions and events programmes, including the V&A's critically acclaimed audio exhibition, *Shhh … Sounds in Spaces* (2004) and *Touch Me: Design and Sensation* (2005). Specializing in moving image, interaction design and digital technologies, she has written widely on global contemporary design and new media and is the author of *Interplay: Interactive Design* (V&A, 2004).

Shi Jian is a curator, critic and researcher on architecture and urbanism. He founded the publishing house ISreading Culture, where he is Planning Director. He frequently contributes to *Domus China, Time + Architecture* and other architectural periodicals, and is on the editorial board of the contemporary culture magazine *Avant-Garde Today*.

Ye Ying is the Art and Design Editor for the *Economic Observer* and Chief Editor of their *Lifestyle Monthly* supplement. She writes widely on Chinese and international contemporary art and design, and on youth culture and trends. She is also a founder of a popular art and culture blog, Mindmeters.com.

Yin Zhixian is the Assistant Publisher of Trends Publishing and Editor-in-Chief of *Trends Home* magazine. She has participated in starting four Trends periodicals: *Trends, Trends-Esquire* (a Chinese version of Esquire), *Trends Home* and *Trends House*. She has also written and lectured widely on the Chinese middle class and is the author of *The Middle Class in China* (1999).

Yu Haibo is Chief Press Photographer of the *Shenzhen Economic Daily* and Director of the Shenzhen Professional Photography Association. He has won numerous national and international awards, including the second prize Arts and Entertainment Stories in the 49th World Press Photo contest and National Top Ten Young Press Photographer. His works have been exhibited internationally.

Zeng Li is the resident designer for the Beijing People's Art Theatre. He has worked internationally as a theatre, opera and ballet set- and costume-designer, most notably for director Zhang Yimou's *Turandot* (Forbidden Palace, 1998) and *Raise the Red Lantern* (Chinese National Ballet and international tour, 2001).

Zhang Hongxing is Senior Curator of the V&A's Asian Department. He curated *The Forbidden City: Treasures of an Emperor*, the first loan exhibition since 1935 to the UK from the Palace Museum, Beijing, and was Editor of the accompanying catalogue, *The Qianlong Emperor: Treasures from the Forbidden City* (2002). He is a specialist in Chinese painting and is responsible for the V&A's collections of Chinese art and design.

Jianfei Zhu is Senior Lecturer in Architecture at the University of Melbourne, Australia, focusing on theories of architecture, the Asian metropolis and urbanism and architectural design. His research centres on Chinese architecture in an international perspective, and on China–West interactions in practice and critical thinking. His publications include *Chinese Spatial Strategies: Imperial Beijing 1420–1911* (2004) and essays for specialist books and periodicals.

FURTHER READING

This is not a comprehensive bibliography on design and architecture in contemporary China, but is intended as a guide to some of the sources in and beyond this book. This bibliography includes books, papers/articles and journals, as well as entries for magazines and websites. It is arranged by discipline, although some materials have relevance to more than one section.

Background reading

Stephanie Hemelryk Donald and Robert Benewick, *The State of China Atlas* (Berkeley, 2005)

John Gittings, *The Changing Face of China: from Mao to Market* (Oxford, 2005)

Peter Hessler, *Oracle Bones: A Journey Between China and the West* (London, 2006)

James Kynge, *China Shakes the World: the Rise of a Hungry Nation* (London, 2006)

OECD, *Economic Survey of China Policy Brief* (Paris, 2005)

Joshua Cooper Ramo, *The Beijing Consensus* (London, 2004)

Wang Hui, *China's New Order: Society, Politics and Economics in Transition* (Cambridge, MA, 2003)

General

9th Chinese National Art Exhibition 1999: Design Exhibition (Guangzhou, 1999)

10th Chinese National Art Exhibition 2004: Collection of Art and Design Works (Beijing, 2004)

Chen Ruilin, *Zhonguo xiandai yishu sheji shi* [*A History of Modern Chinese Design*], (Changsha, 2003)

Edward L. Davis (ed.), *Encyclopedia of Contemporary Chinese Culture* (London and New York, 2005)

Ji Long (ed.), *Dangdai zhongguo de gongyi meishu* [*Contemporary Chinese Applied Art*], (Beijing, 1984)

Ou Ning, *2010 de chuangyi shenghuo tiyan* [*Life Experience 2010*], special issue, supplement of *Modern Weekly* magazine, no.32, 2005

Ou Ning et al., *07 dasheng zhan shouce* [*07 Get It Louder exhibition handbook*], (Guangzhou, 2007)

UK Trade and Investment, *Changing China: The Creative Industry Perspective* (London, 2004)

Yuan Xiyang, *Zhongguo yishu sheji jiaoyu fazhan licheng yanjiu* [*A Study in the Development of Chinese Art and Design Education*], (Beijing, 2003)

Zhongguo sheji nianjian [*China Design Year Book*], (Beijing, 1995–)

Zhongguo xiandai meishu quanji [*Comprehensive Catalogue of Modern Chinese Art*], vols 1–48 (Beijing, 1997–8)

Zhu Dake, *21 shiji zhongguo wenhua ditu* [*The Chinese Culture Map of the 21st Century*], vols 1– (Guilin, 2003–)

Chengshi huabao [*City Pictorial*], (Guangzhou, 1998–)

Sanlian shenghuo zhoukan [*Sanlian Lifestyle Weekly*], (Beijing, 1995–)

Xinzhou kan [*New Weekly*], (Chuangzhou, 1996–)

Yishu yu sheji [*Art and Design*], (Beijing, 1997–)

Zhoumo huabao [*Modern Weekly*], (Guangzhou, 1998–)

Bieguan [Alternative Archive], www.alternativearchive.com

Danwei [Chinese media, Advertising and Urban Life], www.danwei.org

Sheji zaixian [Design Online], www.dolcn.com

Shijue tongmeng [Vision Union], www.visionunion.com.cn

Shijue zhongguo [China Visual], www.chinavisual.com

Siwei de lequ [Mindmeters], www.mindmeters.com

Architecture and urbanism

Richard Burdett (ed.), *Cities, Architecture and Society* (Venice, 2006)

Marlies Buumna and Maarten Kloos (ed.), *Dutch Architects in Booming China* (Amsterdam, 2005)

Bernard Chan, *New Architecture in China* (London, 2005)

Yung-ho Chang et al., *Shenzhen chengshi jianzhu shuangnian zhan* [*Shenzhen Biennial of Urbanism and Architecture 05*], (Shenzhen, 2005)

'China Boom: Growth Unlimited', *AV Monographs* 109–110, 2004

Chuihua Judy Chung, Jeffrey Inaba, Rem Koolhaas and Sze Tsung Leong, *Great Leap Forward*, Harvard Design School Project on the City (Cambridge, MA, 2001)

Layla Dawson, *China's New Dawn: An Architectural Transformation* (Munich, 2005)

Christine de Baan et al. (ed.), *China Contemporary: Architecture, Art, Visual Culture* (Rotterdam, 2006)

Hanru Hou and Hans Ulrich Obrist (ed.), *Cities on the Move* (Ostfildern, 1997)

Neil Leach, *China* (Hong Kong, 2004)

B.D. Leong and E. Manzini, *Design Vision: A Sustainable Way of Living in China* (Guangzhou, 2006)

Rem Koolhaas (ed.), *Content* (Cologne, 2004)

Peter Rowe, *East Asia Modern: Shaping the Contemporary City* (London, 2005)

Kai Vöckler and Dirk Luckow (ed.), *Peking Shanghai Shenzhen: Städte des 21. Jahrhunderts* (Frankfurt and New York, 2000)
'Volume 8: Ubiquitous China', *Archis*, no.2, 2006
Charlie Q.L. Xue, *Building a Revolution: Chinese Architecture Since 1980* (Hong Kong, 2006)
Kongjian Yu and Mary Padua (ed.), *The Art of Survival: Recovering Landscape Architecture* (Mulgrave, Victoria, 2006)
Jianfei Zhu, 'Criticality in between China and the West', *Journal of Architecture*, no.5, November 2005
Zou Dennong et al. (ed.), *Zhongguo xiandai jianzhu shi* [*The History of Modern Chinese Architecture*], (Tianjin, 2001)

Chengshi zhongguo [*Urban China*], (Shanghai, 2005–)
Domus China (Beijing, 2007–)
Jianzhu shi [*Architects*], (Nanjing, 1979–)
Jianzhu xuebao [*Architectural Journal*], (Beijing, 1954–)
Jianzhu yu dushi [*a+u China*], (Ningbo, 1995–)
Shidai jianzhu [*Time+Architecture*], (Shanghai, 1984–)

Abbs Jianzhu luntan [Abbs Architecture], www.abbs.com.cn
China–US Centre for Sustainable Development, www.chinauscenter.org
Chinese-Architects, www.chinese-architects.com
Dynamic City Foundation, www.dynamiccity.org

Fashion and lifestyle
An Yuying, Jin Gengrong, *Zhongguo xiandai fuzhuang shi* [*The History of Modern Chinese Clothing*], (Beijing, 1999)
Julia F. Andrews and Kuiyi Shen, 'The New Chinese Women and Lifestyle Magazines in the Late 1990s', in Perry Link, Richard P. Madsen and Paul G. Pichowicz (eds), *Popular China: Unofficial Culture in a Globalising Society* (Lanham, MD, 2002), pp.137–61
China Central Television, *Shangpin de gushi* [*The Story of Commodities*], (Guangzhou, 2001)
Deborah S. Davis (ed.), *The Consumer Revolution in Urban China* (Berkeley, CA, 2000)
Antonia Finnane, 'China on the Catwalk: Between Economic Success and National Anxiety', *The China Quarterly*, September 2005, pp.587–607
David Gilbert, 'From Paris to Shanghai: The changing geographies of the fashion's world cities', *Fashion's World Cities* (Oxford, 2006)
Claire Roberts (ed.), *Evolution and Revolution: Chinese Dress 1700s to 1990s* (Sydney, 1999)
Valerie Steele and John S. Major (eds), *China Chic: East Meets West* (New York, 1999)
Vivienne Tam, *China Chic* (New York, 2000)
Yin Zhixian, *Hunda zhongchan jia* [*The Mix-Match in Middle-class Homes*], (Beijing, 2005)

Fushi yu meirong [*Vogue China*], (Beijing, 2005–)
Qingnian shijue [*Vision*], (Beijing, 2001–)
Shijie shizhuang zhiyuan [*Elle China*], (Shanghai, 1988–)
Shishang [*Trend*], (Beijing, 1993–)
Zhongguo fuzhuang [*China Garment*], (Beijing, 1985)

Graphic design, advertising, new media
Martin J. Heijdra, 'The Development of Modern Typography in East Asia', *The Eastern Asian Library Journal*, vol.xi, no.2, Autumn 2004, pp.100–169
D.J. Huppertz, 'Simulation and Disappearance: The Posters of Kan Tai-Keung', *Third Text*, vol.16, issue 3, 2002, pp.295–308
Eva Lüdi Kong, *Typo China* (Baden, 2006)
Heinz-Juergen Kristahn (ed.), *Das AvantgardePlakat aus China* (Berlin, 2001)
Stefan Landsberger, *Propaganda Posters: From Revolution to Modernisation* (New York, 1995)
Liu Libing (ed.), *Zhongguo guanggao mengjin shi 1979– 2003* [*A History of Chinese Advertising 1979–2003*], (Beijing, 2004)
Scott Minick and Jiao Ping, *Chinese Graphic Design in the Twentieth Century* (London, 1990)
'New China', *Amelia's Magazine*, 06 A/W 2006
Shenzhen Graphic Design Association, *Shenzhen Graphic Design 1995–2005* (Shenzhen, 2006)
Henry Steiner and Ken Haas, *Cross-Cultural Design: Communication in the Global Marketplace* (London, 1995)
Matthew Turner, 'Early Modern Design in Hong Kong', *Design Issues*, vol.6, no.1, Autumn 1989, pp.79–91
Jing Wang, 'Youth Culture, Music, and Cell Phone Branding in China', *Global Media and Communication*, vol.1, no.2, 2005, pp.185–201
Wendy Siuyi Wong, 'Detachment and Unification: A Chinese Graphic Design History in Greater China since 1979', *Design Issues*, vol.17, no.4, Autumn 2001
Yu Yangming, *Gongyi guanggao de aomi* [*Public Service Advertising in China*], (Guangzhou, 2004)
Zhao Yan (ed.), *2003 China International Poster Biennial* (Hangzhou, 2003)
Gu Zhengqing, *Shanghai Cool – Creative Reproduction* (Shanghai, 2005)

Baozhuang yu sheji [*Packaging and Design*], (Guangzhou, 1973–)
Shuma sheji [*Computer Graphics*], (Beijing, 2000–)
Xiandai guanggao [*Modern Advertising*], (Beijing, 1994–)

Industrial design
Design Issues, special issue on design in Hong Kong, vol.19, no.3, Summer 2003
John Heskett, 'Design in China', paper given at the 'China Design Now' workshop, Central Academy of Fine Art, Beijing, 14–16 October 2005
Japan Design Foundation, *Policy for The Design Promotion Cooperation Project in China* (Osaka, 2004)
David Rocks, 'China Design: How the mainland is becoming a global center for hot products', *Business Week*, Asian edition, 21 November 2005, pp.64–72
Shao Hong and Yan Shanchun (ed.), *Suiyue mingji – Zhongguo xiandai sheji zhilu xueshu yantaohui lunwen ji* [*Documenting the Past – Essays Presented in the Conference 'The Chinese Road Towards Modern Design'*], (Changsha, 2004)
Tong Huiming, 'Zhongguo gongye sheji ershinian fansi' ['Reflection on the Twenty-Year Chinese Industrial Design'], (www.dolcn.com, consulted September 2005)
Shou Zhi Wang, 'Chinese Modern Design: A Retrospective', in *Design History: An Anthology, A Design Issues Reader*, ed. Dennis P. Doordan (Cambridge, MA, and London, 1995), pp.213–41

Chanpin sheji [*Product Design*], (Beijing, 2002–)

EXHIBITION PARTICIPANTS

Ai Weiwei 艾未未

Amateur Architecture Studio 业余建筑工作室
(Lu Wenyu 陆文宇, Wang Shu 王澍)

Art Research Centre for Olympic Games, China Central
Academy of Fine Arts 中央美术学院奥运艺术研究中心

Arup

Atelier Deshaus 大舍建筑设计事务所 (Chen Yifeng
陈屹峰, Liu Yichun 柳亦春, Zhuang Shen 庄慎)

Atelier FCJZ 非常建筑设计研究所 (Yung Ho Chang
张永和, Lu Lijia 鲁力佳)

Atkins

B6 楼南立

Bi Xuefeng 毕学锋

Alan Chan 陈幼坚

Edison Chen 陈冠希

Chen Feibo 陈飞波

Chen Man 陈曼

Chen Shaohua 陈绍华

Chen Shaoxiong 陈劭雄

Chen Xiongwei 陈雄伟

Chen Yifei 陈逸飞

Chen Zhengda 陈正达

China Architecture Design and Research Group
中国建筑设计研究院 (Cui Kai 崔恺)

China Central Television 中央电视台

Coldtea Online Magazine　Coldtea网络电子杂志

Danwei.org 单位网

Deng Yuanjian 邓远健

Eddi Yip

Fang Er 方二

Feng Boyi 冯博一

Feng Jiangzhou 丰江舟

Foster + Partners

Graduate Center of Architecture, Peking University
北京大学建筑学研究中心

Gu Fan 古凡

Guan Xiaojia 关晓佳

Han Feng 韩枫

Han Jiaying 韩家英

Han Zhanning 韩湛宁

He Jianping 何见平

He Yan 何艳

Hei Yiyang 黑一烊

Herzog & de Meuron

Taddy Ho 何清辉

Hu Yang 胡杨

Ji Ji 吉吉

Jiakun Architects 家琨工作室 (Liu Jiakun 刘家琨)

Jiang Jian 姜剑

Jiang Jianqiu (Lao Jiang) 蒋建秋 (老蒋)

Jiang Jun 姜珺

Jiang Qiong Er 蒋琼耳

Jiang Zhi 蒋志

Kan Tai-keung 靳棣强

Yue-sai Kan 靳羽西

Kengo Kuma and Associates (Kengo Kuma 隈研吾)

Lam Hung 林伟雄

Freeman Lau 刘小康

Lenovo Group Innovation Design Centre
联想集团创新设计中心

Limited Design 有限设计 (Wang Hui 王晖)

Lin Jing 林菁

Liuli Gongfang 琉璃工房 (Chang Yi 张毅, TMSK 透明思考,
Loretta Hui-Shan Yang 杨惠姍)

London Crystal Digital Technology 伦敦水晶石数字科技

Lu Kun 陆坤

Ma Ke 马可

MAD Ltd　MAD建筑师事务所 (Dang Qun 党群,
Yosuke Hayano 早野洋介, Ma Yansong 马岩松)

MADA s.p.a.m. 马达思班 (Ma Qingyun 马清运)

Maleonn 马良

MC Yan 陈广仁

Meng Jin 孟瑾

MEWE Design Alliance 米未设计联盟 (Guang Yu 广煜,
	He Jun 何君, Liu Zhizhi 刘治治)

Miao Xiaochun 缪晓春

Nacha Studio 腔调多媒体制作 (Li Yong 李勇, Qi Yanyan
	齐炎焱, Zhang Yufei 张宇飞)

New Pants 新裤子 (Liu Bao 刘葆, Pang Kuan 庞宽,
	Peng Lei 彭磊)

Office for Metropolitan Architecture

Ou Ning 欧宁

Peng Han (Yan Cong) 彭撼 (烟囱)

Perk 破壳 (Jin Ningning 金宁宁, Si Wei 司玮)

Pigstyle Net-Zine 风格癖中文网络杂志

PK 彭凯

PTW Architects

Qian Qian 钱骞

Runyo 陈润耀

'Society' — The People's Skateboards 社会滑板
	(Raphael Cooper, Li Qiuqiu 李球球)

Scenic Architecture 山水秀建筑设计顾问
	(Zhu Xiaofeng 祝晓峰)

Shao Fan 邵帆

SOHO China　SOHO中国

Standardarchitecture 标准营造规划设计咨询 (Ru Lei 茹雷,
	Claudia Toborda, Zhang Hong 张弘, Zhang Ke 张轲)

Studio 8 Architects (cj Lim 林纯正)

Studio Pei-Zhu 朱锫建筑设计事务所 (Wu Tong 吴桐,
	Zhu Pei 朱锫)

Tudou.com 土豆网

Turenscape (Turen Design Institute) 土人景观与建筑规划
	设计研究院 (Yu Kongjian 俞孔坚)

Unmask (Kuang Jun 匡峻, Liu Zhan 刘展,
	Tan Tianwei 谭天帏)

Urbanus 都市实践建筑事务所 (Liu Xiaodu 刘晓都,
	Meng Yan 孟岩, Wang Hui 王辉)

Vanke 万科

Wang Xu 王序

Wang Yiyang 王一扬

Wang Yuefei 王粤飞

Weng Peijun (Weng Fen) 翁培竣 (翁奋)

Wing Shya 夏永康

Wong Kar-wai 王家卫

Himm Wonn 王秉彝

WZL 汪钰伟

Xing Danwen 邢丹文

Xu Bing 徐冰

Yan Jun 颜峻

Zeng Xiaojun 曾小俊

Zhang Da 张达

Zhang Dali 张达利

Zhang Yuan 张元

Zhao Bin 赵斌

Zhuang Hui 庄辉

This list credits all participants at the time of publication, but is by no means exhaustive. We are grateful to all lenders and contributors who generously gave their time towards the fulfillment of this project.

INDEX

This book is published to coincide with the exhibition *China Design Now* at the Victoria and Albert Museum, London 15 March–13 July 2008

First published by V&A Publishing, 2008
V&A Publishing
Victoria and Albert Museum
South Kensington
London SW7 2RL

Distributed in North America by Harry N. Abrams, Inc., New York

ISBN-9781851775316
Library of Congress Control Number 2007935234

10 9 8 7 6 5 4 3 2 1
2012 2011 2010 2009 2008

A catalogue record for this book is available from the British Library.

Designer: Hybrid 2 Ltd
Copy-editor: Mandy Greenfield
Translator: Nicky Harman
Research Assistant: Gigi Chang

Cover photograph: John Ross
Pages 10–11: Maleonn, Days on the Cotton Candy #4, photography series, 2006.

Printed in China by C + C Offset Printing Co.Ltd

V&A Publishing
Victoria and Albert Museum
South Kensington
London SW7 2RL
www.vam.ac.uk